SKOOKUM
TUGS

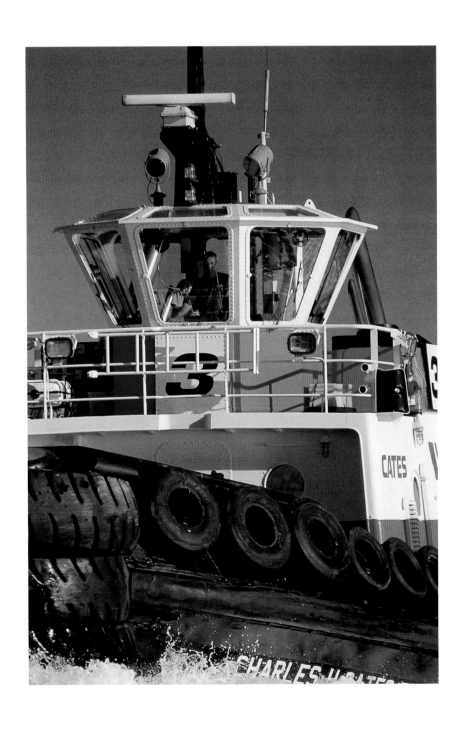

British Columbia's Working Tugboats

Photographs by ROBB DOUGLAS

Text by Peter Robson and Betty Keller

Foreword by Stephen Hume

SKOOKUM
TUGS

HARBOUR PUBLISHING

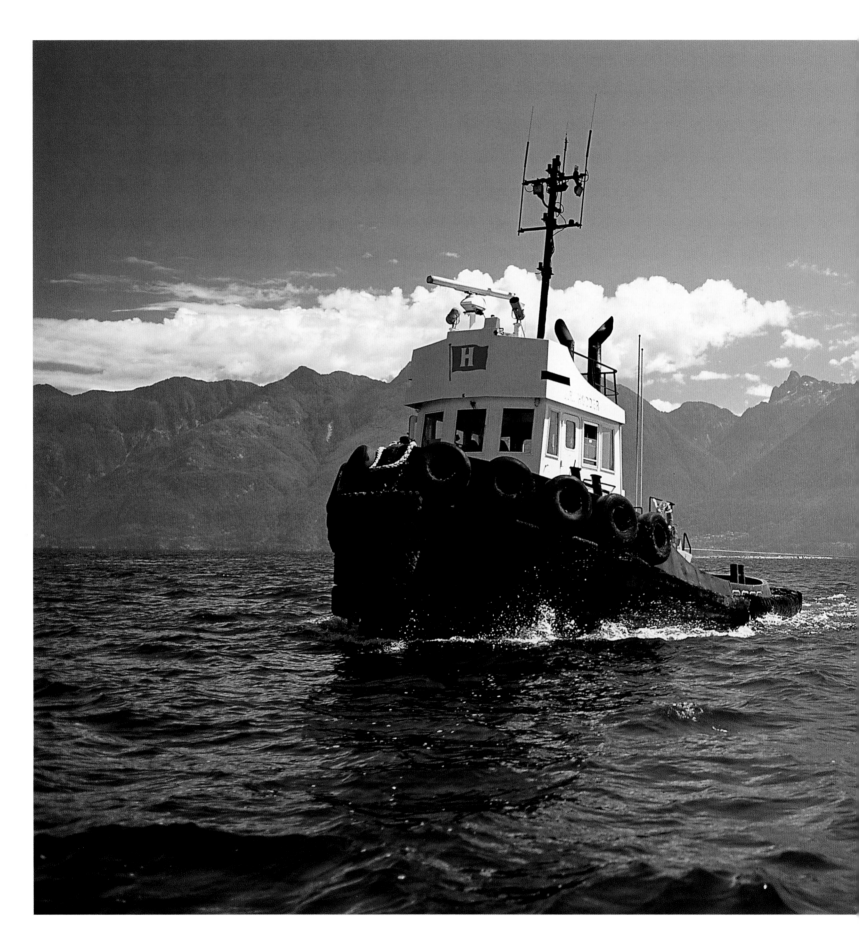

CONTENTS

Hodder Tugboat Co. Ltd's 12.3-metre, 850-horsepower tug the
J.R. Hodder **pulls a chip barge in Howe Sound.**

PREVIOUS PAGE
A tugboat tows a trio of barges into Malaspina Strait,
between Lasqueti Island and the Sechelt Peninsula.

FIRST PAGE
Charles H. Cates No. 3 **heads off to escort a freighter into**
Vancouver's harbour—a job done by tugs bearing the Cates
name for over a century.

Almost 70 years ago, when hawks killed all the carrier pigeons that were supposed to take his story about the first ascent of Mount Waddington back to civilization, *Vancouver Province* reporter Bill Mayse descended the mountain and its icefields by himself, bushwhacked through devil's club and cedar jungles to the head of Knight Inlet, danced his way over the log booms and hailed a passing tug, which took him to Vancouver to file his story.

He thought this all in a day's work. So did the tugboat skipper, who never asked why a guy from the Big Smoke might be standing on a log boom in the middle of nowhere looking for a ride. He must have had a real good reason to be there, right?

"Son," said the somewhat more solicitous cook, eyeing the gaunt, ragged traveller, "I got a cooler full of grub here, whatcha want? Steak, pork chops, I can fix anything."

"Gee," said the famished reporter, "have you got any peanut butter?"

Strange what gets fixed in your head as being essential after a few days without food.

Mayse told that story sitting out behind his house near Campbell River, where we watched another tug from another era moving a bunkhouse south from the logging camps. Indeed, his own cozy little beachfront house had come by the same route. It was a former floathouse from the A-frame camps and had been lost in a poker game at the Lorne Hotel in Comox. The winner just picked a likely beach, the tug ran a cable through a pulley on a tree and winched that house right up to its present location. It sits on the original skids and you can see it still about 15 kilometres south of Campbell River.

Those two quintessential British Columbia stories say much about the understated role the towboat industry plays in the life of this coast. In some ways, it's an industry that seems to operate beneath the surface of our consciousness. We know it's there—and the remarkable photos in *Skookum Tugs* capture it in all its brawny yet beautiful splendour—we just don't pay a lot of heed to it. Perhaps that's because it's been such an integral part of the region's history that we take it for granted. Perhaps it's because the seductions of urban living—sheltered as most of us are from the perils of the storm coast by the shield of Vancouver Island—serve to isolate us from the history that shaped us.

Looking out into winter squalls from the comfort of our air-conditioned towers of steel and glass or settling in for a tawny summer evening barbecue with the sound of sprinklers on immaculate lawns, it's easy to forget that we have always been a maritime people with the world's biggest ocean pounding at our gates. But turn into the Strait of Juan de Fuca at the Swiftsure Bank with the tide running against a gale, the rockbound coast of Vancouver Island shrouded in torn cloud and spindrift and the trans-Pacific swells stacking up into short, angry seas the size of suburban houses and you know why even today's mariners still call this the graveyard coast.

The turbulence extends hundreds of kilometres out into the Pacific, a churn so powerful it's been known to capsize 30-metre boats. And this is just the start. From Cape Flattery to the Alaska Panhandle, British Columbia's contorted coastline of fjords, narrows, reefs, tidal rapids, fog banks and tide-rips has claimed more than 200 ships. The bottom is strewn with all types and sizes of vessels—clipper ships and paddle steamers, steel freighters and sealing schooners, grimy colliers and barges loaded with railway cars. You name it, it's probably lying on the bottom somewhere along the 28,000 kilometres of coastline jammed into the 1,500 kilometre span between the 49th and 60th parallels of latitude.

Those shipwrecks are a testament to the maritime commerce that still pulses through the economic heart of British Columbia. On average, a foreign vessel enters the port of Vancouver every three hours. They carry more than a million passengers a year and an equal number of cargo containers. Wheat, pulp, wood chips, newsprint, coal, ore concentrate, logs and crude oil fill the bulk carriers, barges and log booms that channel a torrent of resources to world markets. At the heart of this flood of goods and raw materials is still the lowly tugboat. Without the province's historic towboat industry, the maritime economy would grind to a halt. And these photographs, from the wild backdrops of the province's sea and mountains to the mist-draped skyscrapers of the urban harbour, capture the muscular vitality of the towboats on which that torrent of wealth depends.

Tugboats reach into the sinewy past of the province and they are helping to shape its future. Tugs once nudged the majestic, white-hulled China clippers to berth and they brought the battered cruisers of the Royal Navy to safe haven at Esquimalt after the Battle

of the Falkland Islands. They've salvaged freighters in distress in the typhoon-torn Pacific 3,000 kilometres from home and they've delivered Christmas groceries to logging camps.

Today coastal tugboats boast some of the world's most advanced marine technology, but the work they do hasn't essentially changed since the ungainly old S.S. *Beaver* made the coast's first powered tow in 1836. Modern tugs still aren't among the ocean's great beauties—unless your definition of beauty has a place for designs where form follows function in the most unassuming and honest way. This is the quality that has led workboats of all countries to be among the most admired vessels on the water, and it is this quality that makes *Skookum Tugs* so much more than a collection of romantic waterfront images. Through the inspired lens of Robb Douglas the under-appreciated contemporary tugboat is revealed as a potent icon of coastal life.

It is a revelation that Bill Mayse of all people would have appreciated.

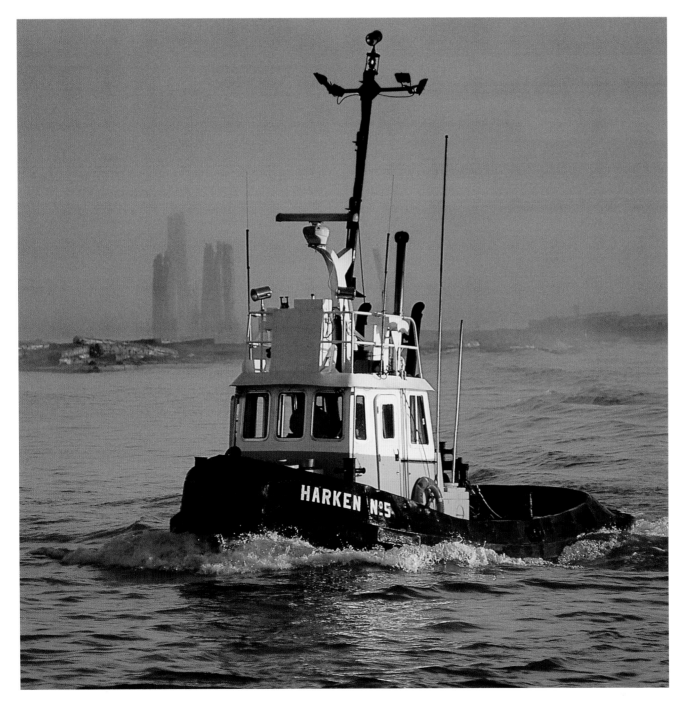

Harken Towing Co. Ltd's 10-metre *Harken No. 5* churns past a log boom as dawn breaks on the Fraser River.

In the 1850s, sailing ships of the world began to make regular runs around Cape Horn and up the western shores of the Americas to the far-flung colony of British Columbia. They were enticed upon this immense journey by the opportunity to load the two exports that have been the mainstays of BC shipping ever since: lumber and coal. The most fearful part of the trip was the very end. After beating their way up the American coast, they had to locate the entrance to Juan de Fuca Strait, a passage often obscured by fog and beset by contrary winds and currents that bore many unlucky ships onto the rock-studded shoreline of Vancouver Island, justly dubbed "The Graveyard of the Pacific." Even once the strait was safely entered, a ship could be thrown back by a prevailing wind funnelling out to sea, or stranded among the labyrinth of islands and reefs at the strait's inner end. The only sure relief from these deadly conditions was to secure a tow from one of the region's few resident steamships, and providing that service was the first assignment of the BC towboat industry.

The first BC towboat was a bluff 31-metre side-wheeler named the *Beaver*. She had been built in 1835 by the Hudson's Bay Company for the purpose of tending the firms's fur trading posts, but the log entry for her first day of operation hinted at a different career path:

At 1:30 took the Columbia *in tow up to the sawmill*

Towing was an unplanned role for the first power boat in the north Pacific but one that would occupy her throughout her half-century of service. You can learn a lot about the evolution of tugboat design just by observing the modifications made to the *Beaver* in the course of her colourful career. At first she had the high decks characteristic of the period's sailing ships, the better to accommodate large crews and cargos. When conscripted for towing duty, the towline, coming off the high stern, made the vessel heel over dangerously while turning. Under the right conditions this could set off a series of serpentine convulsions that scared the wits out of more than one unwary steersman. One paddle would lift clear of the water while the other dug in, causing the ship to veer around in the opposite direction of the intended turn. This, in turn, would cause her to heel over to the other side. As soon as this happened, the paddle that had originally gone

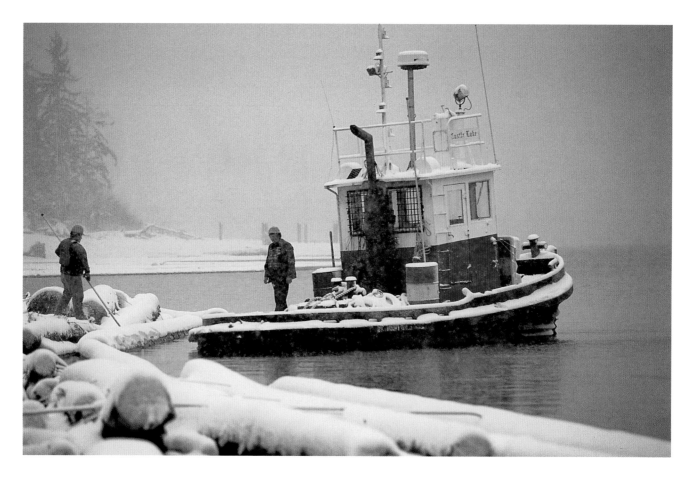

Skipper and deck-hand of Western Seaboard Marine's 8.6-metre *Castle Lake* work through a snowy day at Kitimat.

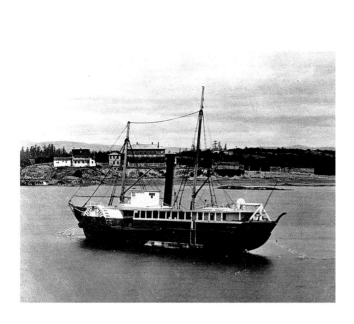

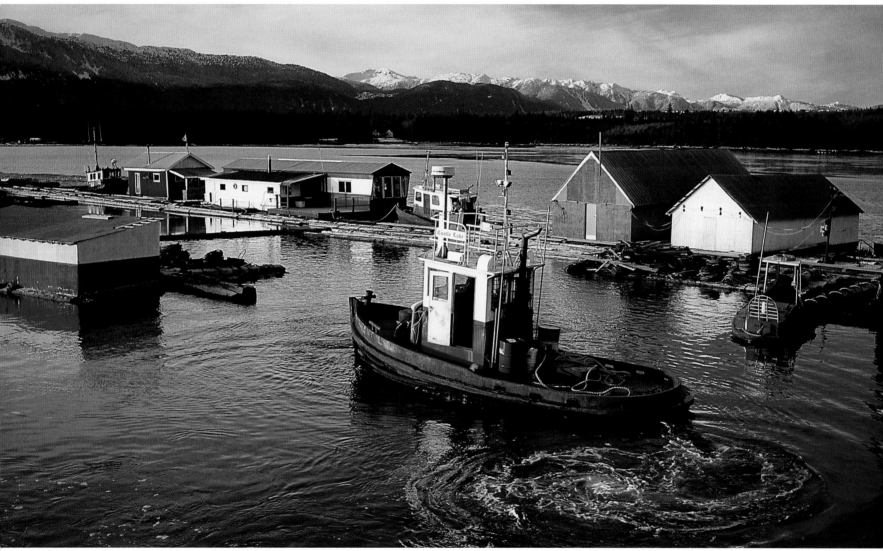

TOP LEFT
The Hudson's Bay Co. paddlewheeler S.S. *Beaver* as she appeared before conversion for towing. Courtesy L.R. Peterson.

TOP RIGHT
The *Beaver* sometime after 1874 and her conversion to a general workboat and log tug. You can see the rough outline of tugboats to come in the raised wheelhouse and low afterdeck. Courtesy L.R. Peterson.

ABOVE
Tug *Castle Lake* backs away from the dock in Kitimat.

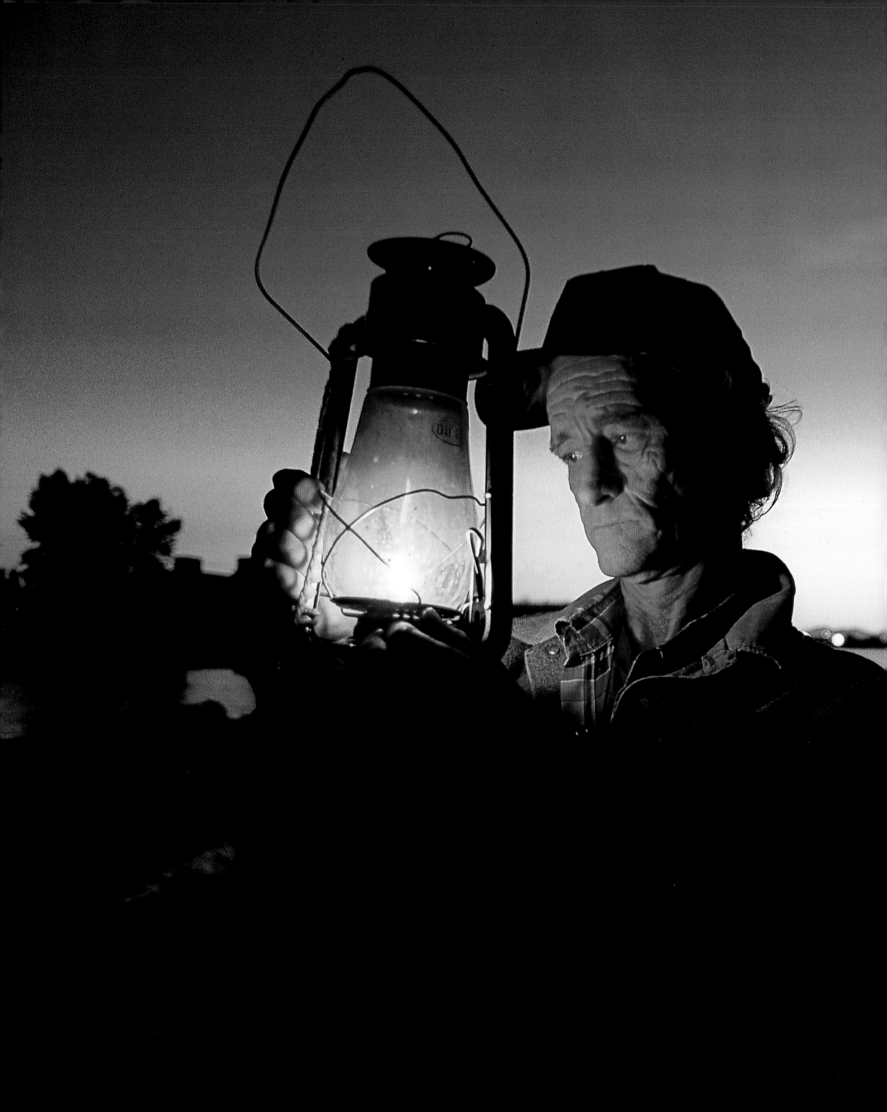

airborne would dig in and the boat would heave over to the first side again, generally causing the ship to thrash about like a harpooned walrus.

Steering under tow was a problem that plagued all of the early paddlewheel tugs and the latter-day owners of the *Beaver* solved it by hacking off the aft deckworks so they could place the tow bitt down close to the water, a modification also welcomed by deckhands faced with the task of hopping back and forth between the tug and low-floating tows. The pilothouse was jacked up at the same time to give the skipper a good view for manoeuvring in close quarters. Thus were the basic elements of the classic towboat profile established: the high, forward-mounted pilothouse and long, low afterdeck that has marked the breed from that day to this.

In 1853 the Hudson's Bay Company introduced a second steamer named for their second most favoured source of fur, the *Otter*. This futuristic vessel incorporated an even more radical technological advance in that the sidewheels were eschewed in favour of the newfangled waterscrew propulsion system, a.k.a. a propeller. Although the *Otter* has been overshadowed by the *Beaver* in the written record of the coast, she

really did a lot more towing and freighting than her more celebrated predecessor and, being bigger, faster and steerable, was a lot better at it. By the 1860s, the shipping traffic into Vancouver and Nanaimo was building to the point that there was call for a fulltime tugboat fleet, and before long purpose-built steam tugs like the *Isabel*, *Etta White* and *Alexander* were being locally constructed. The interesting thing about these first tugs is that they were some of the largest towboats ever built on the West Coast. They had to be because their main purpose was to tow sea-going ships in and out of the open ocean. The *Alexander*, launched in 1875, was 54.5 metres long, and the *Lorne*, launched in 1889, was 47.5 metres long and had 900 horsepower. It would be another 100 years before tugs of this size and power were again built on the coast. As steam took over from sail in the closing decades of the nineteenth century, there was less call for tugs capable of weathering the open ocean conditions off Cape Flattery and a much smaller class of tugs came into being to tow log booms and barges in the protected inner waters.

Although in the century or so since those first wooden tugs the basic hull design hasn't changed that much, there has been a continuous procession of

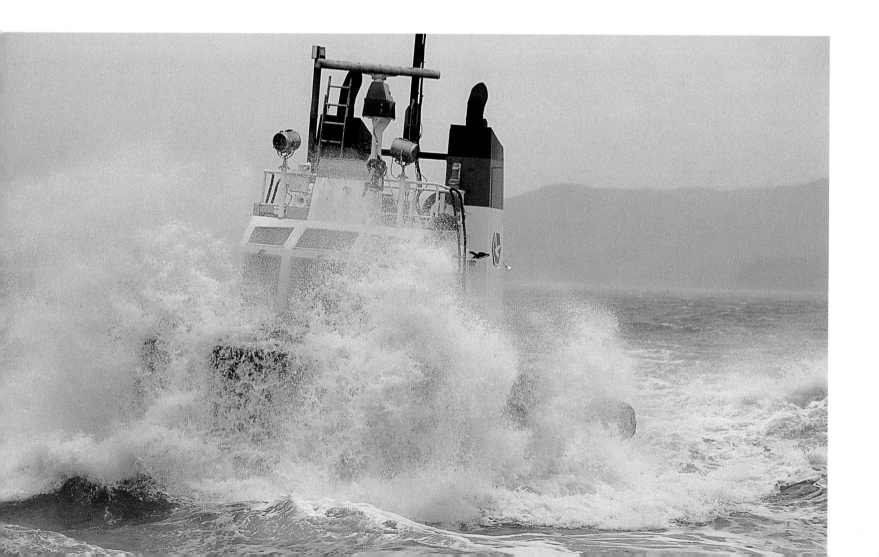

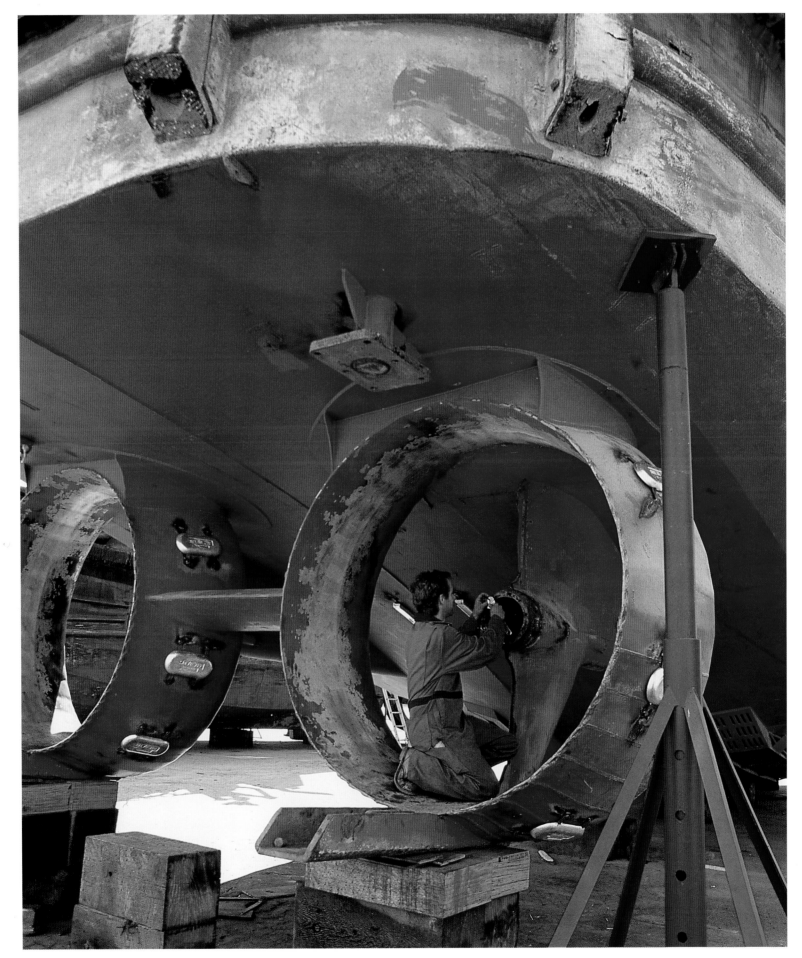

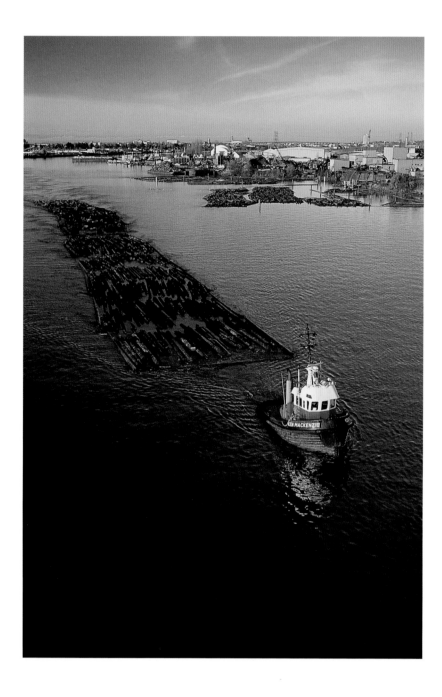

ABOVE
The *Ken Mackenzie* moves its tow of logs up the
Fraser.

RIGHT
Three flats tugs at rest on the North Arm of the Fraser
River.

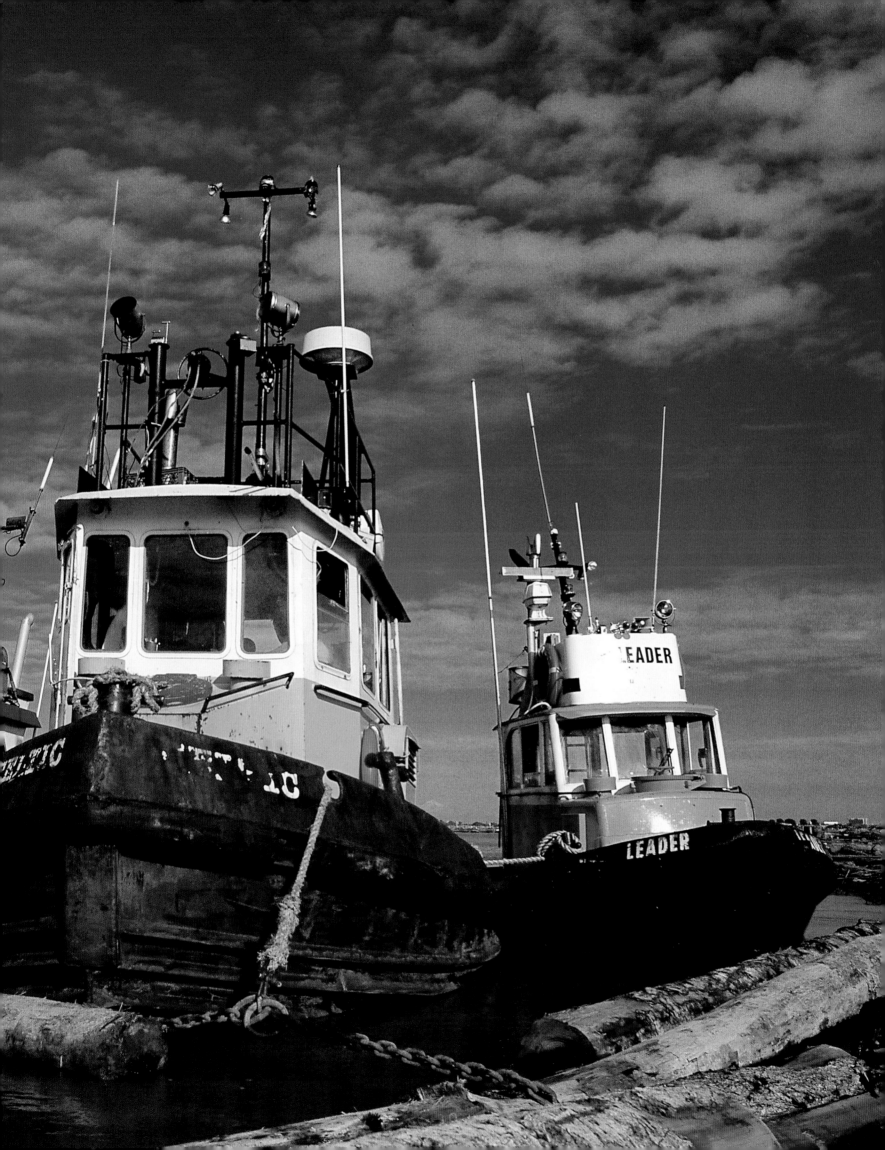

technical advances. Following World War I, diesel engines gradually replaced steam engines, steel construction began to replace wood and engines became lighter, more compact, and more powerful. In many cases, this meant that tugs could be smaller, but still far more powerful than their predecessors. Tugs requiring more horsepower than a single engine could produce began to install twin diesels. The next change came in the 1960s with the introduction of nozzles—streamlined jackets of steel around the propeller that directed the thrust and increased a tug's pulling, or pushing, power. In the 1980s, a new breakthrough

called the Z-drive gave these nozzles the capacity to rotate 360 degrees on the vertical axis, doing away with rudders and providing manoeuvrability the beleaguered steersmen of the old *Beaver* could only dream of. Z-drives have revolutionized the design of harbour tugs in particular, finally moving away from the *Beaver*'s "cheese-box-on-a-plank" look to something like a double-ended passenger ferry on steroids.

Following the demise of deep-sea ship towing around the end of the nineteenth century, towboating along the West Coast diversified into four basic areas. First and foremost was log towing. The forest industry

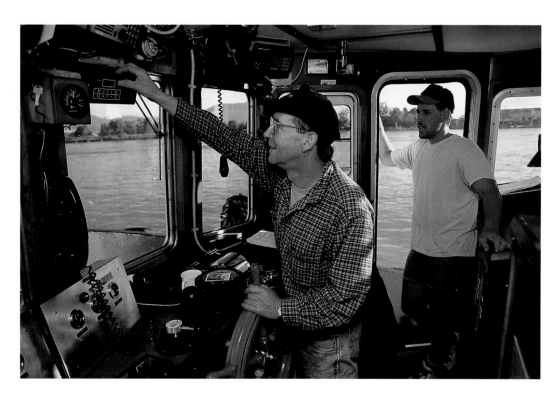

ABOVE
Aboard the Tidal Towing Ltd. river tug *Granny Hutch*, skipper Jim Stone and deckhand Lawrence Tatosky keep their eyes and ears on traffic above the Port Mann Bridge.

RIGHT
The 3,000-horsepower *Seaspan Falcon*, a new-wave berthing tug built in 1993 by Vancouver Shipyards Co. Ltd., muscles a freighter up against a dock in Vancouver Harbour.

grew to prominence as coal mining declined—at least on the coast—and as mills used up the timber near at hand, they found themselves in need of a tug fleet to deliver rafted-up logs from camps farther up the coast. As the reach of the mills grew further still, they found it necessary to load their logs on huge barges capable of travelling long distances over rough seas, and a new breed of super-tug came into being. While all this was going on, the inner coast was being settled and the protected waters favoured the growth of a general freighting industry based on the tug and barge. And while the ever-growing deep sea shipping traffic no longer needed the help of local towboats to make it down Juan de Fuca Strait, they needed more help than ever from a new generation of harbour tugs adept at manoeuvring their vast bulk to dockside in the increasingly busy ports of Vancouver, Roberts Bank, New Westminster and Ridley Island.

To perform each of these different jobs a special kind of towboat came into being, operated by a special kind of towboater.

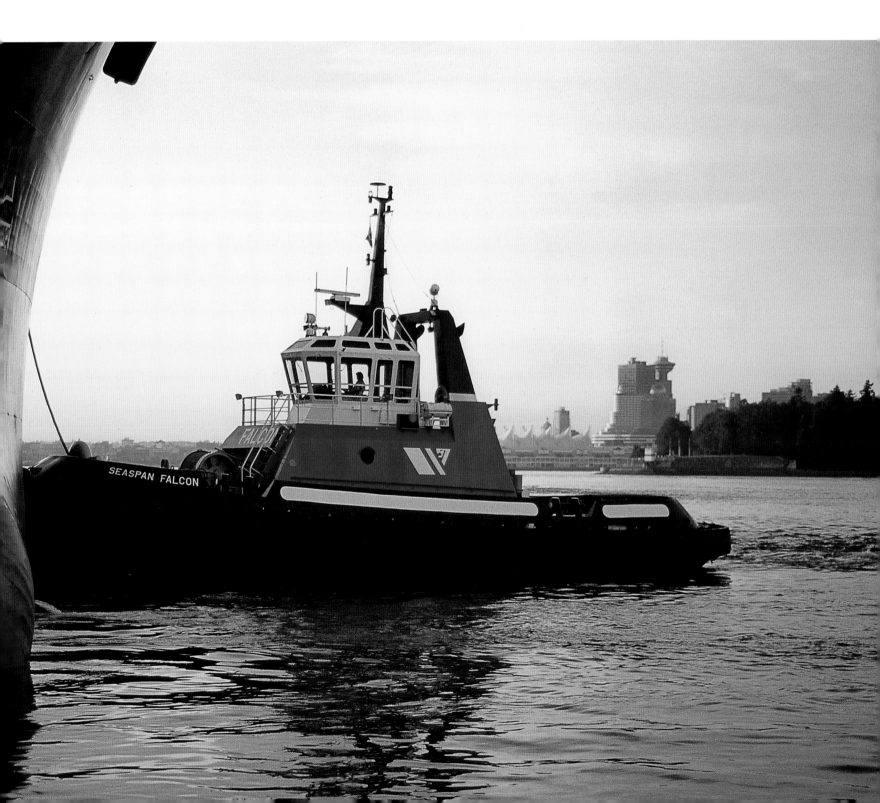

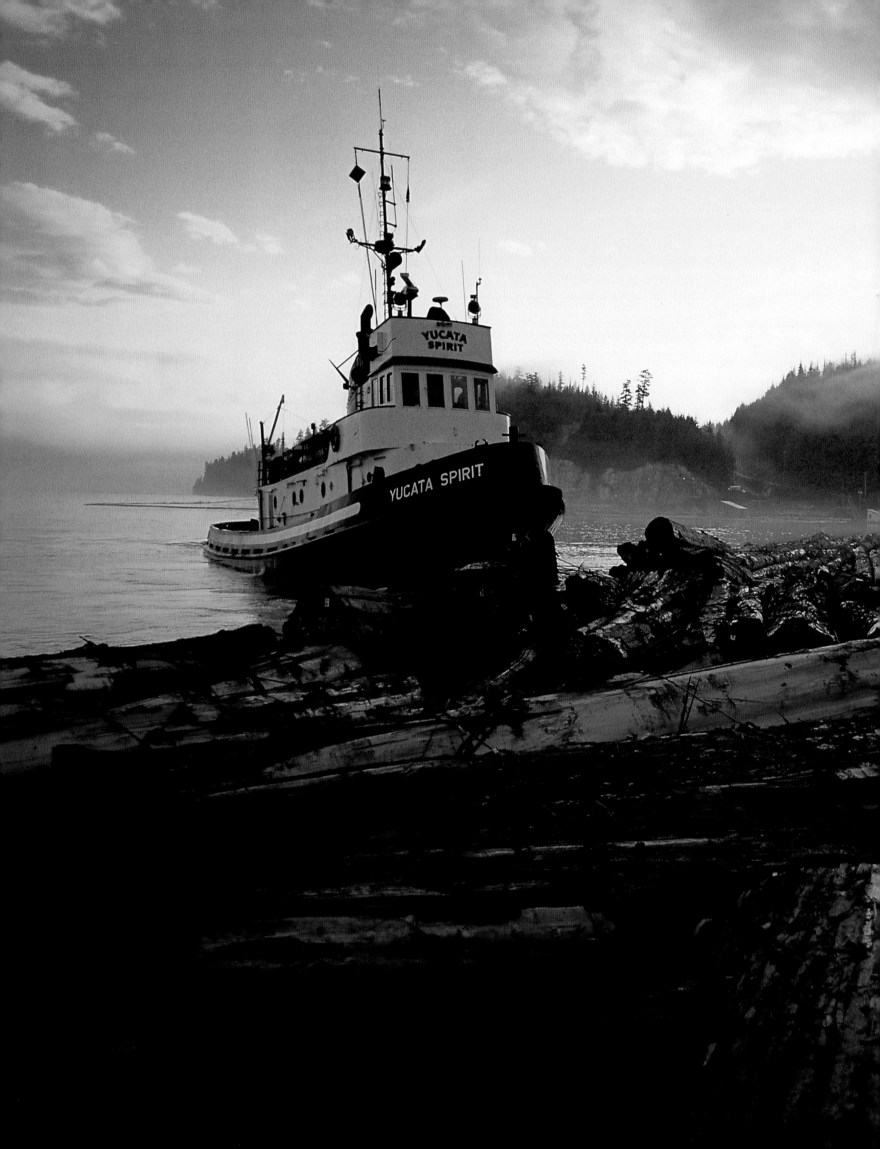

1

WOOD FLOATS, DOESN'T IT?

In the earliest days of BC's forest industry, most sawmills were clustered on the shores of Burrard Inlet and Alberni Canal where great timber was close at hand. Oxen dragged logs from the stump right to the mill's doorstep. By the 1870s, when timber on nearby slopes began to dwindle, mill owners turned to more distant forests. This raised a whole new problem: how to get this faraway wood down to the mills. Well, wood floats, doesn't it? They just dumped the logs into the saltchuck, fenced them in with a loop of long skinny logs chained together at the ends, and began looking around for some kind of steamboat to do the towing.

Pacific Cachalot Ltd's 26.6-metre log tug *Yucata Spirit* readies a cedar bundle boom for the long tow south from Beaver Cove.

OPPOSITE
This tow off Roberts Creek is made up of 20 or more bundle booms lined up four abreast. Depending on the species, a single large tow may contain $1 million worth of timber.

BELOW
The *Yucata Spirit*, with skipper Rick Hollingsworth at the helm, heads south from Mermaid Bay. Formerly the *Comox Argus*, the 143-ton vessel was built in England in 1963.

It wasn't long before log booms became standardized. Four 20-metre logs, known as boomsticks, were chained together to form a square enclosure. Inside, the logs were stowed side by side. To reinforce the section, one or more boomsticks, called swifters, were pulled up across the top of the logs and chained in place. These booms were known as flat booms and each one of the "squares" was called a "section."

The first flat booms were made up of one to three sections, because this was all that the early steam-powered paddlewheel tugs could manage. With the arrival of propeller-driven towboats more and more sections could be towed at one time. The downside to flat booms was that they were prone to losses en route to the mills. Waterlogged logs floated out from under the boom. Boomsticks and boom chains could break or pull apart in rough seas. A boom might become snagged on a rock.

Rough weather was the greatest bane of the flat boom. Although many loggers tried, it was soon apparent that the flat boom simply didn't work on the exposed waters of the west coast of Vancouver Island, Queen Charlotte Sound and Hecate Strait. G.G. Davis, logging at Port Renfrew, had lost nearly half his flat booms to rough seas while towing them around southern Vancouver Island to Victoria. In 1911 he decided he'd had enough, and made an innovation that opened the entire coast to logging—and towing. His invention, known to history as the Davis raft, was really quite simple—he just cabled all his logs together in one giant, torpedo-shaped bundle that the rough seas could not shake apart. Early Davis rafts coming out of Port Renfrew were up to 75 metres long. Davis rafts of spruce towed from the Queen Charlotte Islands for use in the construction of World War I aircraft were even larger and regularly held one million board feet. Davis rafts made the transport of logs economically viable in open waters. The downside was that it took a crew of 50 men an average of three months to build one, and they towed like a medium-sized iceberg.

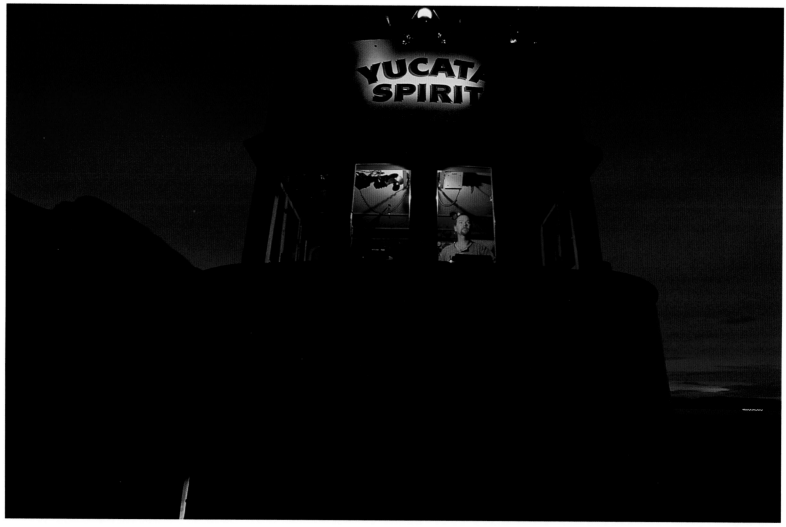

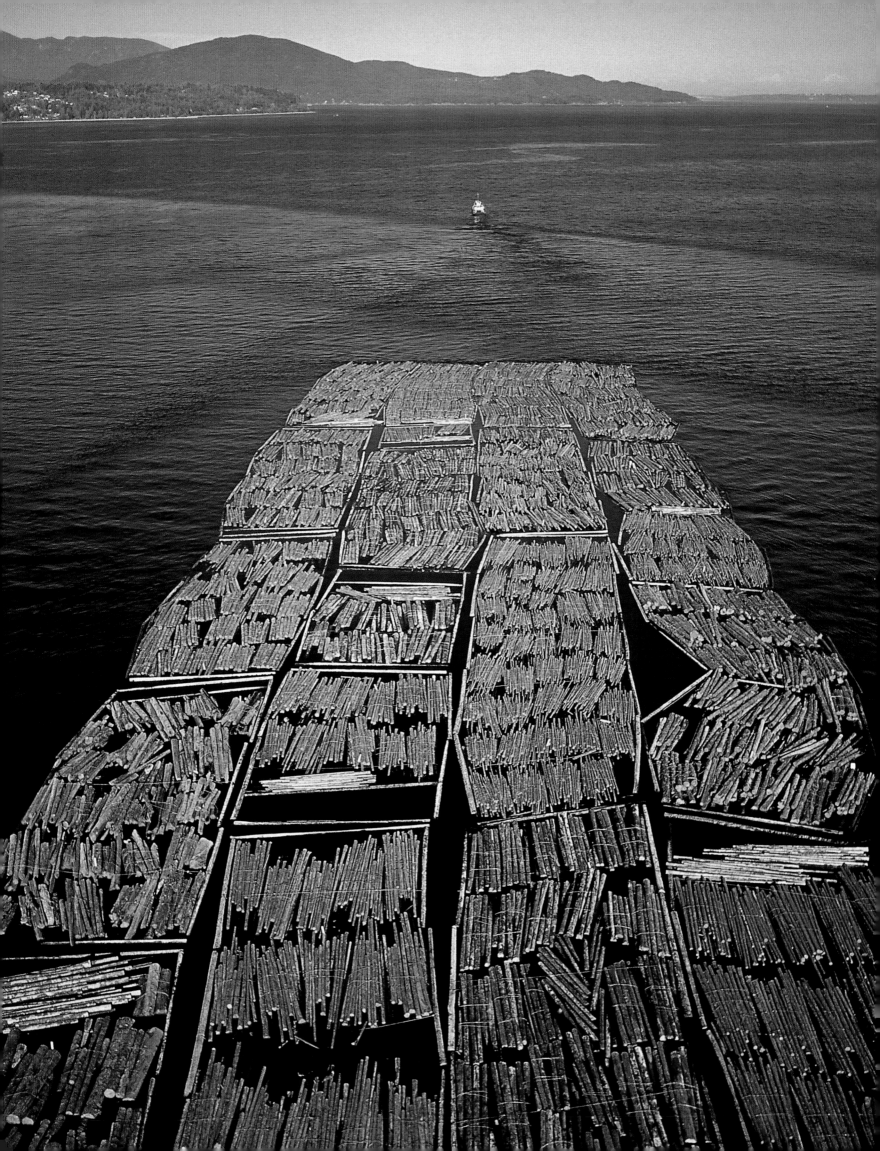

TOP LEFT AND RIGHT
Yucata Spirit deckhand Brian Newhouse shackles up cables while mate Ray Philipow takes a flying leap from tug to boom, counting on his caulk boots to grip the log when he lands.

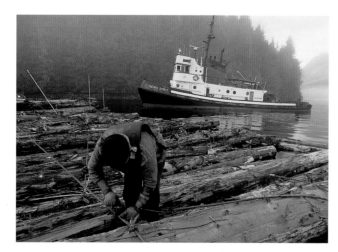

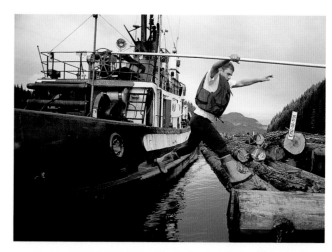

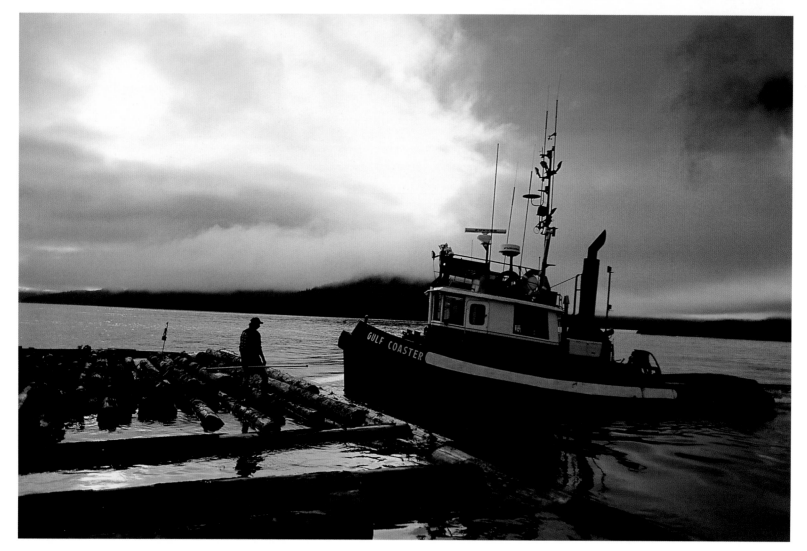

ABOVE
Deckhand Len Stefiuk looks on as Jarl Towing's 11.4-metre assist tug *Gulf Coaster* pushes a boom off Kelsey Bay on Vancouver Island.

OPPOSITE
The *Gulf Coaster* noses up to a bundle boom in the always dangerous Yuculta rapids.

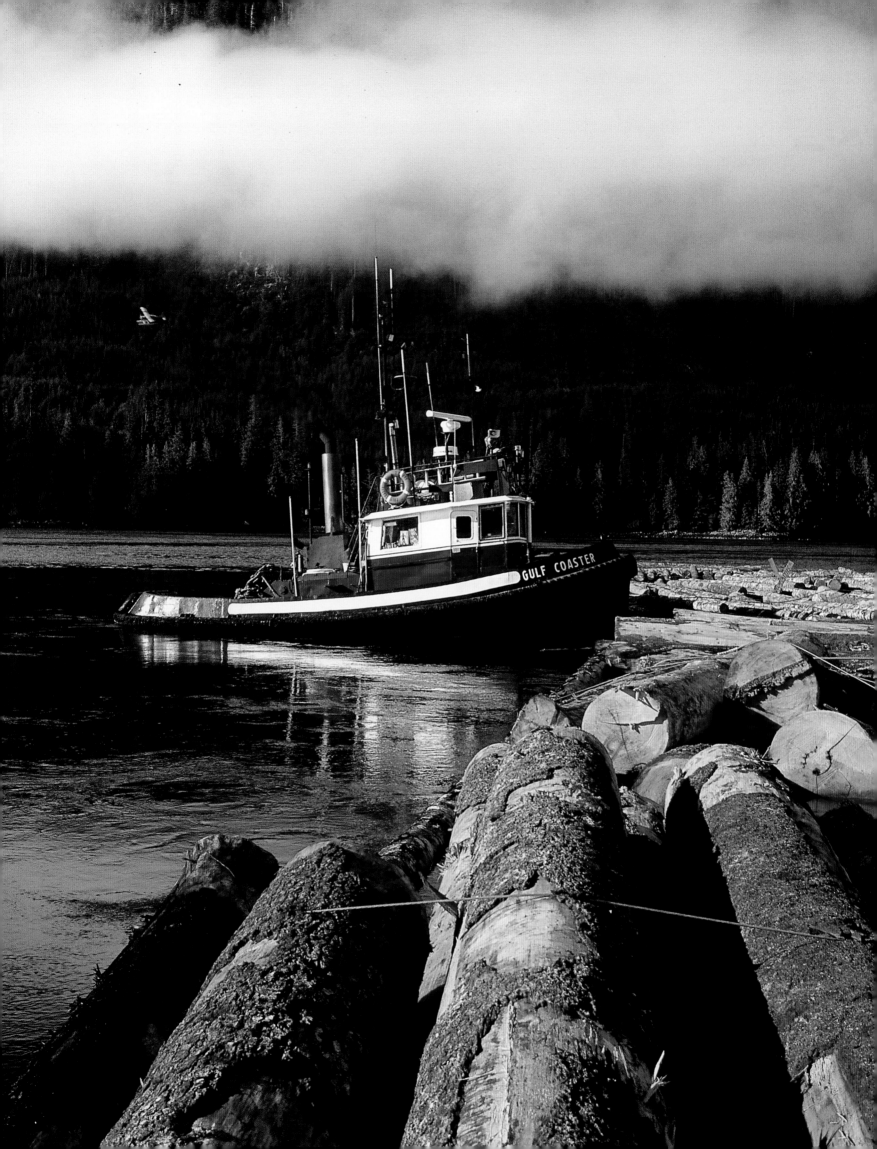

The 24-metre, 1,800-horse-power *Seaspan Corsair*, another log-towing specialist, eases a tow through the Yucultas. A wrong move here, where tidal currents run up to 10 knots, can cost a fortune in lost logs.

Whether it was flat booms or Davis rafts, at a towing speed of one to three knots, it took a long time to get logs to the sawmills. But once logs were placed in salt water, they had to be moved as soon as possible. The reason was shipworms, known on the West Coast as teredos. These voracious little molluscs eat wood for a living and can turn a boom of logs into Swiss cheese in a matter of weeks. So the log tower couldn't dawdle but at the same time he didn't want to be caught out in an open stretch of water in bad weather where a boom or raft worth several fortunes could break apart. It was the responsibility of the skippers to be able to forecast the weather and make decisions when to take shelter or proceed with a tow. They were familiar with every bay or channel in which they could seek shelter. Sometimes they would have to wait out weather for weeks at a time.

Approaching the lower coast from the north, towboaters had to contend with a maze of inlets, islands and winding waterways made more interesting by some of the world's strongest tidal currents. The idea is to get a push from favourable tides, and to get out of the way of unfavourable ones. This was more of a challenge before the advent of accurate tide and current tables. Guess wrong and the boom could be swept backwards onto shore, or ripped apart by whirlpools. Many of the famous old captains knew every back eddy of the coast and rivalries developed as to who could make the best speed.

Capt. C.W. Cates of the pioneer towboating family told a story about a skipper who made a mistake judging the tide in the Yuculta rapids and "hit her in the middle of a big flood."

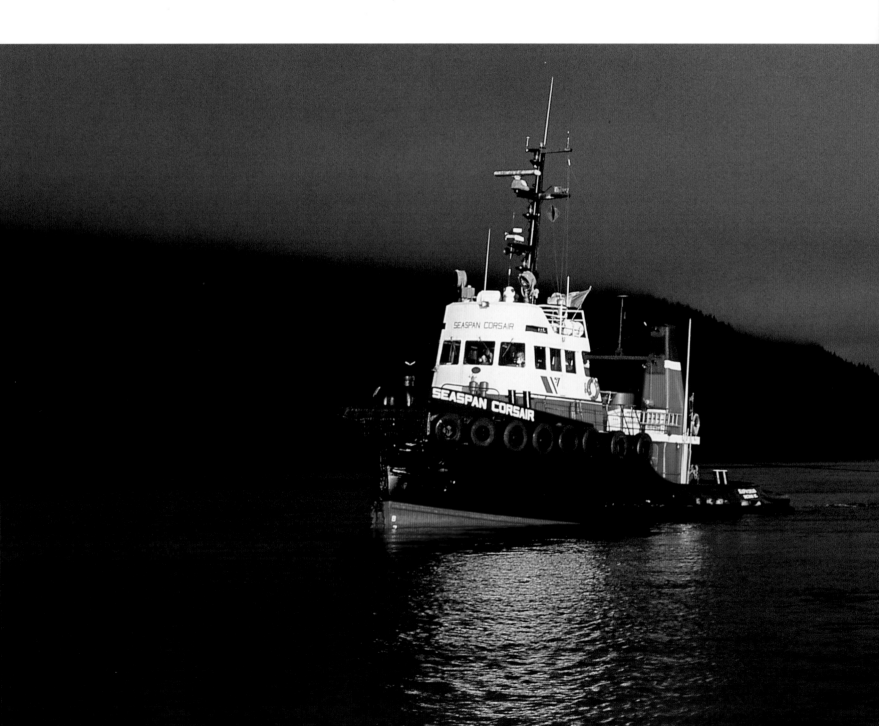

"When I passed Dent Island a whirlpool formed right in the middle of the boom and eight logs were sucked out right under the side sticks," this skipper told Cates. "I couldn't stop, so I went right through and after I had passed the Gillard Island light, those eight logs were back in the boom again." He paused briefly, then added with a chuckle, "But all the rest of my logs were gone."

Each skipper kept a black book of "marks"—mountain tops, islands or headlands—and their bearings, by which he could steer to avoid reefs and rocks. Skippers also kept detailed notes on the timing of the tides, the behaviour of currents in certain locations, and running times between points on the route. This way, at night or in fog they could calculate the boat's position by dead reckoning even if they couldn't see the marks. Lacking radar or other navigational aids, they often measured their distance from shore by the length of time it took for the echo of a tug's whistle to "bounce" back from a nearby bluff.

In the 1920s log barges began to replace booms and Davis rafts for long-distance hauling, and when self-dumping log barges were introduced after World War II, followed by self-loading, self-dumping barges in the 1960s, Davis rafts were phased out.

For medium distances, loggers employed a different type of boom halfway between a Davis raft and a flat boom. Logs were again bundled together with cable, but in smaller bunches of anywhere from five to 100 logs. They were then stowed in a normal rectangular boom surrounded by boomsticks chained together. Bundle booms could take more weather than flat

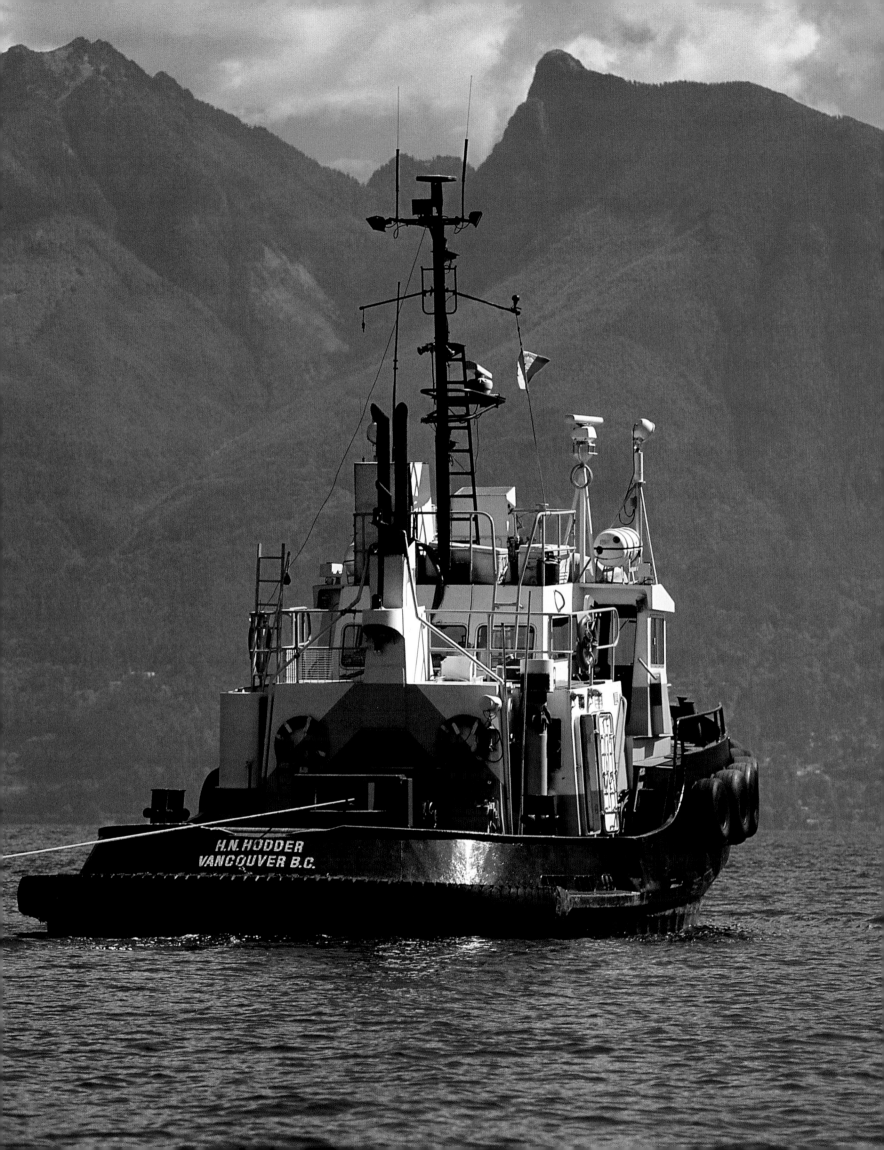

booms but, like Davis rafts, they were harder to tow because they drew as much as three metres of water. Bundle booms grew more popular over the years and have now largely replaced flat booms even for shorter hauls.

Nowadays, tugs working in the more remote areas of the coast will often collect booms from outlying logging camps and deliver them to a central sorting ground. There they will either be loaded on a log barge or bundled and marshalled into a bigger tow, which a larger tug will take south. The destination is usually one of the large booming grounds on Vancouver Island, in Howe Sound or in the North Arm of the Fraser River, where they will be broken into smaller parcels and delivered to mills or stored in fresh water away from "worms." (Teredos are actually closer to clams than worms.)

Most logs harvested in BC end up in the Fraser River, home to the largest concentration of logs, tugboats and sawmills in the province. Some of the logs are being stored here to protect them from teredos and may end up being towed back across the strait to Vancouver Island mills. Others are waiting to feed hungry sawmills upriver or to be loaded aboard foreign ships to be exported as raw logs. Others are waiting for potential buyers who will clamber over the booms with log brokers. One thing they all have in common

OPPOSITE Straining on her towline, Hodder Tugboat Co. Ltd's 14.8-metre, 900-horsepower *H.N. Hodder* eases a boom toward the sorting ground. Vessel is named for company founder Horatio Nelson Hodder.

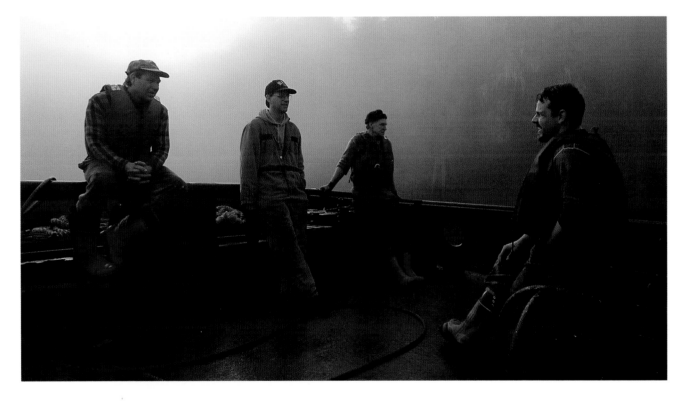

After assembling their tow, the exhausted crew of the *Yucata Spirit* take a breather.

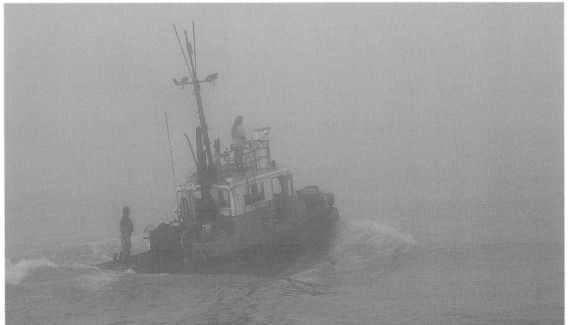

A Harken shift tug steams full speed into the fog as skipper mans upper control station for better visibility.

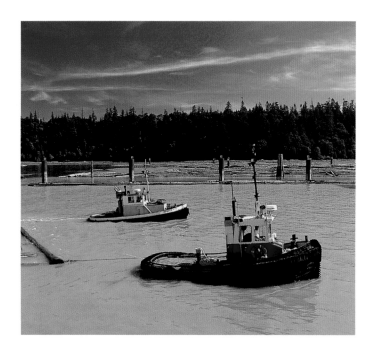

TOP
Veteran skipper Billy Cotton Sr. and deckhand Paul Smethurst in the wheelhouse of Riverside Towing Ltd's 7.7-metre *Leader* on the Fraser flats.

ABOVE
The Fraser "flats" is a busy boom tie-up and sorting area at the mouth of the river's North Arm.

RIGHT
Smethurst keeps an eye on the boom as the *Leader* moves amid the congestion of the Fraser flats. The fresh water of the Fraser offers sanctuary from wood-boring teredos that can render logs worthless in mere weeks.

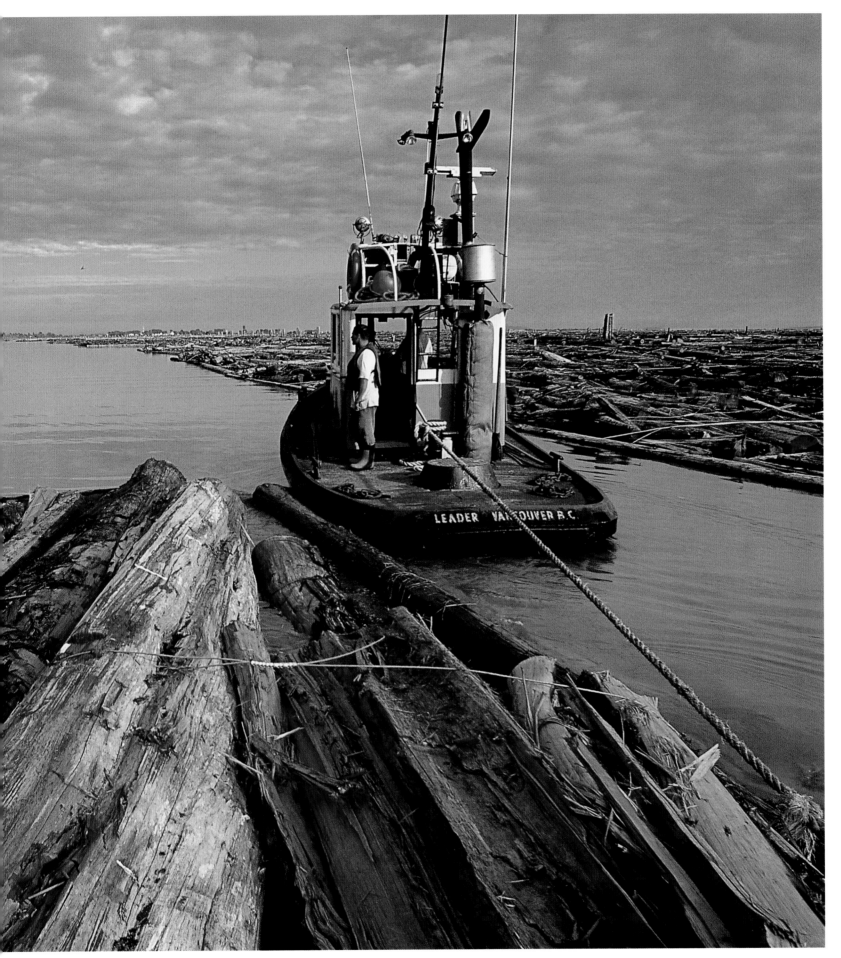

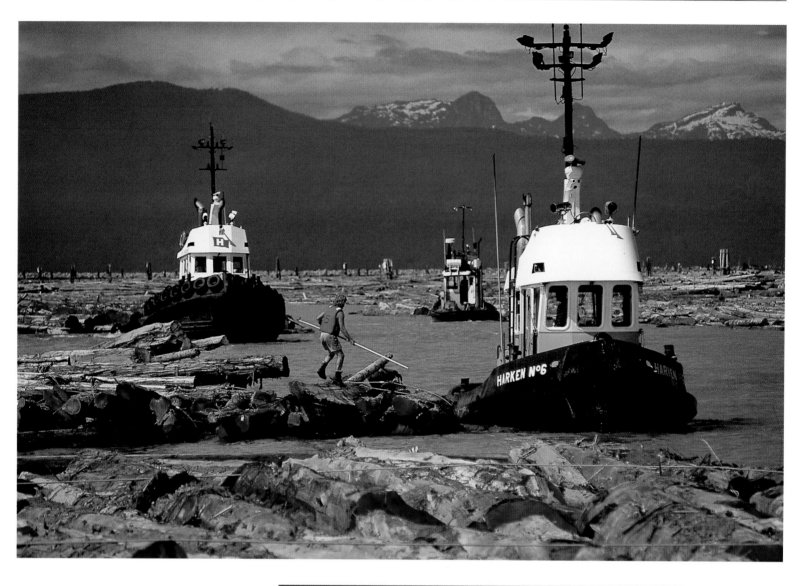

ABOVE
River tugs ready their tows in the lower Fraser.

RIGHT
Granny Hutch hand Julian Beaulieu strains to tighten up a boom. Booms require constant adjustment to keep from pulling apart during the perilous journey upriver.

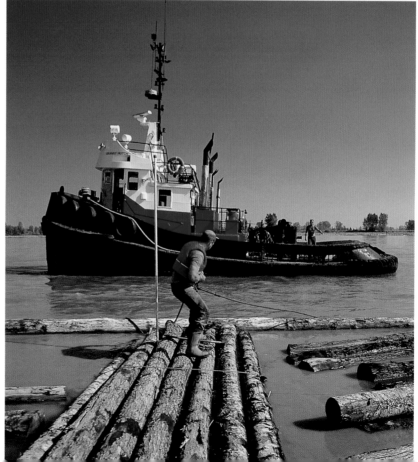

is that they are extremely valuable. A single boom may be worth several million dollars, depending on the size, species and quality of the wood.

Most booms towed to the Fraser River arrive as large tows, several sections wide. They are first tied up in the mouth of the river's North Arm. Those intended for short-term storage are tied up on the south side of the river in the area known as "the Jetty." Those intended for longer storage are left on "the Flats," the protected, shallower water on the north side. If destined for upriver, the tows are taken apart here and singled up (arranged in single file) by small, nimble, shallow-draft tugs, or they may be sorted and reassembled into a larger tow. The job of distributing these booms to sawmills farther upriver belongs to more powerful "river" tugs—also known as shift tugs. These tugs are smaller than their coastal towing cousins.

The basic game plan is to tow upriver on a flood (incoming) tide and downstream on the ebb. When the incoming surge of seawater runs against the river, it all but stops the natural downstream current. In fact, the incoming tide sends the surface water as far as the Mission bridge 75 kilometres upstream, raising the river level by as much as 1.5 metres. It is this—nature's temporary reversal of gravity—that the tugs take advantage of for a push upriver.

Towing downriver they do the same thing, but in the opposite direction. They'll wait till the end of the flood tide—high water slack—and just as the incoming seawater starts to turn back toward the sea, they begin towing. From the heavy rains of late winter and spring through the early weeks of summer, mountain snowmelt swells the river more or less all the time. This increased volume of water flowing down the river can overpower any upstream tidal flow. During these freshets, the job of towing logs upriver takes twice as long.

Because of the many obstacles and dangers inherent in towing logs up the Fraser River, tows are seldom longer than 32 sections and never wider than one section. On the North Arm a typical upriver tow takes at least two tugs. One is the lead tug and the others are the assist tugs. The assist tugs are needed to bunt and push the booms through tight spots and around shoals and bends in the river's channel and through narrow bridge spans.

The *Leader* heels to starboard while attempting to swing a boom.

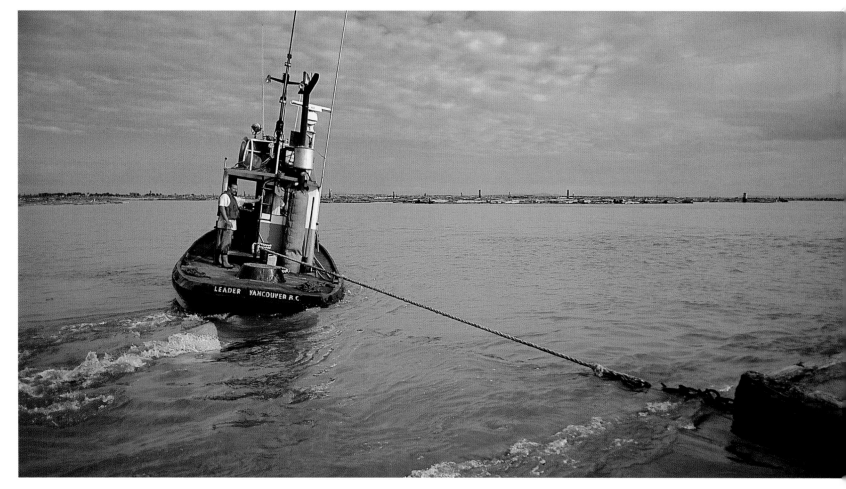

The tow will begin at "the Flats" or "the Jetty," where the booms will be assembled and taken under tow by the lead tug. When things go as planned, the tug will drop off smaller booms at various destinations along the river. Deckhands will climb onto the tow and disconnect the appropriate boom, which the assist tug can then nudge into its slot along the shoreline. From here, the sawmill's acrobatic little boomboats (also known as dozer boats) will move the boom into the "mill pocket" and break it up.

Once upriver, there may be the task of picking up booms harvested in tributaries and connected lakes. Many of these booms are stored for pick-up in the Harrison and Pitt rivers.

Above Mission, about 75 kilometres up the Fraser from the Flats, the river changes into a world of even more fast moving currents, shifting channels and sand and gravel bars. Upriver work is the domain of fast, powerful, shallow draft river tugs.

When the tides are right, tugs can be working 24 hours a day. Crews work 12-hour shifts and if a crew hasn't been able to return to their home base, a fast crew boat will meet the tugs along the way and while a new crew takes over, the tired crew is returned. The tugs will continue on their endless rounds of chugging up and down the river with their valuable cargo of logs.

At 0630, seven guys jam into a tiny crew boat and motor down the North Arm to relieve the night shift. Just east of the North Arm jetty they meet up with two Riverside tugs hauling 34 sections of logs upstream. The *River Star* is the lead tug, 11.5 metres long with a 600 horsepower Cummins diesel and a nozzle. The *Ranger* is the assist boat, the same length, with another 600 horses from twin engines.

The *Ranger* has spent the night assembling the tow and is low on fuel. She hightails it upstream to the fuel dock while the *Star* continues to tow the boom slowly on its own, trying to maintain steerage without getting too far upstream. Can't afford to get too close to any of the notorious tight spots that lie ahead. Can't shoot the gaps till the *Ranger* returns.

The tide is low and slack, just beginning to turn. Three metres of dark wet rocks are exposed in dim light along the riverbank. November's last leaves have dried from gold to crispy brown. Bare limbs scratch the eastern sky. The flanks of Mount Baker glow flame red with the sunrise. Overhead is a high flat deck of torn grey clouds.

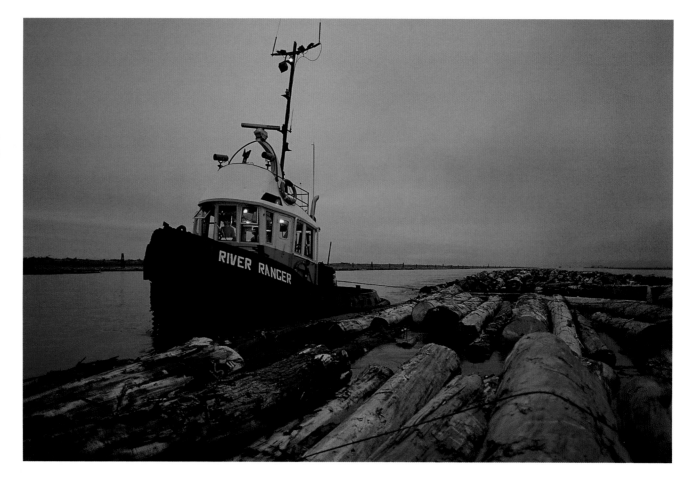

The *River Ranger*, a 10.2-metre assist tug owned by Riverside Towing Ltd., takes her place alongside a tow of booms starting up the Fraser River at first light.

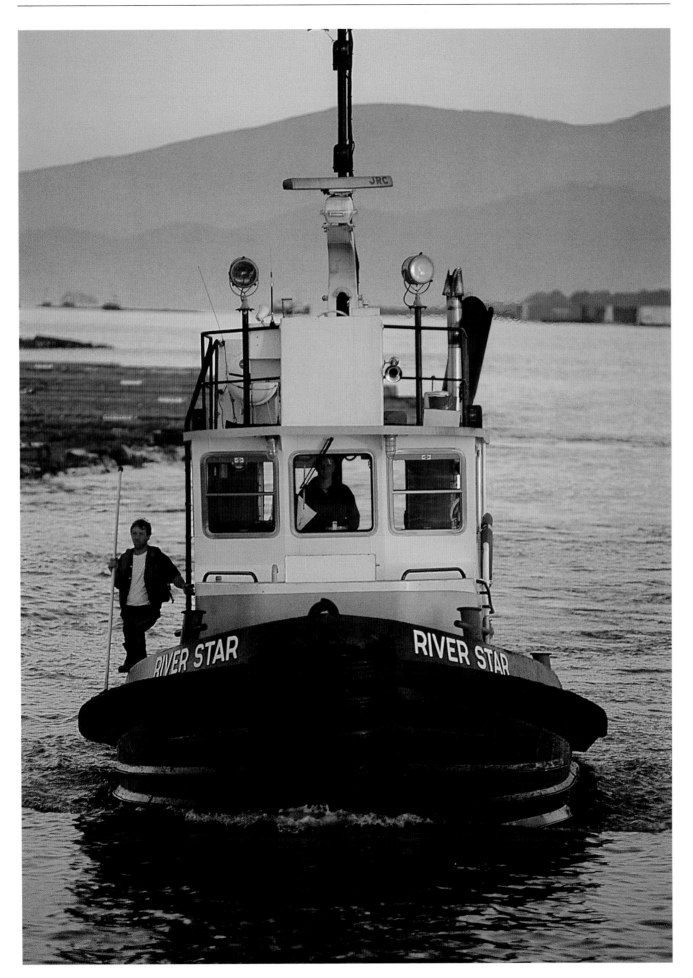

Riverside's 10.5-metre lead tug *River Star* moves into position at the head of the upriver tow.

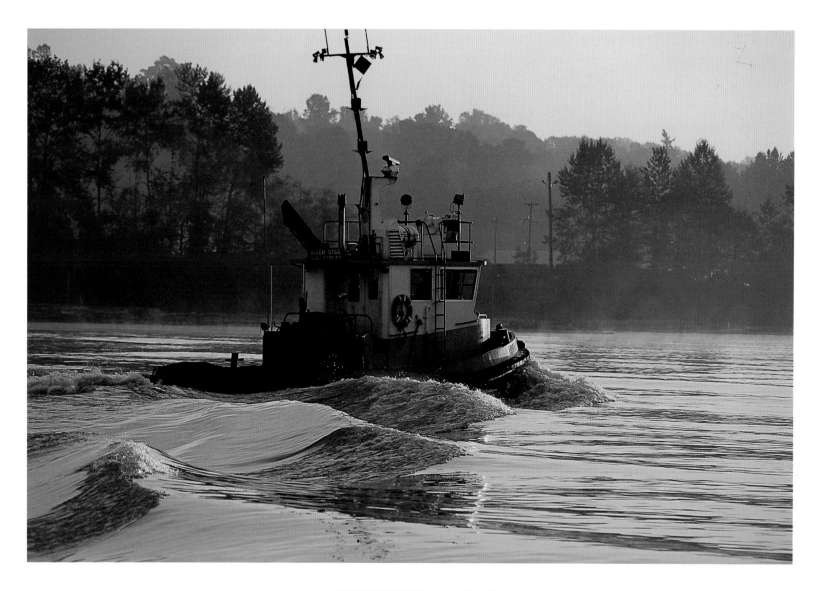

ABOVE
The *River Star* running light.

RIGHT
Riverside deckhand shows how to carry lots of
log staples as you skip across the slippery
booms—turn your life jacket into a pincushion.

OPPOSITE
Morning rush hour on the Fraser, as seen from
the Knight Street Bridge. Booms bound upriver
travel single file, and are never more than one
section wide.

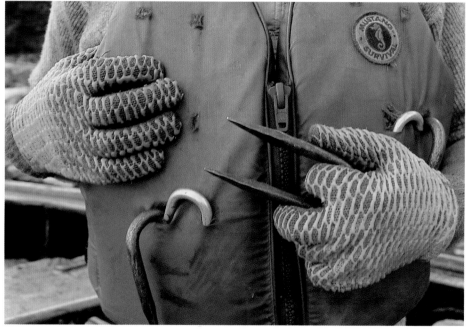

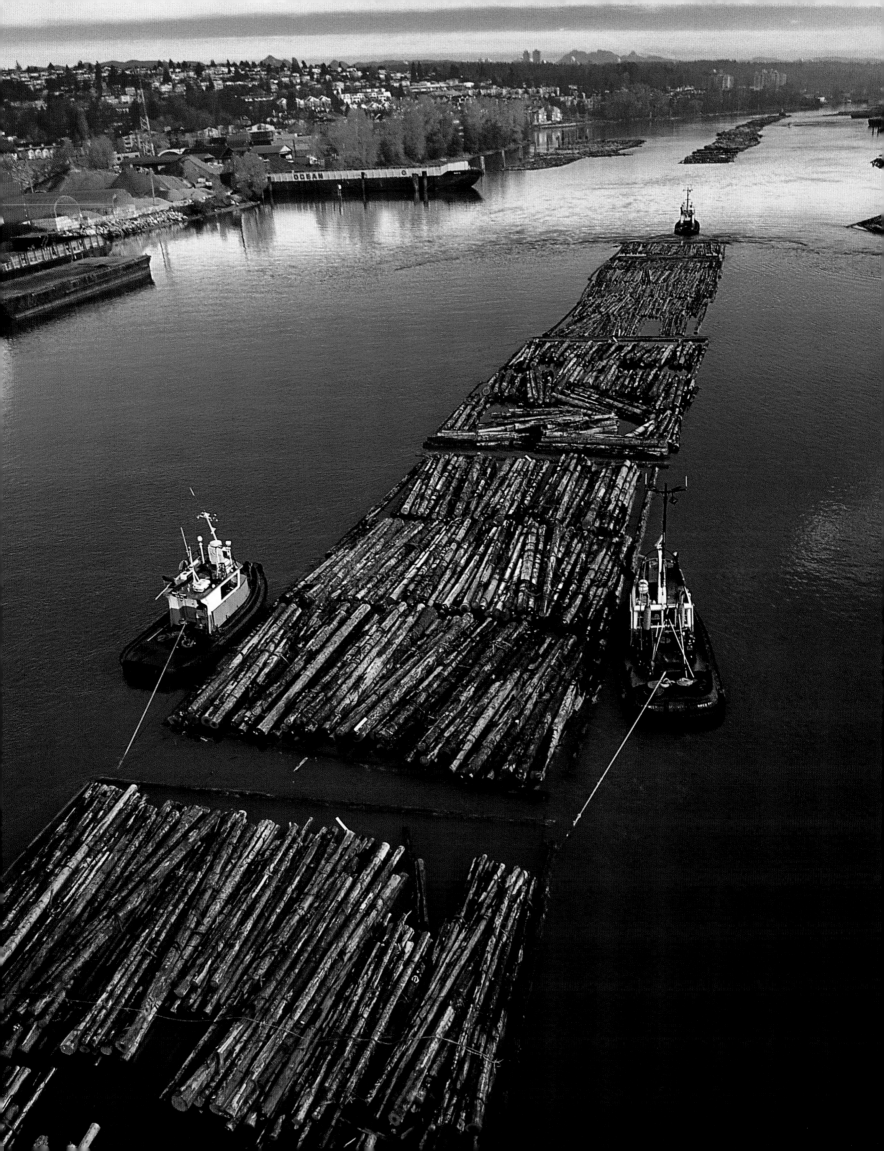

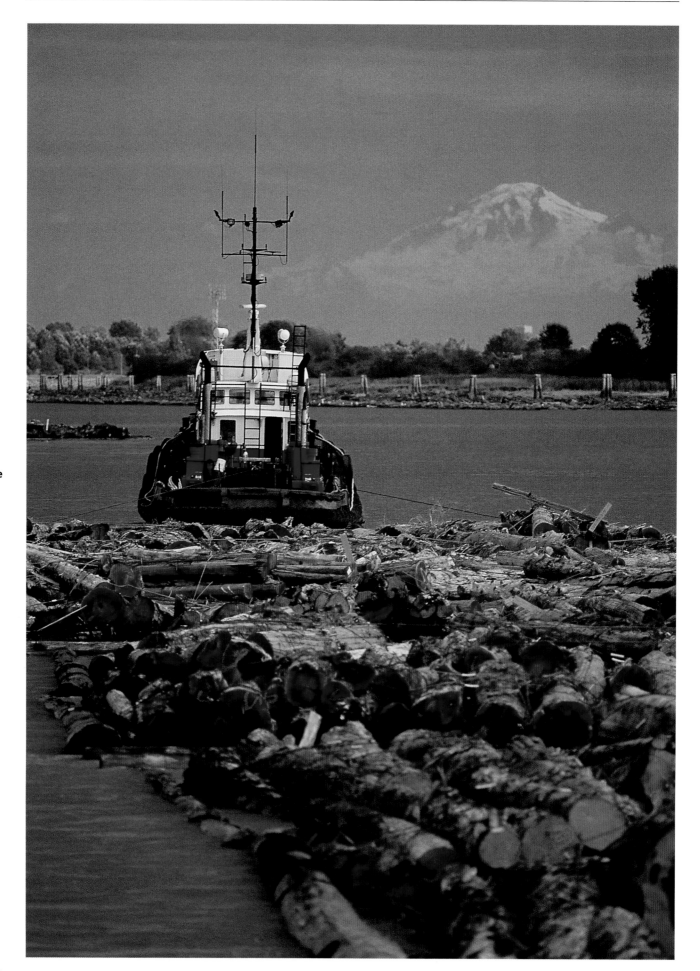

Mount Baker shimmers on the horizon as the *Granny Hutch* heads up river with a tow.

Deckhand Rick Letestu surveys the gear on the tug's deck. He notices only a handful of "patch wires" are left. As their name suggests, these are used to patch booms that have come apart. Must have been a busy night shift. He unravels the end of a two-metre wire strap, bends a 30-centimetre loop and weaves the strands back into a smooth eye splice. "You have to create a farmer's eye at one end," he says, his fingers sorting and twisting. To piece a broken boom together, he explains, you drop the eye across a log and into the chuck, reach down with a pike pole, snag the eye and haul it up the other side. Push the free end of the wire through the eye, pull tight, and you've choked the log. Hammer some heavy log staples into the nearest boomstick, whip a quick knot through the staple and you've tied it back together. Patch wires are the first aid kits that get a deckhand through the day—and Rick is busy making more of them.

Skipper Al Woodward studies the clipboard chart of the tow, then uses his binoculars to examine the snaking line of floating rafts that hang behind the *River Star*. A small sign at the head of each boom identifies where it came from and what it is: CD 104-17B-4B. CD means the logs came from the Chemainus Division (of Weyerhaeuser); 104 indicates the grade and species (fir); 17B is the boom number; and 4B means there are four bundles in this tier. It's a mixed load of mostly fir, but there are some "545s, 445s and 204s" (cypress, cedar and hemlock) as well.

The *River Star* is hugging the north bank. Another tug, the *Granny Hutch*, is towing a boom along the south shore. Between the two of them, the river is pretty much paved with logs with only a narrow lane of open water between the two booms. When the two skippers see the tug *Fraser Eagle* coming up behind towing two empty scows, they steer as far apart as they can to allow the *Eagle* to pass up the middle between them. This is the morning rush on the North Arm.

Deckhands Rick Letestu and Glen Bergsma in a rare moment of repose, pike poles at the ready.

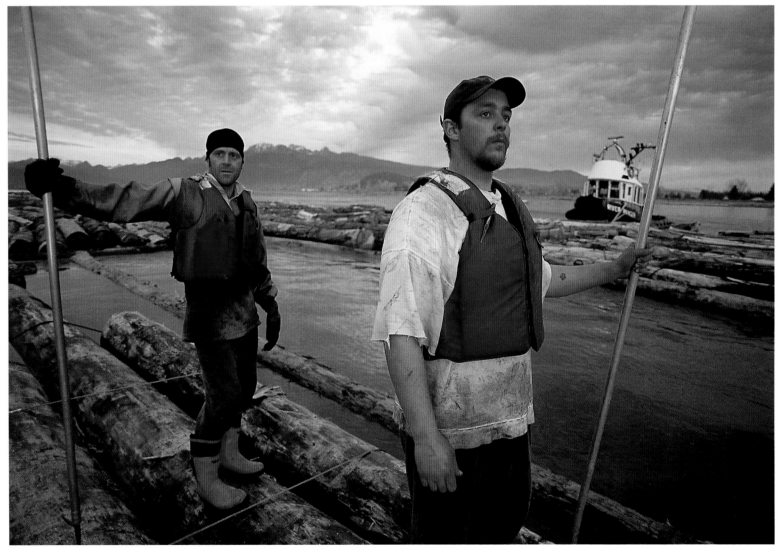

PREVIOUS PAGE
Tidal Towing's 14.5-
metre *Granny Hutch*
pulls a tow of logs
up the North Arm, as
seen from MacDonald
Beach on the north
shore of Sea Island.
Towing upriver is
easier with help from
a rising tide; the
incoming Pacific
pushes against the
Fraser's flow as far as
the Mission Bridge,
75 kilometres
upstream.

BELOW
The river tug *Young
Hustler* at work on
the Fraser.

The *River Star* is holding back now to let the *Granny Hutch* get ahead. There's room for only one boom at a time to get through the narrow channel past Jimmy's Island. The *Star* will need the *Ranger* to push the back end of the boom sideways so it doesn't hang up coming around the corner at the bottom of the island.

Skipper Al Woodward turns his captain's chair sideways so he can watch out the back and front at the same time. The logs snake from side to side as the flooding tide pushes the tail end of the boom around. "Basically you have to steer with the tail end in mind all the time," says Al. "You've got to anticipate the next bend and figure out where the tide will try to drag the tow, and then steer the head end toward the opposite bank."

Too much power from the tug's engine would rip the boom apart. We appear to be moving so slowly upstream a person could walk the riverbank and get there ahead of us. But don't be deceived, says Al. "You don't have to be going very fast to have a disaster."

Rick picks it up from there. "If the tow breaks open and stuff starts pukin' out all over the place," he grins, "the party's on!" And it's easy to tell from the gleam in his eye that he enjoys a bit of a challenge. "Yeah, it's exhilarating. For me, it's a good fitness job. And because there's a little bit of danger in it, you know, you're livin' on the edge."

That element of risk comes with the job at no extra charge. "When shit hits the fan, it can be pretty dangerous," he says. It's just a fact of life on a river tug. And what makes it dangerous, in Rick's opinion? "Various things like when you're working quickly and you catch your foot on a bundle wire or on a towline or on the bulwarks of the boat." He shrugs and adds to the list. "There are numerous ways of getting hurt. Just the tools of the trade—using an axe and a pike pole all day. Bending. Lifting chains and wires and various things."

The *Ranger* swings alongside, tanked up and ready for action. We're approaching the bottom end of Jimmy's Island, where the river bends. On the *Ranger*, skipper Jim Connon sets about to swing the tow. He

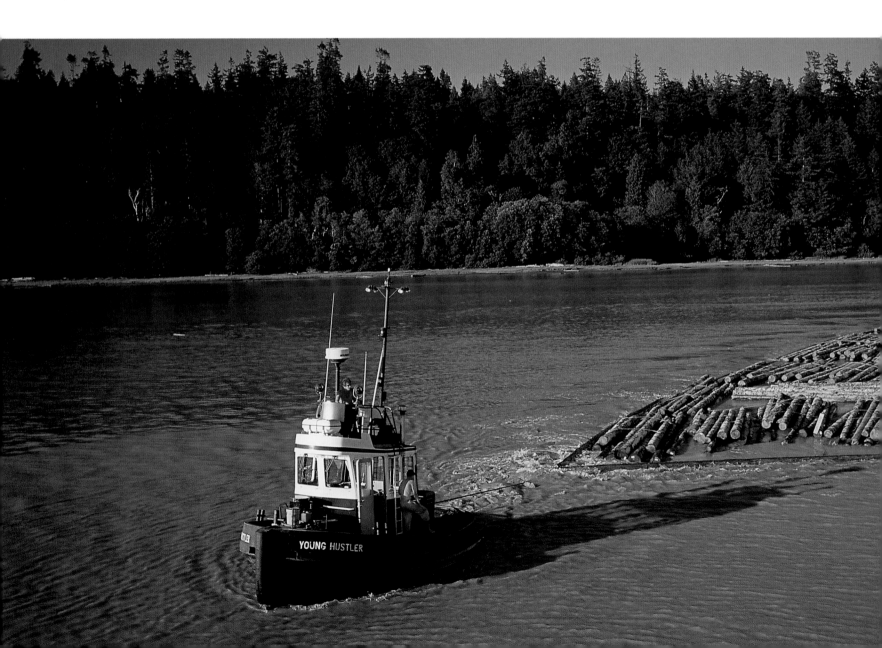

YOUNG HUSTLER

LEFT
Surrounded by high-powered searchlights, veteran skipper Bob Shotropa scans the river from the command bridge.

BELOW
Henriette Oskam helps *River Star* deckhand Don Kester loop a cable around a log.

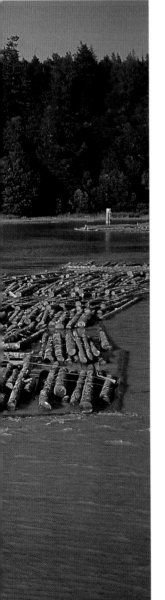

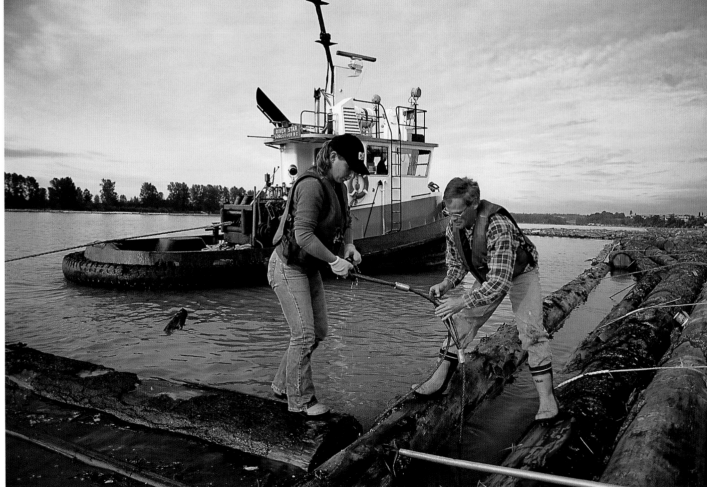

immediately peels around to the tail end of the last boom and bumps into it bow first. He punches it hard several times, shoving the last section of logs into line with the rest of the boom, which has now cleared the corner of the island without incident.

No sooner has he got the tail sorted out than the *Star* has dragged the head end through the next choke point—a narrow railway swing span called the BC Hydro Bridge. Aboard the *Ranger* Jim Connon and his deckhand, Glen Bergsma, both have their eyes on the current as it boils up under the logs, forcing a sideways bulge in the boom.

The Hydro Bridge has a fixed span on either end, with a swing-span at centre channel. Along the beach underneath the north end of the bridge, a dredge crew working from a flat deck barge is dropping big slabs of broken rock into the murky water. Jim's not entirely sure what for, but he thinks it has something to do with construction of a riverfront park. The only thing that concerns him and the rest of the towboat crews on the North Arm is that the rocks have created a strong new eddy underneath the bridge and it's playing havoc with log booms.

The dredge crew has a small assist boat standing by on the north side to help keep the booms in line as they pass through the swing span. The *Ranger* is bumping a bulge back into line and Jim is thinking they've got it pretty well aced, when he spots another curl of twisted logs caught in the eddy and snaking sideways toward the south abutment of the swing span. He races ahead and says, "Hold on!"

The *Ranger* butts the side of the boom, shoving the swollen belly of fir back into the centre of the channel. With less than a metre to spare, Jim has straightened the tow again and prevented it from scraping against the rough concrete wall of the bridge pier. It looks like everything's going to be fine. But then Murphy's Law kicks in.

Having cleared the bridge, the *Star* starts coming up to speed again. With no warning, something snaps. The *Star* lurches slightly. Skipper Al Woodward reefs back the throttle. The boom has come apart just aft of the first section. Loose bundles of logs are spilling from a hole where a boom chain has apparently torn through a weak stick.

The *Ranger* boots it around the head end of the tow

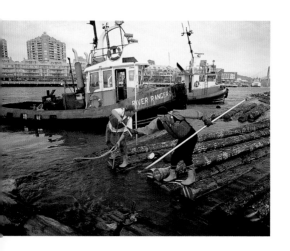

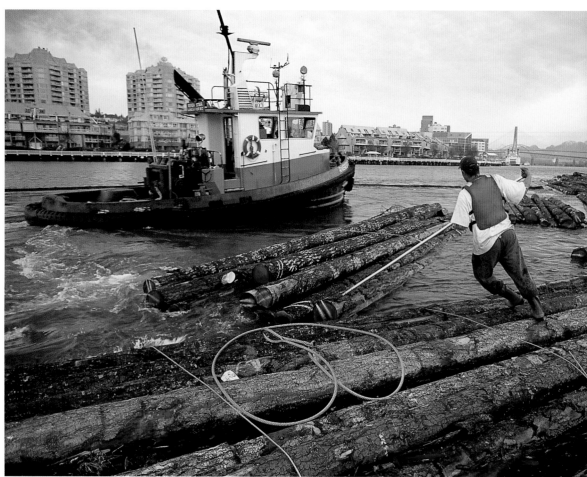

"Party's on!" Without warning a boom breaks open, spilling bundles, and deckhands Rick Letestu and Glen Bergsma fly into action. As the *River Ranger* and *River Star* herd errant bundles back into the boom, Letestu and Bergsma stow them and close the break with patch wires.

and pulls alongside the *Star* just long enough for Rick to jump aboard with patch wires slung over both shoulders. Jim Connon then wheels the *Ranger* around to the break point and puts both deckhands onto the boom where they go jogging across the logs with pike poles, wires and axes at the ready.

The boom has now drifted apart at several points. Rick and Glen run back and forth, bright orange caulk boots chewing bark. They reach under logs with their long aluminum poles, fishing for chains, snagging heavy links of rusted steel, hoisting them up, sliding toggles through rings, dropping patch wires around drifting logs, choking them up, pounding huge staples into wet timber with the flat head of an axe, whipping quick knots in steel cable, then sprinting across to do it all again as skipper Jim Connon shoves another loose bundle back into the boom.

Glen does it all bare-handed, reaching into icewater time and time again to grab and twist and tie. His hands are swollen red and laced with dozens of nicks, cuts and splinters. His palms are coated black with aluminum oxide from the pike pole.

Rick, who's a few years older (an athletic 35 with eight years on tugs) and already suffering from chronic tendonitis, wears long rubber gloves. The gloves reach from finger tip to armpit and are held together by an elastic band that stretches over the shoulders and behind the neck. They look funny but they do take the edge off the cold. Glen won't wear them because he says he can't feel what he's reaching for or get a firm grip through all that rubber.

There is no uniform on the river and every deckhand has a different way of coping with the elements. In the cool, damp autumn breeze, Glen wears a short-sleeved sweatshirt, faded black jogging pants and a green ball cap—bill forward. Rick wears black sweatpants, a sleeveless football jersey and a black toque. The only apparel they seem to have in common are their life-jackets and caulk boots.

When Rick comes to work in the morning he brings a knapsack full of food (bread, meat, fresh veggies, pasta, apples, cheese and a huge jug of water) for a series of meals and snacks that seem to be part of an ongoing refuelling manoeuvre spaced out across all twelve hours of the shift. Basically he gets hungry about six times a day.

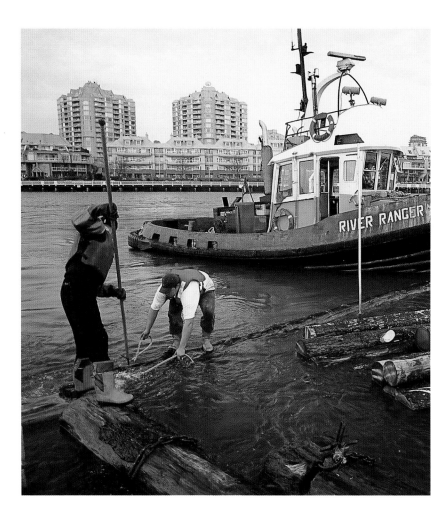

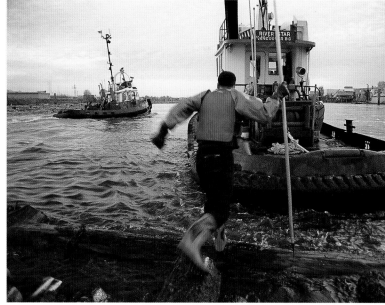

RIGHT
The chain that holds the towing industry together. Deckhand Brent Cheer hefts a spare boomchain—two metres long and 20 to 30 kilograms.

BELOW AND BOTTOM
Mike Johnson laces on his caulk boots before venturing onto a boom. There's no dress code on the river, but every wardrobe includes two essentials, a life jacket and caulk (pronounced "cork") boots. The caulks, sharpened steel spikes, provide secure footing on the slippery logs.

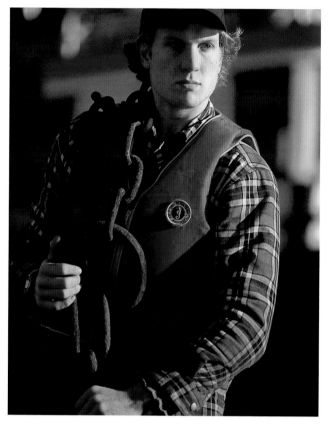

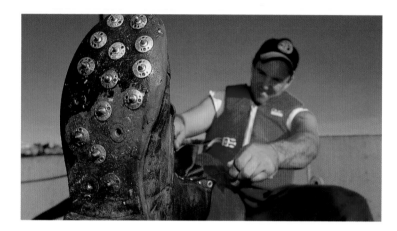

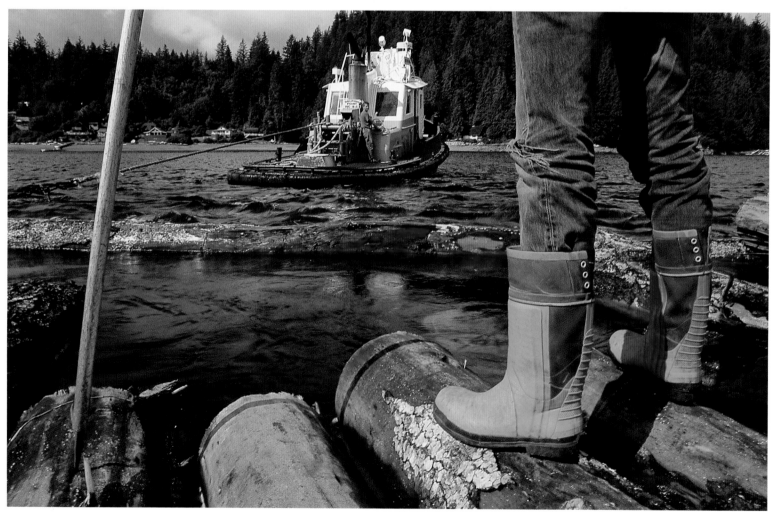

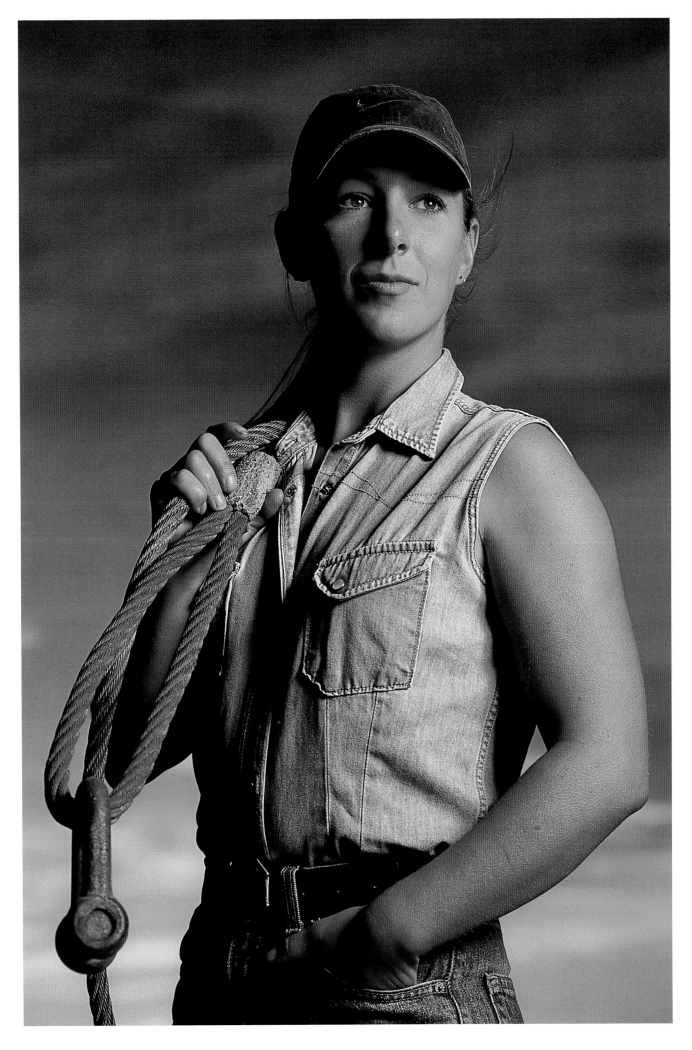

Henriette Oskam, one of the few women working on the boats, served her time as deckhand before earning her skipper's ticket.

Rick and Glen work up a considerable sweat at nearly every turn in the river and restoke the fires every chance they get. They also seem to work well together, which is another part of the job Rick likes. Solving problems on the river can be a lot like competitive sports. It's your team against the elements. And it feels mighty damn good to win. "There's no 'I' in team," says Rick. "You have to work together out here. And if you don't work together, you're working against each other—and that just *does not* work."

Back in the wheelhouse aboard the *Ranger*, with the boom patched together and moving upstream again, Jim Connon watches the jet stream of water from the tug's twin propellers. He has positioned the *Ranger* midway down the boom and Glen has dropped a towline with a hook onto a ring through one of the boomsticks. Now the two tugs are pulling in tandem through a relatively straight stretch of water.

From around a bend in the river, a heavy metal crew boat, belly deep and moving at speed, zooms downstream along the far side of the boom. Seconds later, thick curls of mocha-coloured wake ride up under the

boom causing logs to ripple and bounce and chains to surge tight.

Twelve hundred horses pulling a half-mile of logs puts everything under considerable pressure even in flat water. When you add fat waves, you're asking for trouble. Glen volunteers a story about the time a big fishboat plowed past a boom, rolling out a series of waves that tossed logs in every direction. The towline snapped and like a cracking whip came whistling forward right over top of the lead tug. With a loud whang, it wrapped itself several turns around the exhaust stack. Luckily no one was standing on deck at the time.

Around the next bend another swing span, the CN Rail bridge, comes into view. The *Star* slows to a crawl. Time to get rid of some logs. The *Ranger* begins picking pieces of the boom apart. Jim and Glen cut loose 26 of the 34 sections and get ready to drop them off at "the bottom of CWP-9," which is river jargon for "Canadian White Pine storage tie-up number nine." Basically, it's a big steel mooring buoy standing upright in the water about 15 metres from the riverbank. There's a line of

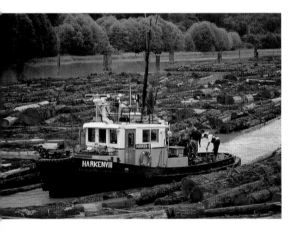

ABOVE
The 12.2-metre *Harken VIII* works in a river of wood, where a skipper needs eyes in the back of his head.

RIGHT
The mast of the *River Ranger* is popular with seagulls. Fortunately it folds down so deckhand Blake McCarten can give it a regular scrubbing.

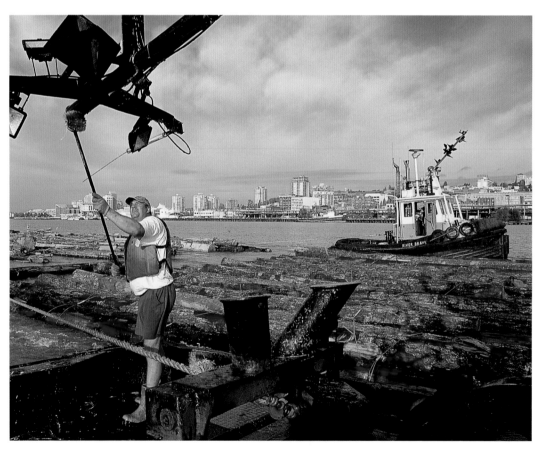

these dolphins as far as you can see in both directions along both banks. In fact, if you hired a small plane and flew low along the Fraser you'd see grey-brown mud flats on both sides of the river covered by a sinuous mat of floating logs stretching mile after rippling mile.

Every nook and cranny from Marpole east to the Pitt River and beyond is staked out with numbered mooring posts—wire-bound clusters of pock-marked pilings or stout tubes of rusting steel sunk deep in the river mud—with acres and acres of log booms chained together to wait their turn before the blade or chipper, or to get away from the teredos.

Jim Connon spins the wheel and swings the *Ranger* around to the tail of the boom where a blue kerosene lantern hangs on a metal rod stabbed into the last log. Glen Bergsma steps across and hooks the tug's towline to the tailstick, which appears to be broken in half, as Jim throttles up to drag the torn mat of logs against the other booms already tied to CWP dolphin number nine.

Glen drapes a two-metre boom chain over one

shoulder (18 to 27 kilograms depending on how big the links are) and a 14-metre "string wire" over the other and jogs across the logs to tie everything back together. Extra chains and wires provide some insurance against the broken boomstick and peace of mind for the skipper who would be responsible if the whole thing came apart during the night and spilled a million dollars worth of raw logs down the river.

With 26 sections safely lashed and delivered to Canadian White Pine, it's time to race ahead and catch up to the *River Star*. And right away we're into another jackpot. Coming through the Queensborough rail bridge, one of the boomsticks scrapes against the concrete pier. Whoever said working the river was like running forty miles of rapids was bang on. Just below the waterline a steel plate, designed to protect the pier, has been bumped, bent and scraped so many times now that a corner piece of metal has been pried loose and sticks out. A jagged twist of steel just waiting unseen beneath the surface to impale the next thing that happens to float by. And it just happens to be our boom.

A morning mist sets a sultry mood as tug drops boom at mill tie-up.

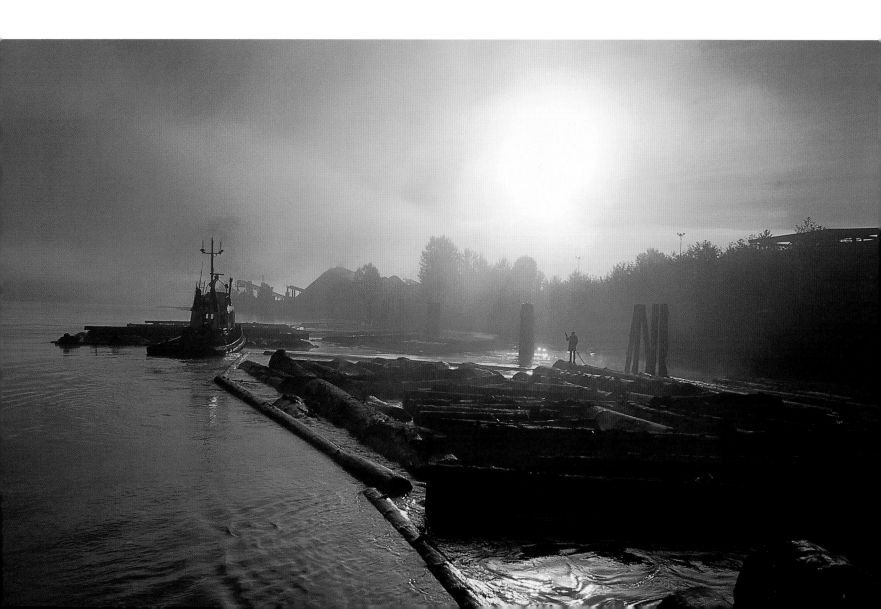

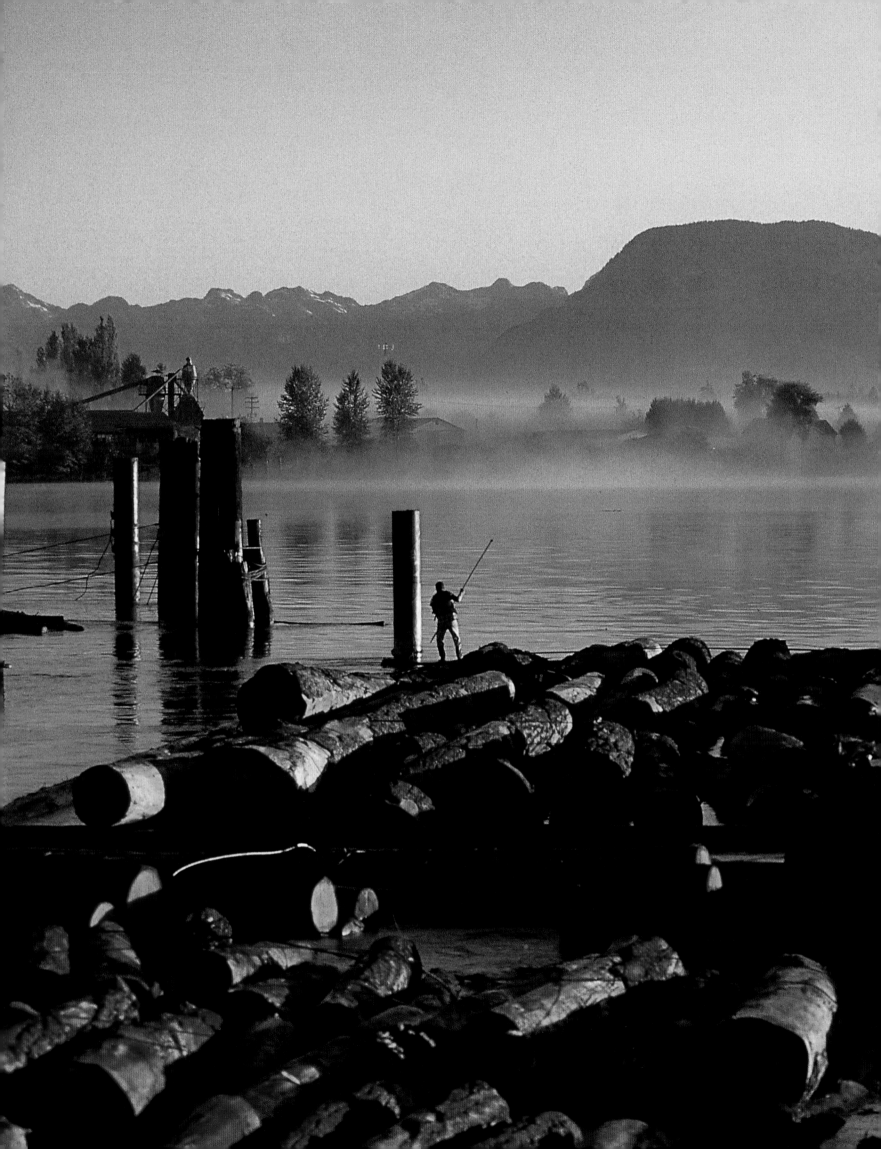

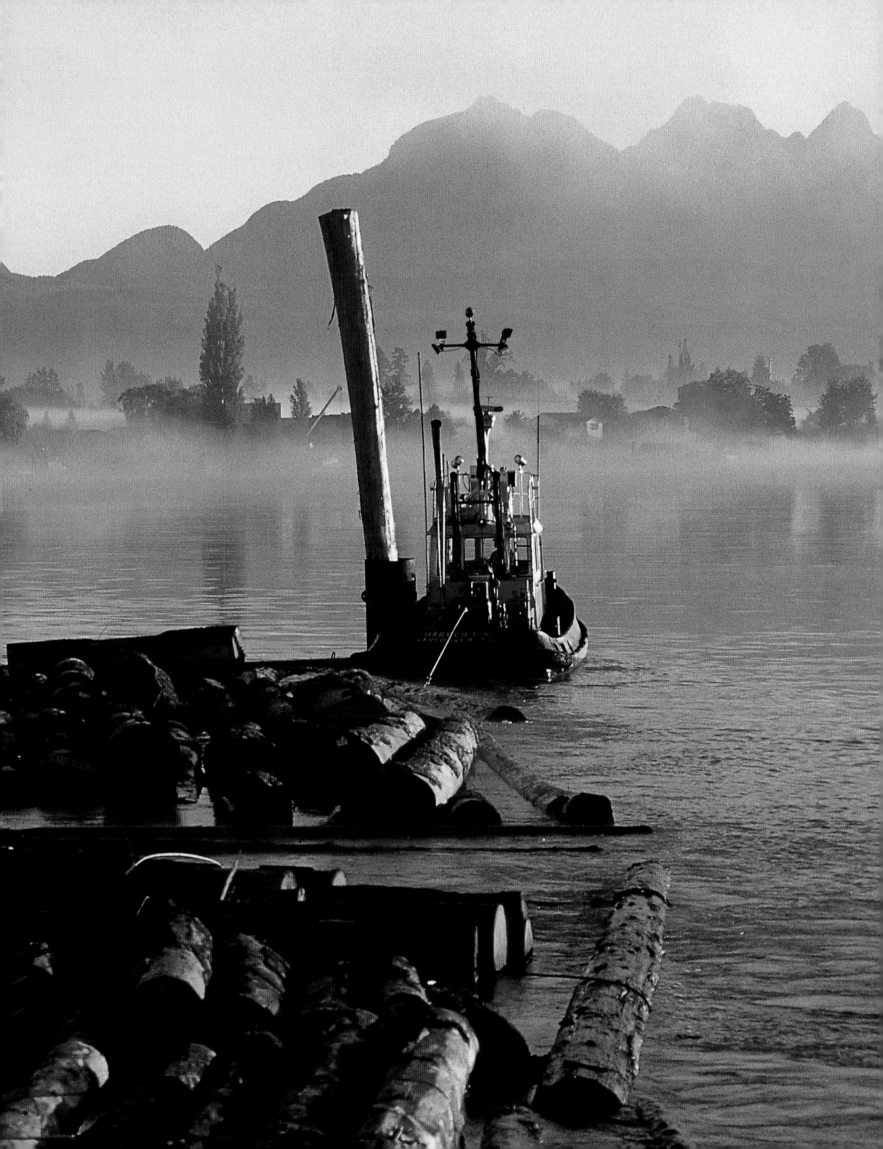

PREVIOUS PAGE
A deckhand secures a boom to a dolphin, a "hitching post" for booms along the bank of the Fraser.

RIGHT
The *Sea Imp XVII*, a high-speed tug built for working in shallow waters, skims past a boom on the Harrison River.

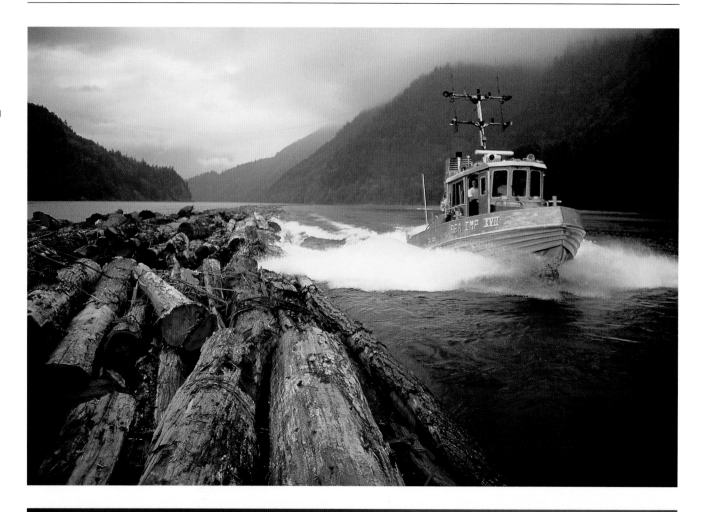

Deckhand Blake McCarten grapples with a towline on the *River Ranger* as the *River Star* nudges logs into place.

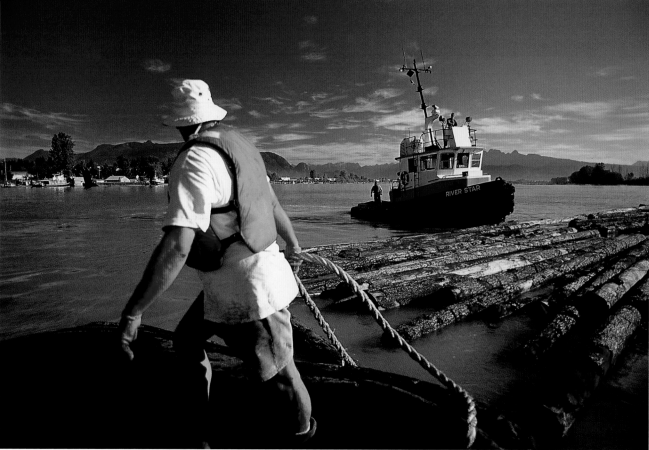

The *River Star* lurches as the towline tightens—and then goes slack. The boom has come apart again. "Ah, shit!" yells Al. Bundles of logs are spilling out of a gaping hole where the sidestick used to be. "Party's on," Rick mutters as he pulls on his caulk boots and jams his hands into the rubber gloves. The skipper of a Seaspan tug and barge coming downstream sees the spreading chaos and has to stop in mid-river. Until this busted boom is out of the way, he'll have to turn circles in the shipping channel and wait for a chance to squeeze through the swing span.

Al hits reverse and backs the *Star* against the boom as Rick whips the towline off to one side and away from the turning propeller. He jumps across to the boom and disconnects the towing bridle—a "V" of cable connected at its point to the towline and at its ends to each side of the tow. The boom is now floating free in mid-channel as the *Star* and the *Ranger* circle, sidestepping each other like partners in a complex dance routine.

They capture the drifting bundles one by one and shove them back against the main boom. Both tugs are butting 25-tonne bundles of wood again and again. Slam, thump and deke—it's like bumper cars at the PNE.

One of the long swifter wires that held the opposite sides of the boom together has busted. Glen is belly down on a greasy log, groping with his bare hands—again—in frigid water, trying to find the other end of the wire. Loose logs have rolled over. The rings, the chains, the toggles—nothing is where it ought to be.

Rick trots across the bouncing logs with a vest full of heavy staples. Glen has found the wire and he pounds furiously with the axe, driving a staple into a half-submerged log, splashing and bashing until he's scored a few solid hits to create a new anchor point. Together they're tying knots with loops of wire and closing another link with a shackle. Rick slides a toggle through a ring—and then sees another log start to drift away.

He leaps like a cat, and the cleats on his left boot bite into the slick, wet boomstick—but his forward momentum is too much. So he keeps going, over the top and into the turbid river, thrashing, swearing and laughing all at the same time as he climbs back up, dripping wet, to finish the job.

Glen stabs his pike into a log as he wrestles with a chain. Rick is belly down on another bundle, fishing for a wire strap. And so it goes until the whole sorry mess is tied back together again. Al and Jim move in to

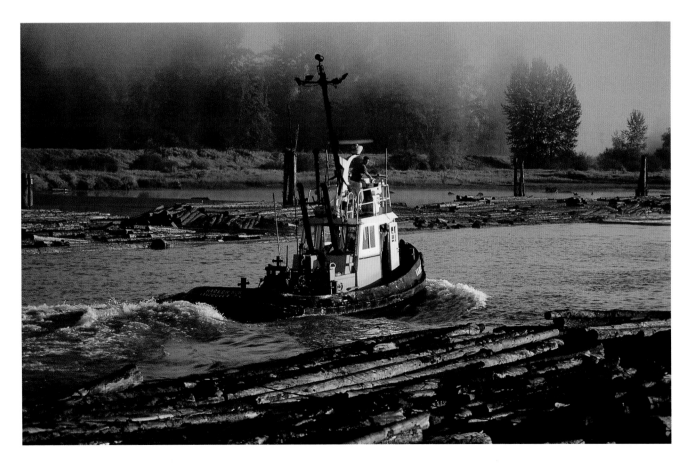

Another delivery successfully completed, a Harken shift tug races upstream for its next job.

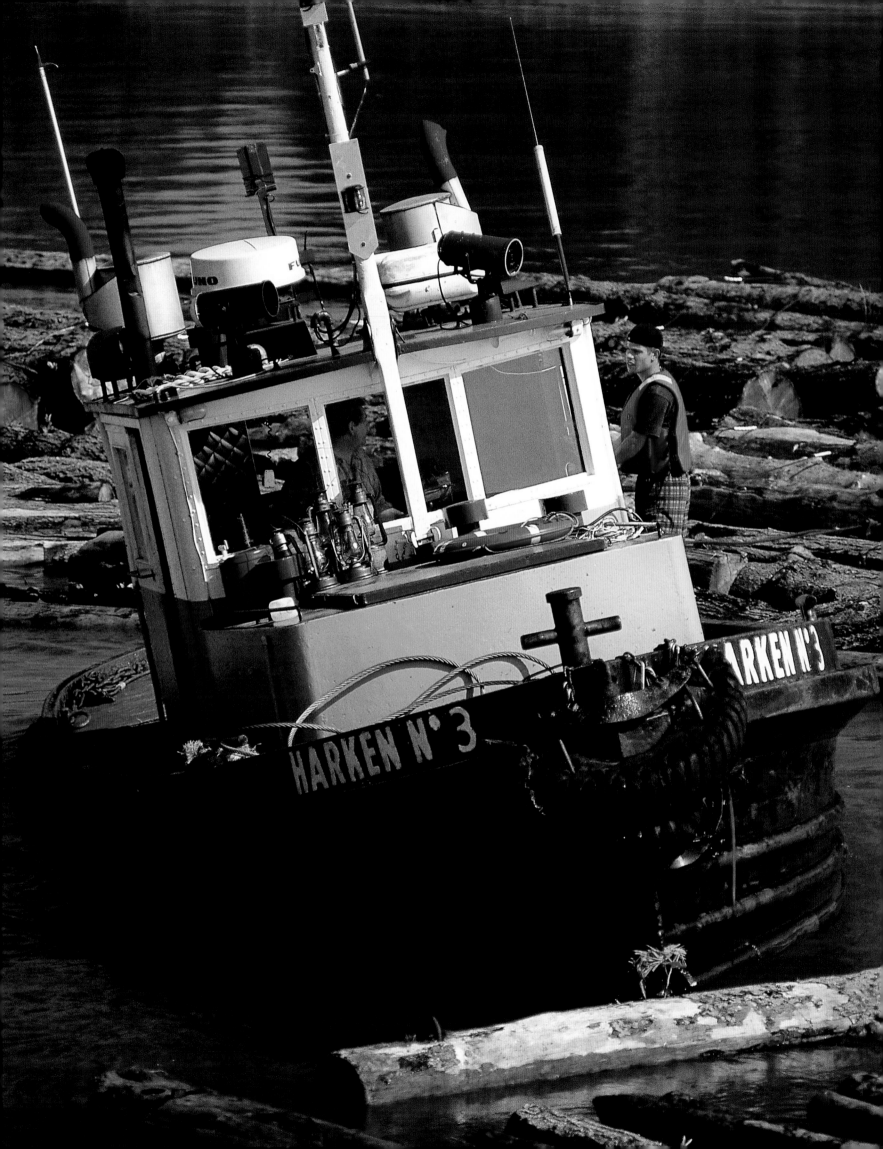

pick up their deckhands. The *Star* whips back around to the head stick and picks up the tow again. The party's over—time to move on upriver. Having scraped past the last of the really tight spots and with only eight sections left in the tow, the *Ranger* now splits away toward the Pitt River, a tributary of the Fraser River, to wrangle the booms it's supposed to haul downstream on the end of this tide.

Back aboard the *Star*, Rick utters an unprintable remark about how much he hates swimming on company time. He takes off his boots and wet socks and crawls down a narrow ladder into the warm engine room to change clothes. Minutes later he's back on deck and searching through his pack for another snack.

Approaching the Port Mann Bridge just after noon, the *River Star* begins to run a gauntlet of gillnet boats as hungry salmon fishermen jockey for position. Commercial fishermen get so few chances to fish anymore you can almost hear the buzz of their pent-up energy and frustration pulsing across the water. Orange and white plastic floats pimple the river's glassy face.

Nets are spun like webs across the main shipping channel. A dodgy business, it turns out. Some of the old salts who see the log boom coming and know the *Star* cannot zig or zag without causing the tow to whiplash, decide to haul their nets as we pass. Others simply take their chances.

Meanwhile, the *Star* keeps chugging upstream to the Barnston Island slough where the remaining eight sections of logs are to be dropped off. Al backs down the engine and steers slightly to the left. When Rick sees the slack in the port side bridle, he unhooks. Now we've got the fir boom by the starboard bridle only.

Al wheels the tug in a broad circle to the right, swings the entire boom around 180 degrees and lays it up alongside the dozens of sections already parked there. While Rick is out on the boom flinging chains and groping in the water, a call comes over the radio directing the *Star* to pick up two more sections of logs around the next bend to go with those the *Ranger* is yarding up on the Pitt River.

Naturally the logs they want are the ones on the

OPPOSITE
Tug *Harken No. 3* leans into a push as skipper Pat Harder shouts instructions to deckhand Dustin McKamey.

At sunset on the Pitt River, crew of *River Ranger* takes a well deserved coffee break.

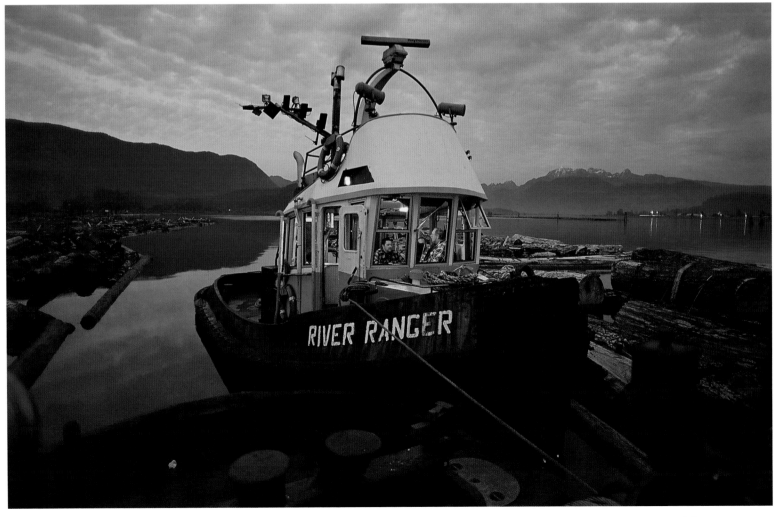

inside, closest to the beach, which means Rick and Al have to pull the outside sections apart and shove them aside before they can drag the ones they need out into the channel. There they let the two big mats of timber drift momentarily while they scramble to put the outer sections back together and re-secure them to the dolphin. Then they hustle back down the shipping channel to capture the wandering bundles, which are halfway across the river already. Once again, Rick is up to his elbows in cold water, groping for a ring on a boomstick to which he will hook the towing bridles. And away we go again.

At sunset on the Pitt River, both crews take a half-hour coffee break before yarding the last few log sections into a single boom to be towed downstream to one of the mills. On this 12-hour day we've seen the sun rise and now we see it set. Both times are easy on the eyes and a tonic for the soul. The work may be wet and hard on the back but the view is great. When it's well and truly dark, Al Woodward sips the last of his mug of chicken soup, checks the tide table one more time and glances at the ship's clock. Rick scans the inky shoreline with binoculars looking through spills of light from a mill across the river to find telltale bits of bark, leaves and other floating debris sliding south and west to confirm that the high slack has turned. Time to go.

So what is the *best* thing about this job? "Certainly not the fame and the glory, let me tell you that much," says Rick. "But the money's good and the time off is fantastic." He explains the work schedule this way: seven days on, then seven days off. Twelve-hour shifts. That gives him 14 days free every month. "Lots of time to pursue dreams in life that you really want to pursue. Time off is important."

But those are seven very long 12-hour workdays. We were all at the dock at 0615. The shift started at 0630 when the crew boat picked us up. Now it's roughly 1930 as the crew boat returns with the night shift guys to relieve the watch. There's still a 30-minute run down the river before we're back at the Riverside dock and the day is truly done. But then, somebody mentions a quick stop at the Drake Hotel for a beer...

The work may be wet and hard on the back, but the view is great.

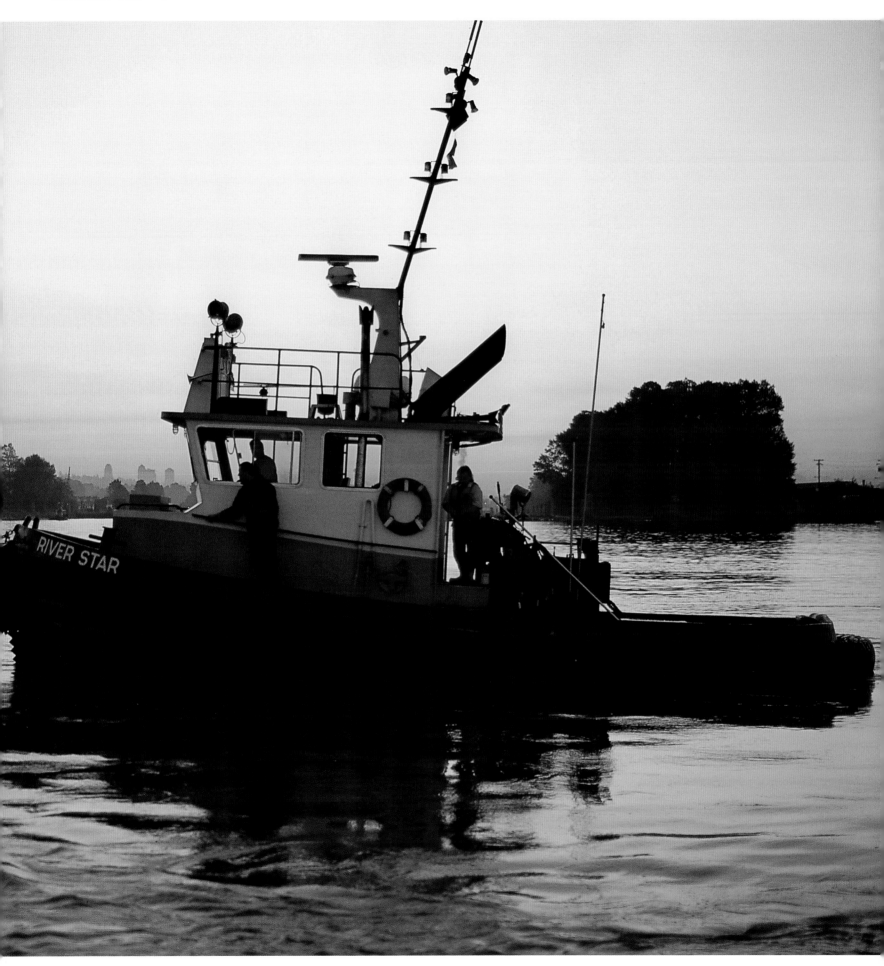

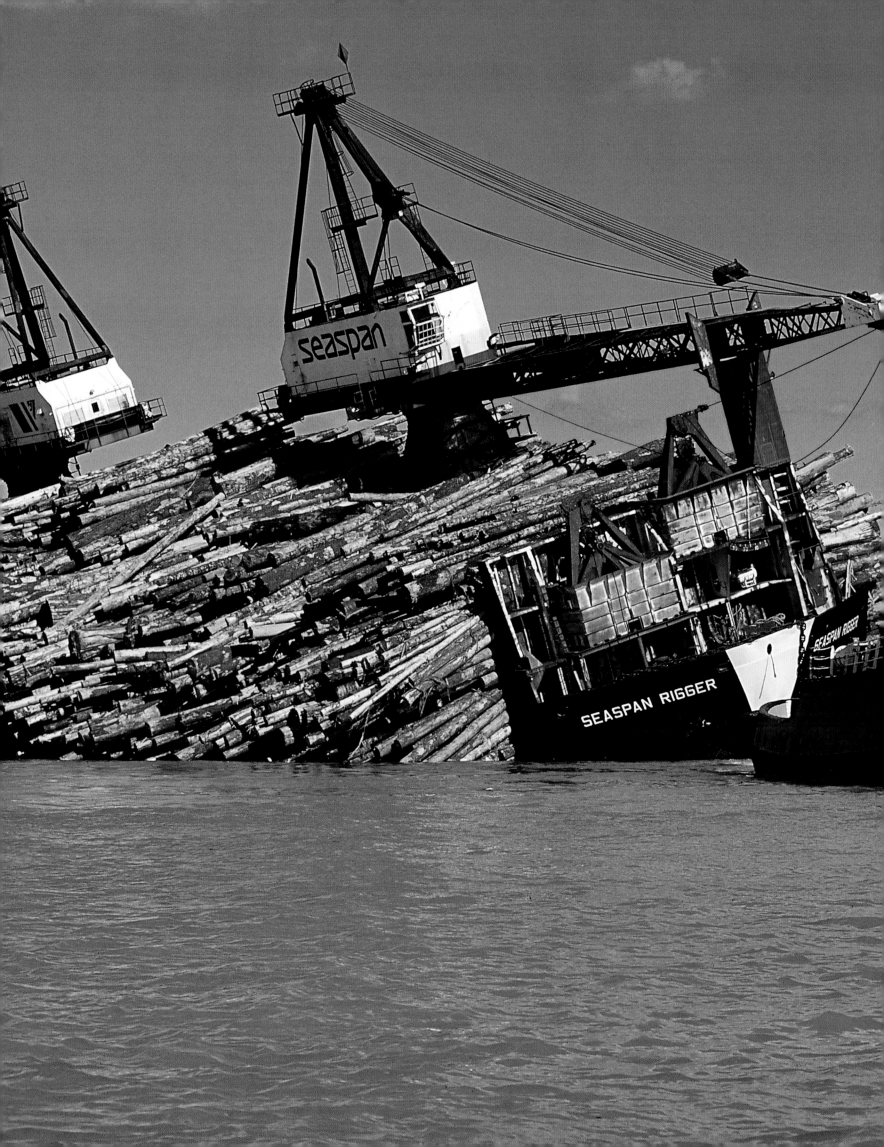

2

THE BIG PIGGYBACK

hile log booms offered a cheap and easy way to move logs from forest to mill in the sheltered inside waters, the challenge of moving logs safely across the storm-tossed open waters of Queen Charlotte Sound and Hecate Strait, or down the west coast of Vancouver Island, imposed limits on the forest industry. The various bundling and rafting techniques allowed some access, but they were cumbersome and occasional disastrous spills restricted their use to fair-weather periods.

The first time you see the controlled violence of a log barge dumping its load, you'd swear it was a horrible accident. But the self-dumping log barge, pioneered by the Sause brothers of Oregon, revolutionized the industry. Here the 37.2-metre, 3,600-horsepower tug *Seaspan King* and its 120.8-metre barge *Seaspan Rigger* unload in the Fraser near New Westminster Quay.

Some of the more far-flung logging operators like Tom Kelley in the Queen Charlottes and the Gibsons brothers on the West Coast realized the only way to get their logs across these trouble spots reliably and efficiently would be to piggy-back them across. As early as the 1920s, some began to convert old sailing ships into log carriers by enlarging the deck hatches and removing bulkheads. These pioneering log barges could be towed at about five knots, more quickly than Davis rafts, and they could stand exposure to heavier weather. The downside was that by removing their bulkheads, the hulls were weakened. These vessels were also easily damaged by rough handling of large logs, their open hatches reduced their seaworthiness, their carrying capacity was small, and their unloading time was excessive.

A turning point for log barging came after World War II when Straits Towing converted four steel-hulled military landing craft to carry logs lashed fore and aft between their steel bulwarks. Then, MacMillan Bloedel researchers studied the small logging operation of the Sause brothers of Oregon, who had solved the unloading problem by allowing one side of their barge to sink so that the logs slid off. It was a concept that would revolutionize log barging in BC. In 1957 MacMillan Bloedel built two self-dumping log barges, both of them 104 metres in length with heavy steel-plated decks, twin skegs for directional stability, and tipping tanks built into the port side of their hulls. These were the prototypes for the modern fleet of log-carrying ships and barges.

By the early 1960s log barges were carrying a third of the coast's log output. Barges grew in size, the *Seaspan Forester*, at 138 metres long with a capacity of four million board feet, being the largest log barge in the world. But as barges got bigger, towing companies were taxed to provide tugs that could move them quickly and safely through tricky coastal waters. Empty barges, with their shallow draft and greater windage, were particularly difficult for under-powered tugs to manage. The result was the arrival of a whole new class of larger and more powerful (3,000 horsepower plus) tugs, each specifically matched to the log barge it was to tow.

The 32.3-metre, 2,640-horse-power *Seaspan Monarch* hauls an empty log barge to the company docks in Vancouver Harbour.

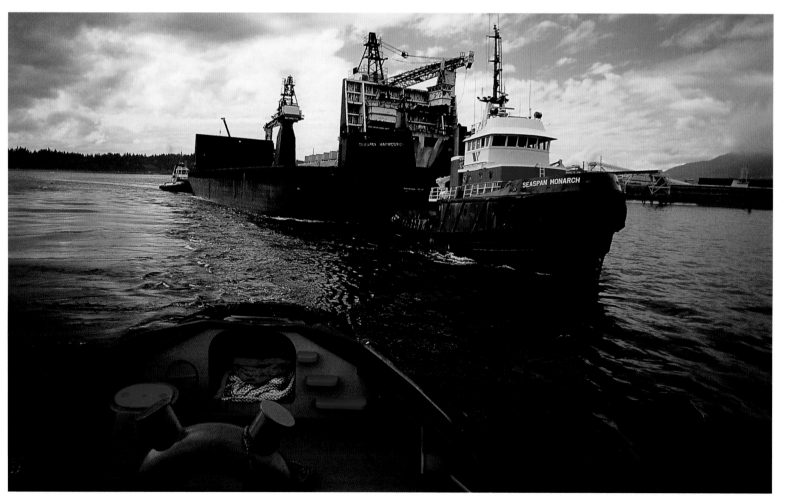

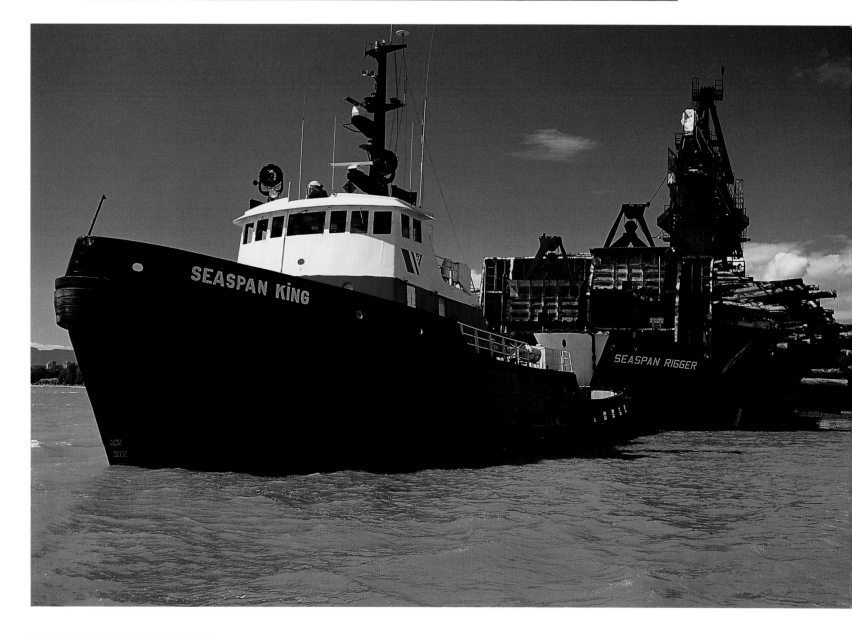

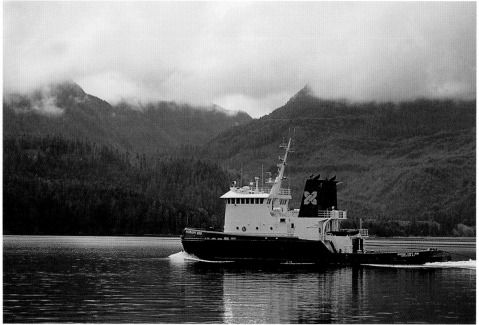

ABOVE
The *Seaspan King* tows a loaded *Seaspan Rigger*.

LEFT
The 6,140-horsepower *Rivtow Capt. Bob*, flagship of the Rivtow fleet, steams through a calm sea.

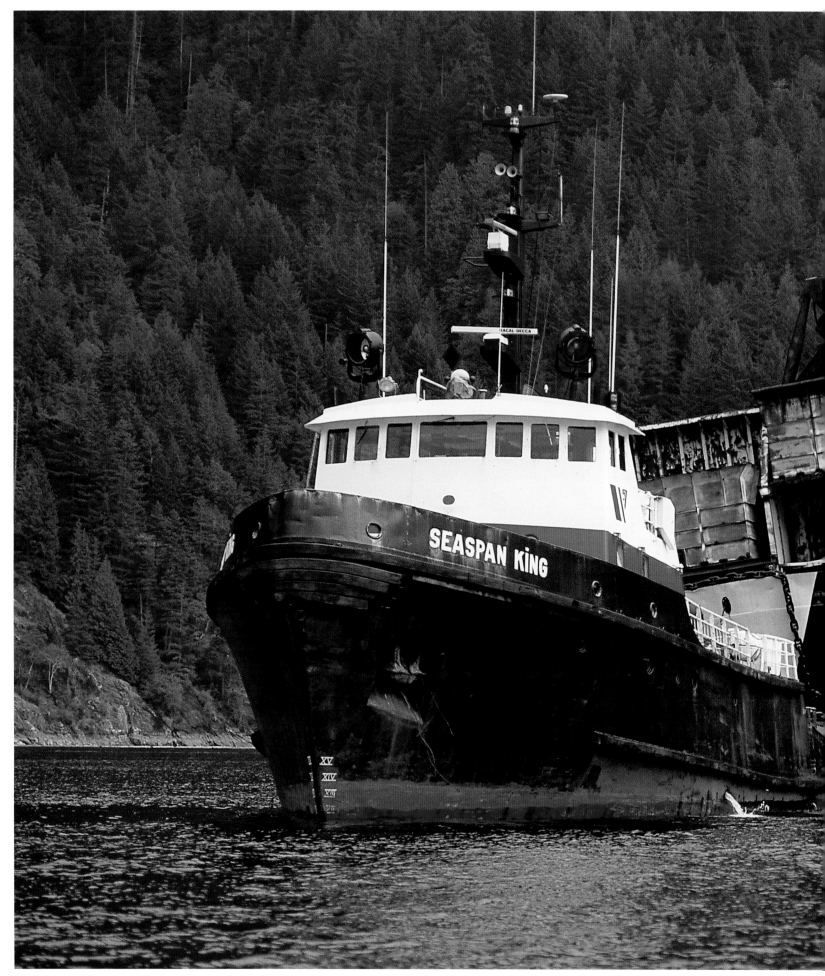

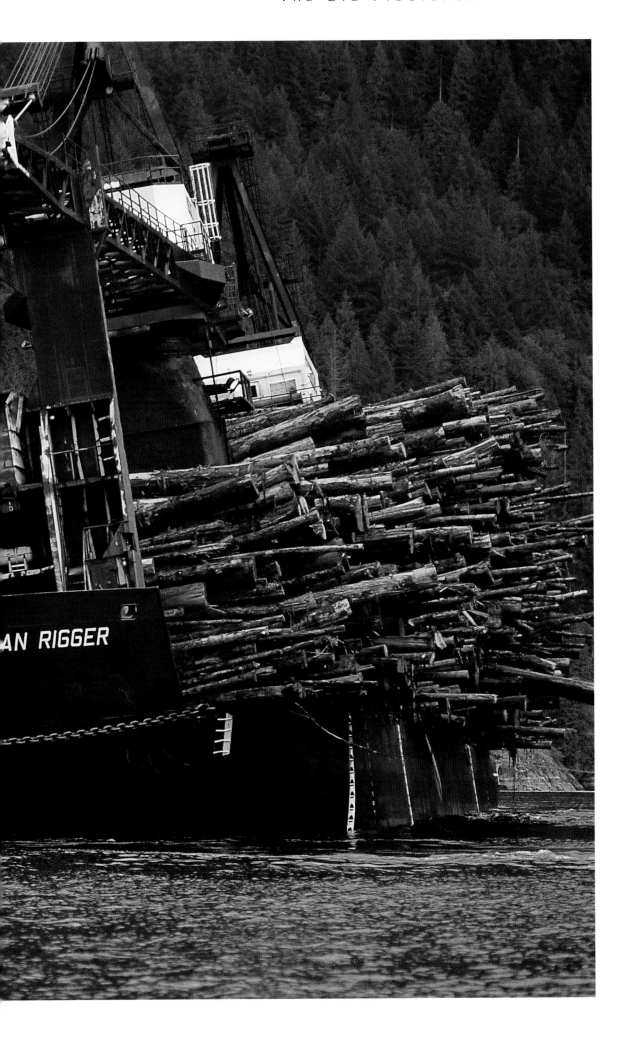

The *King* and *Rigger* prepare to unload in Howe Sound. Some barges dump to port, some to starboard.

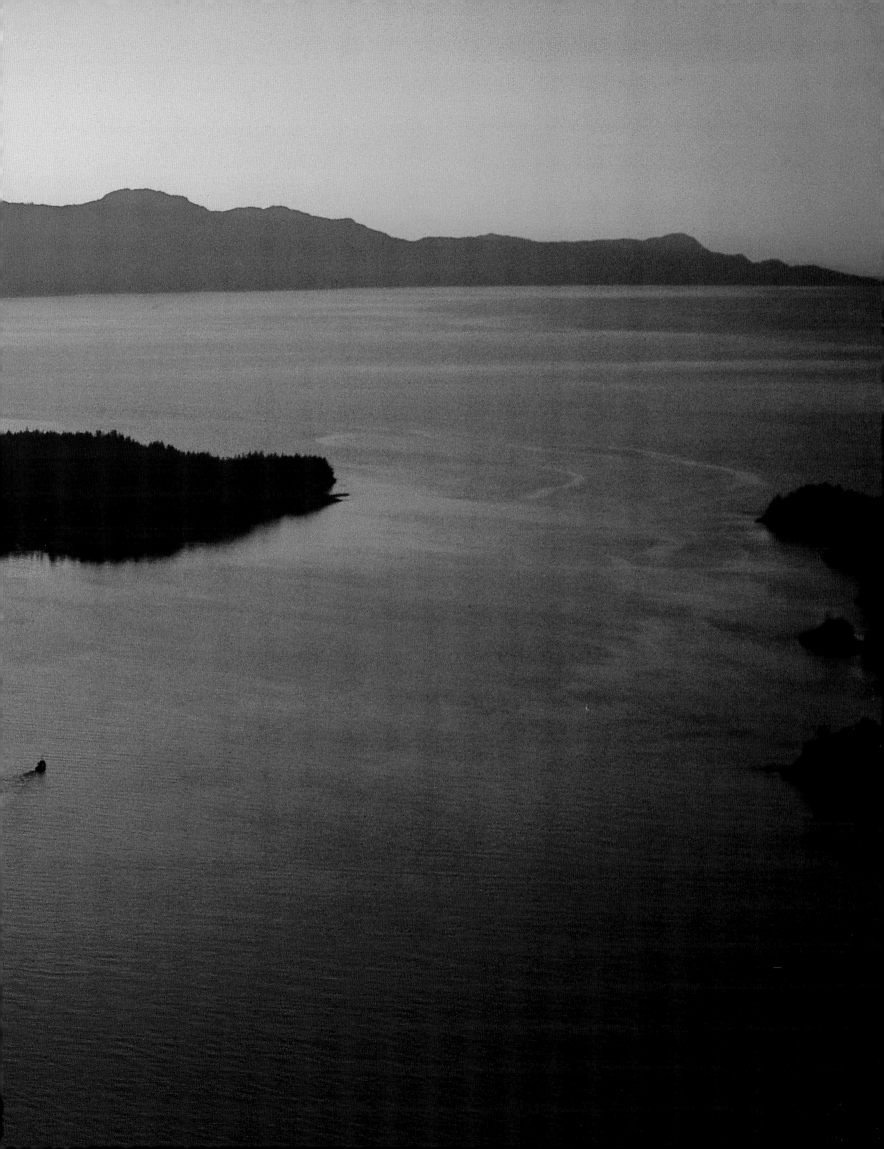

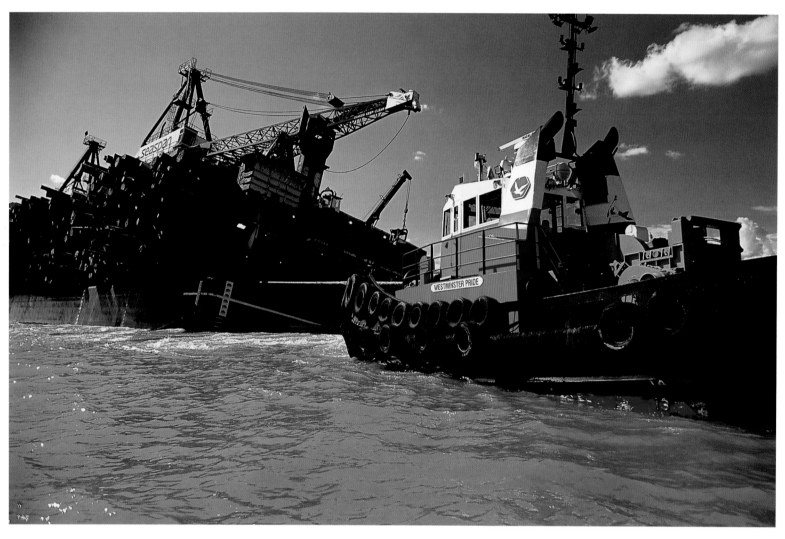

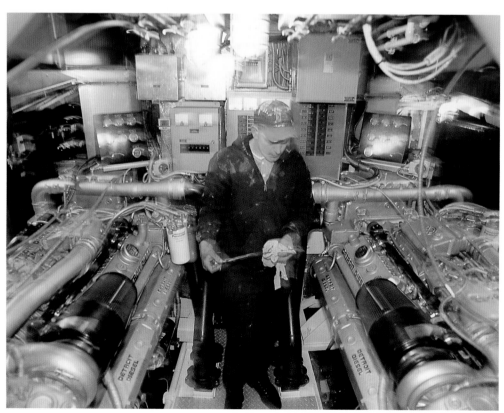

PREVIOUS PAGE
A tug and boom inch northward through Welcome Passage on a beautiful September evening. Booms are fine in protected waters like this, but are too fragile for the open seas of Hecate Strait, Queen Charlotte Sound and the west coast of Vancouver Island.

ABOVE
15-metre, 3,060-horsepower berthing tug *Westminster Pride* holds a log barge in place as its tipping tanks fill with water. Some barges have tanks above the waterline that will drain by gravity after the load is dumped; others must be pumped out.

RIGHT
Below deck, most of a tug's hold is filled with its power plant, in this case a pair of high-speed diesels.

In the mid-1970s MacMillan Bloedel's Kingcome Navigation advanced log barging technology one step further with the launch of two 120-plus-metre self-propelled, self-loading, self-dumping ships. Both can travel at 12 knots when fully loaded and require no help from tugboats except during loading and unloading. When construction costs rose in the next decade, motorless barges were built once again. Still, these barges aren't cheap: the combination of the *Hercules* and the mighty *Rivtow Captain Bob* built to tow it is estimated to have cost over $20 million. Many barges have also been re-equipped with new, more powerful cranes, allowing them to pick up 50-tonne log bundles, but even this comes at a cost of about $1 million per crane.

Five minutes before Saturday midnight at the Rivtow dock on Commissioner Street in Vancouver, two deckhands hustle aboard the *Rivtow Captain Bob* with the last of the supplies for a week at sea. Someone on day shift has already fuelled her up and packed the food. In the wheelhouse, the skipper's on a little green phone to the engine room, asking for power. A voice crackles from the VHF radio as the coast pilot aboard a China-bound freighter calls Vancouver Traffic to report his approach to Second Narrows.

Two engines kick over and begin a low, throaty rumble. At 990 tons, the 44-metre *Captain Bob*, flagship of the Rivtow fleet, is at least twice the size of the half-dozen other boats at the dock. It's said to be the most powerful tug on the BC coast, with a pair of 16-cylinder marine diesels that crank 3,070 horsepower each—the same brute strength you'd find in two railway locomotives. Through a pair of four-bladed props three metres in diameter mounted in nozzles, the *Captain Bob* can generate 91.6 tons of liquid thrust.

Chief engineer Len Walsh, a former Newfoundlander, wanders out on deck. "I'll sleep good tonight," he says with a satisfied grin. "The sound of them engines... I just can't sleep ashore. It's too quiet."

The *Seaspan Falcon* helps to steer an empty log barge in Vancouver Harbour.

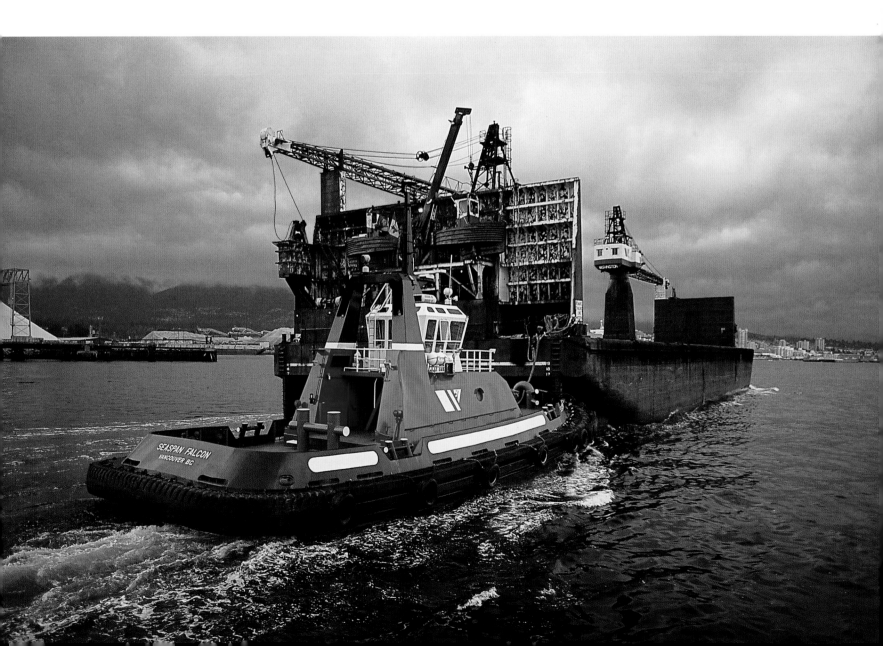

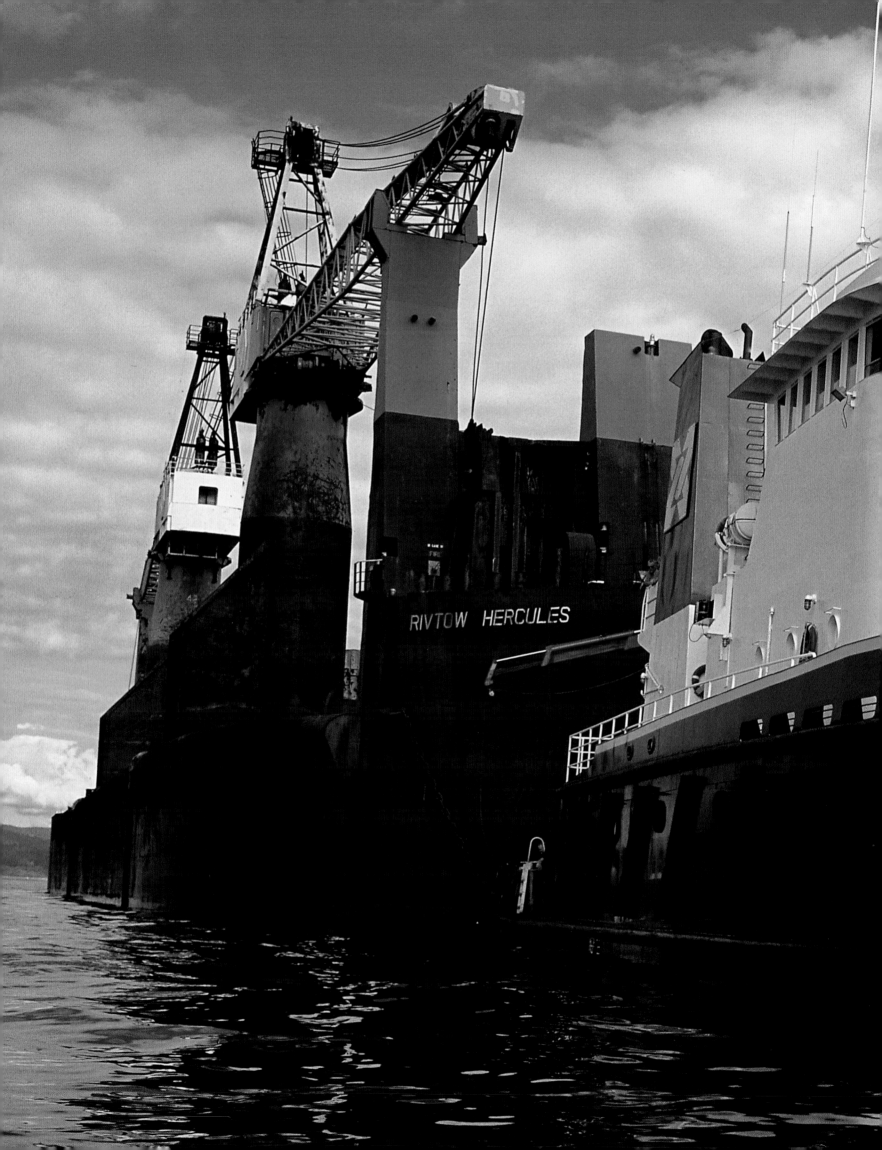

RIVTOW CAPT. BOB

Deckhand Darren Towers slips the mooring lines but remains standing on the dock as the *Captain Bob* glides away. Skipper Don Rose takes a short turn around the corner to an adjacent dock where the *Rivtow Hercules*, its paired self-loading, self-dumping log barge, lies moored to a finger wharf. She's 122 metres long, 29.5 metres across the beam and, when she's fully loaded, her draft is about six metres. She has two dozer boats, two 71-tonne cranes and can haul 17,000 tonnes of logs through almost any weather.

Deckhand Murray Haines is on the tug's stern deck preparing the two towlines that will be connected to the *Hercules*. The port towline is connected to 27 metres of surge chain, which is connected to two chain "bridles" from the barge. The starboard towline is connected to approximately 10 metres of chain, which is connected to the bow of the barge at deck level. The chains act like a set of shock absorbers. In heavy weather, the weight of both must be lifted from the water before the towline itself comes up tight.

An assist tug has a line on the port quarter of the *Hercules* to help pull it away from the dock. At the controls of the towing winch, Don Rose snubs the tug and barge together, making the two vessels into a single unit for better control. Down on the finger, deckhands let go the mooring lines—and we're away.

We make a long, graceful turn into the main channel. The skipper's in the wheelhouse now. From the gang of three radios mounted just above the big spoked wheel, Don grabs a mike and makes our departure official.

"Vancouver Traffic, the *Captain Bob* is away from Commissioner Street with a light barge. Outbound for Gold River."

Clear of the dock, Don lets out roughly 120 metres of towline, just enough for good control. The barge is far enough behind us that turbulence from the tug's twin props won't cause it to veer off to one side or the other. But the towline itself is "bar tight," completely out of the water, a throbbing steel clothesline strung across the flickering water. Straight ahead we cruise past a nearly deserted Stanley Park, then underneath the Lions Gate and into the blackness of English Bay. In open water another 180 metres of cable rolls off the drum, reducing stress on the towline. With 300 metres of six-centimetre wire rope strung out between tug and barge, the heavy chain shock absorbers are now sagging in the chuck and we are fully underway.

It's just before one o'clock in the morning when first mate Ken Roskelley assumes the watch. He and deckhand Darren Towers will take us through the night,

south and west around the Gulf Islands. We'll be just outside Victoria Harbour in roughly five hours time, when Captain Don Rose and deckhand Murray Haines are due back on watch again. Between now and then, time for a quick snooze.

"Normal people wouldn't do this job," Don jokes. "It took 35 years of marriage for my wife to realize why I tend to fall asleep and take a little nap in the middle of the afternoon. Nobody realizes what six-on, six-off watchkeeping will do to your sleep patterns."

And thus begins a work week that could take an able seaman almost anywhere. From hauling logs to deep sea rescue. Whatever the day brings.

By mid-morning Sunday we've rounded the bottom of Vancouver Island. During the night we threaded the shipping lanes between Canada and the United States, passed Victoria and are now out in Juan de Fuca Strait. We are plowing headfirst into one metre swells, so long and gentle you can hardly see them. But the pitching of the bow is proof that the open Pacific is rolling down the channel right on our nose. And the smooth ride is probably over for awhile.

In better light, it's easier to see the wheelhouse layout. It's like a spacious penthouse living room with a small chesterfield and a million dollar view in all four directions. It comes complete with a tiny sink, fridge and coffee maker, plus an endless supply of saltine crackers and sugar cookies to settle the stomach. For handgrips, stainless steel handrails are mounted along the ceiling and along the port and starboard bulkheads. They're put to good use, no doubt, in dirtier weather.

There's an old-fashioned, wooden-spoked wheel for the helm and twin throttles of gleaming chrome. The bank of VHF radios hanging from the ceiling is within easy reach of the captain's chair. Two joysticks serve as the tug's steering controls. Actually, there are three complete sets of steering and engine controls in the wheelhouse, one on the port side, one on the starboard and one in the centre. There are several banks of gauges and dials, a marine radio-telephone and a small boombox radio with a cassette player. The TV set is down in the galley; can't have any frivolous distractions in the wheelhouse.

Facing toward the stern on the starboard side is a chart table and a fax machine that spits out hourly weather reports on long strips of glossy thermal paper. And there's another radio—this time a single-sideband for long-distance calls to head office in Vancouver from

places where no cell phone can reach.

Just when you think it's like the starship *Enterprise*, you spot that very un-fancy, crank-powered telephone to the engine room and an older model radar with the black rubber hood to keep glare off the screen. There's even a homemade-looking periscope to view the magnetic compass, which is mounted higher up, above the wheelhouse, to keep it safely away from the magnetic interference of all the electronic gear.

The *Captain Bob* is almost 20 years old but she looks as shipshape as the day she was launched. Somebody—probably a lot of somebodies—are clearly proud of this boat and have taken good care of her. But the familiar green and white livery many people know her by is gone. She's freshly blue, yellow and white—tricked out in her new owner's colours.

Rivtow Marine, for 61 years a Cosulich family powerhouse in the BC towboat industry, has been sold to the Dutch giant Smit International. Depending on your point of view, it's either the end of an era or the beginning of a whole new game—a chance for some BC mariners to play in the really big leagues.

The Smit company has been on the job for 155 years with deep-sea tugs, rescue and salvage operations and workboats that install and service offshore drilling rigs worldwide. Smit is the outfit hired to raise the *Kursk*, the sunken nuclear submarine the Russians lost off the coast of Norway.

For now, at least, it's business as usual for Rivtow. Smit's corporate logo, which looks like crossed links of bright yellow anchor chain, stands out against the *Captain Bob*'s big blue stacks. The only reminder of her Rivtow past is the familiar flying gull logo (outstretched white wings against an orange hexagon that looks like a setting sun) just below the wheelhouse windows.

By the time we've passed Jordan River the boat is pitching and twisting in slightly bigger swells. How can so much steel be so flexible? It's not creaking or moaning like a wooden boat. It's more like a metal bull squirming in a harness. Captain Rose opens a carrying case of audio cassettes and pops in a collection of old hot rod hits. Pretty soon we're singing along with Robert Mitchum: "Thunder, thunder, over Thunder Road. Thunder was his engine and white lightnin' was his load. There was moonshine, moonshine to quench the devil's thirst. The law they swore they'd get 'im, but the devil got him first."

It creates a very un-Sunday-like kind of spell as the

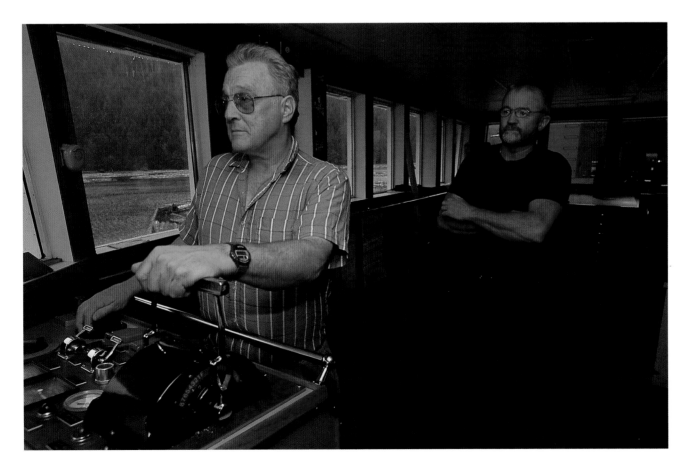

Skipper Don Rose and deckhand Murray Haines dock the *Capt. Bob*, a surprisingly nimble boat despite its size.

lunch hour approaches. We slip past the nooks and crannies of Vancouver Island's coastline, where Canadian rumrunners used to play hide and seek with the US Coast Guard.

By mid-afternoon a fog bank hugs the island shore. The mate, Ken Roskelley, is standing watch now, steering a course just outside the fog bank. We're somewhere west of Carmanah Point. Hidden in the low smudge of mist beneath a bright blue sky, in broad sunny daylight, is a cluster of fishboats working for the federal government. It's a test fishery to find out how decimated the salmon run is this year. Big boats and skiffs, strung-out nets and rigging, probably a gaggle of government scientists, all concealed beneath a grey-white fog shroud, as if it were some big secret. Or maybe just a cryin' shame, visible only on radar.

As we glide along listening to Cross Country Check-up on CBC radio, people are yattering about human cloning. Ken wonders why they don't ask somebody who knows what they're talking about instead of listening to all these regular yahoos spout their uninformed opinions. Why would anyone want to be cloned

anyway? Way out here on the edge it all sounds a bit surreal. The radio signal is breaking up, fading in and out. We are slipping farther upcoast—out of range of civilization... and not a moment too soon.

All Sunday night we are rockin'. Dipping and swerving. The music is groaning metal. The tug's tendons and joints are twisting again. Lying in a narrow bunk in the dark, head uphill only half the time, it's like riding a mattress tied to a roller coaster. The drone of the engines shifts momentarily to a higher pitch as the props "cavitate," or suck a bit of air.

Just before 0600 Monday, cook Brian Hunter serves a breakfast of French toast and bacon. Despite the rough night, he's amazingly cheerful. It's as if getting up before the sun to break eggs and flip bacon across a spattering hot stove that's tilting like a see-saw is...almost normal. How do you feed nine hungry guys when the galley deck is heaving and spilt milk flows uphill? Brian grins. No big deal. He's just doing his job.

After coffee, we turn into Nootka Sound where the sea is now smooth. We're cruising past Bligh Island in

The *Rivtow Capt. Bob* uses up to 1,000 metres of towline when in outside waters.

the pre-dawn gloom. Up in the wheelhouse, Captain Don Rose has re-assumed the watch. As mate Ken Roskelley heads down to breakfast, deckhand Darren Towers mentions to the skipper that on his last shore leave he took and passed the "Watchkeeping Mate" exam.

"Congratulations," says the skipper. "How was it?"

"Well, there were some strange questions," says Darren. "Have you ever heard of 'casting the compass'?"

Captain Rose says no, not that he can recall. So Darren explains it this way: "If you're the helmsman and you're steering a course of 350 degrees, and the skipper gives you an order to steer 00 degrees—well, instead of steering ten degrees to starboard, you go all the way back around to zero. That would be 'casting the compass.' But who in their right mind would do that?" Darren wonders.

Don Rose grins and mumbles, "Well, sometimes they like to ask you a trick question."

"He wanted to know what were types A, B, C and D flares?" recalls Darren. "I knew one was orange smoke. Another is a rocket flare. Another is a rocket that fires twice at 15-second intervals. But which is which?"

With his score in doubt, Darren was a bit worried. "For the last 35 minutes of the exam, he just closed the book and talked to me... And all I wanted him to say was whether I'd passed or not."

The skipper smiles, as if he's seeing it all again from a long time ago. The ticket Darren has just earned qualifies him to stand watch as a mate in vessels up to 322 kilometres offshore. As a third-generation tugboat mariner, having passed this exam puts him in line to climb the industry ladder fairly quickly as guys of Don Rose's generation begin to retire in the not too distant future.

By 0620 Monday, we have passed Bligh Island and entered Tlupana Inlet, a long crooked finger of saltchuck pointing at the island's rocky heart. Tattered mist hangs in mountain gaps shot through with spears of early light. The hulking shadows of sunrise retreat slowly up the inlet as we make the last turn into Nesook Bay. Skipper Don Rose and deckhand Murray Haines shorten up the towlines.

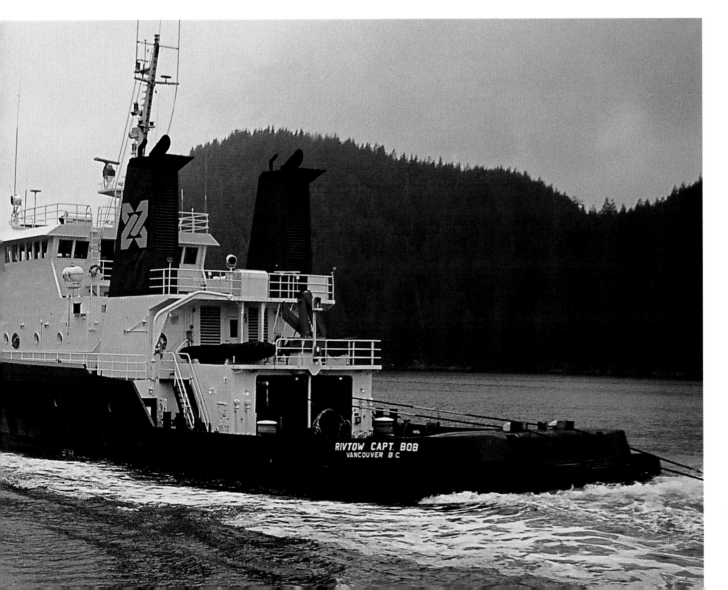

RIVTOW CAPT. BOB
VANCOUVER B C

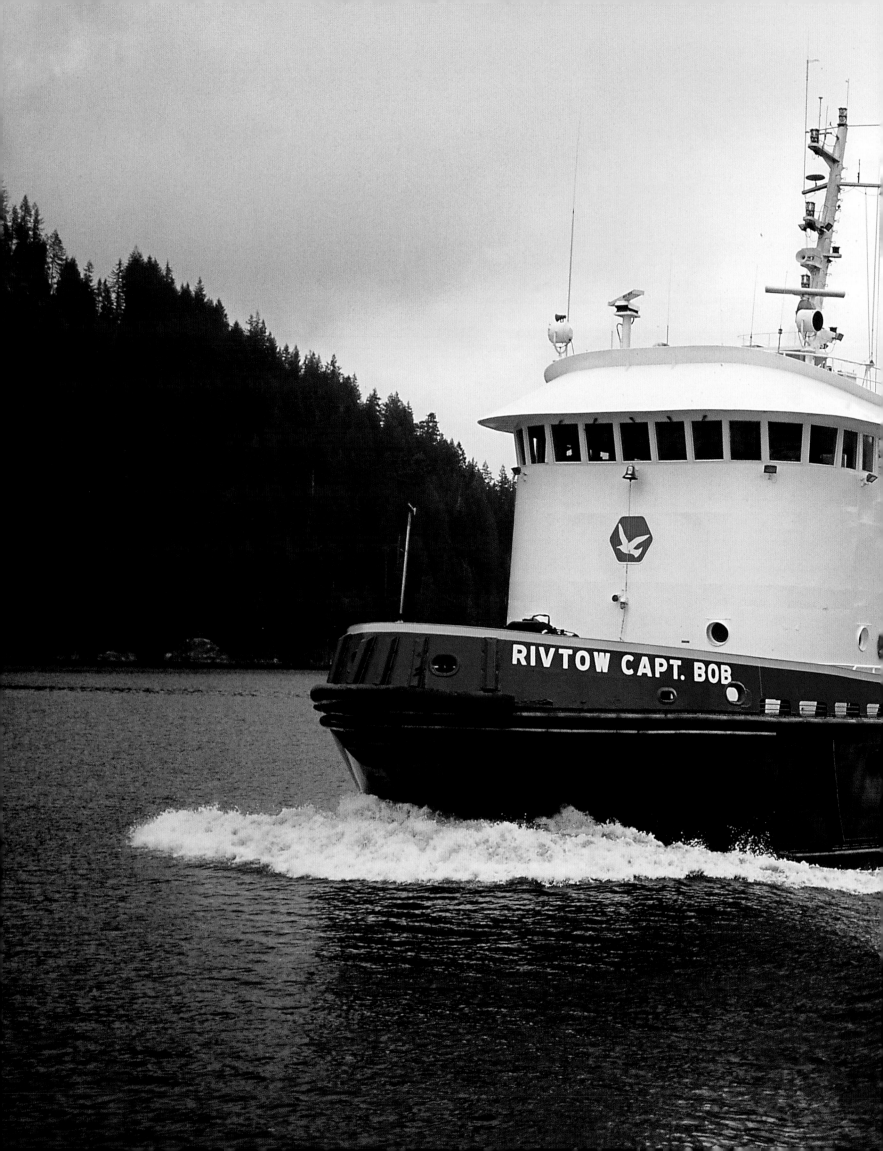

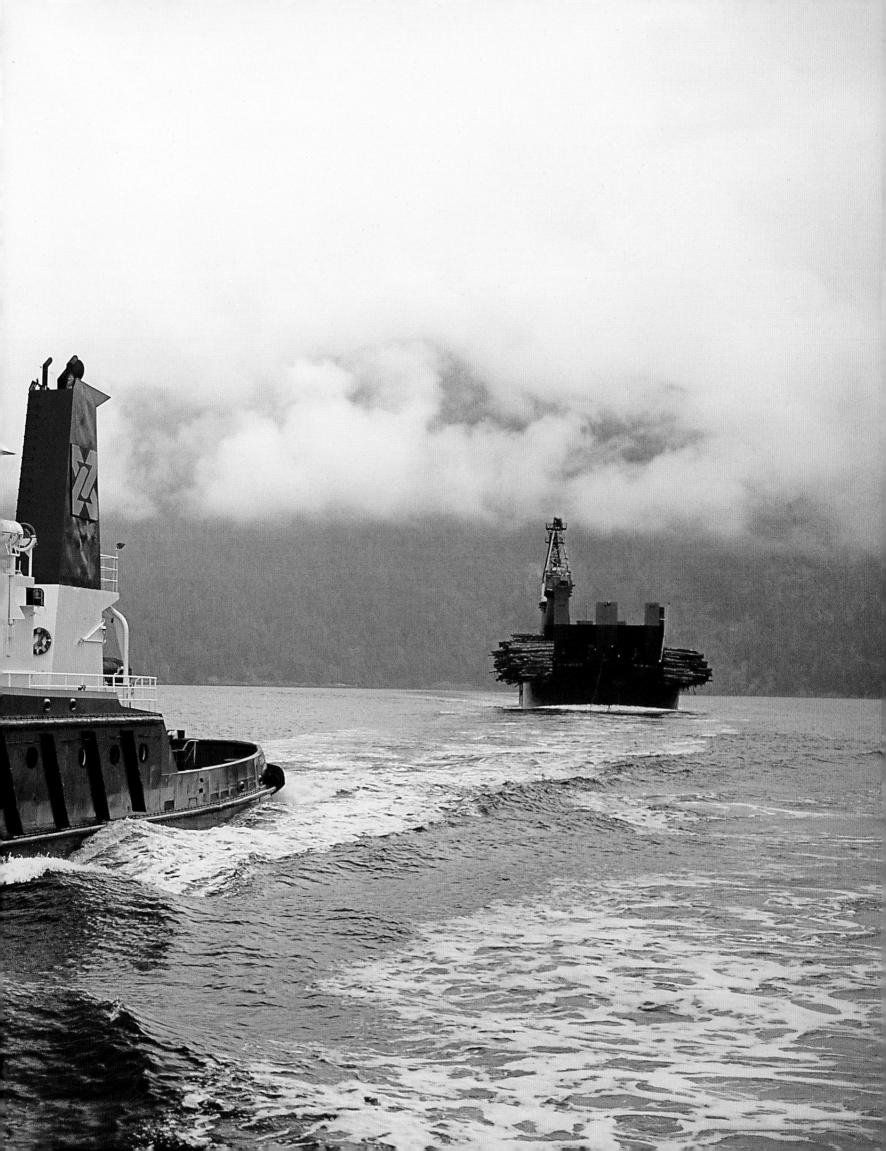

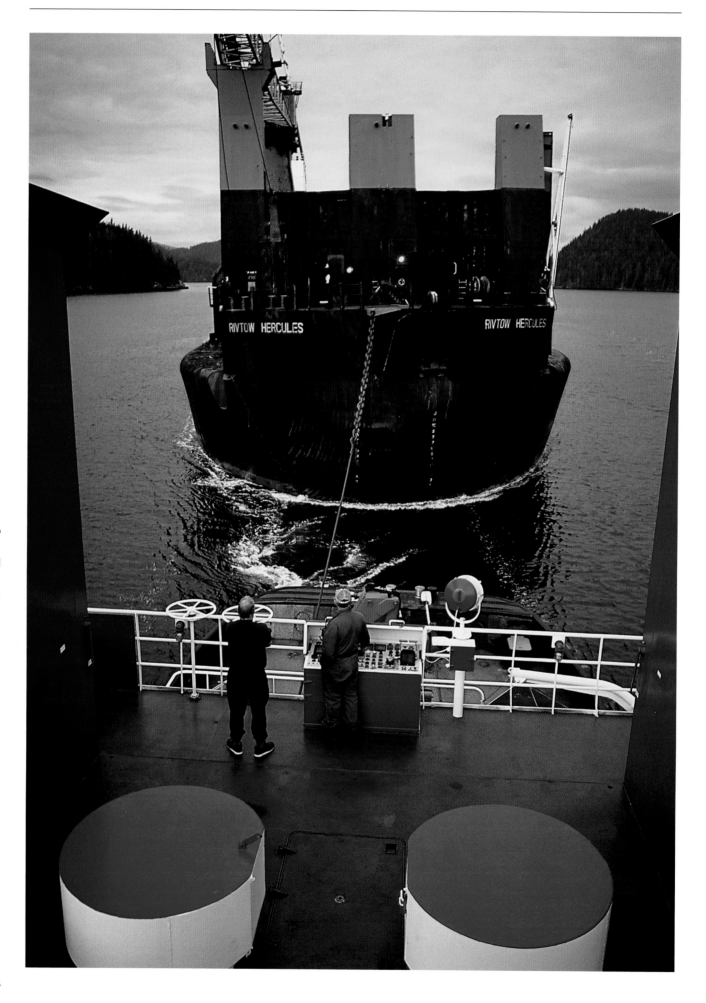

PREVIOUS PAGE
Rivtow Capt. Bob hauling half-loaded barge between Nesook Bay and Gold River on Vancouver Island.

RIGHT
Crew members of *Capt. Bob* draw the *Hercules* snug to the stern. The *Capt. Bob* is said to be the most powerful tug on the BC coast; each of its twin diesels packs a 3,070-horse-power punch.

The winch hauls the *Hercules* close behind the *Captain Bob* to make manoeuvring easier. At this range the barge looms, massive and silent, veering slowly from side to side as we creep across the little bay in the pre-dawn glow. Leaving no wake to speak of, we move toward a sprawling bag boom of bundled logs, acres and acres of red and yellow cedar in a floating corral of boomsticks and chains.

The *Sand Point Chief*, a 10-metre assist tug owned by Western Forest Products, comes alongside with four log loaders who have flown in from Vancouver. It's show time. All hands on deck. It'll take two or three hours to load 6,400 cubic metres of wood—the first half of our scheduled cargo.

Closer now, Don gives the order to snug her up tight. Tug and barge become a single vessel again as the *Sand Point Chief* moves into position on the port quarter to help nudge the *Hercules* against the dock. Actually it's not really a dock; it's a stiff-leg—a floating barricade of jumbo sun-bleached logs chained in twos and threes side by side and end to end across the bay and anchored to shore. A lone boom man ambles along the outermost log with his pike pole, waiting for the *Captain Bob*'s bow line.

Behind the barricade, bobbing like a glistening black apple amongst the cedar bundles, a harbour seal watches and waits to see what's going on here. Darren Towers observes that seals can be a real nuisance, especially on the booming grounds over in Howe Sound.

"You can be walking a log at night and all of a sudden there's a big splash," he says. "Scares the hell out of you." After thinking about it, he raises a knowing eyebrow. "Of course the sea lions are even worse. They stink and burp and fart."

Don Rose creeps the *Captain Bob* along the stiff-leg trying to centre the two barge cranes over the floating bundles of cedar. The mate, Ken Roskelley, is aboard the *Hercules* now, calling out the barge's position on his portable radio.

"Might have to kick it a bit," Ken says.

Don gives the tug's twin throttles a nudge. The engines churn. Prop wash boils white and green. Tug and barge drift forward again. The assist tug keeps the barge's backside tight against the stiff-leg.

"Okay, stop," Ken says.

Don quickly puts the engines astern and we come to a full stop. Mooring lines go over the side and two of the loaders begin their climb up wet steel ladders to control stations atop the cranes. At 0705, a weak sun finally crests the highest eastern ridge and two dozer boats are hoisted down from their heavy metal pockets on the barge's stern.

With steel grapples—crablike mechanical claws seven metres across—the cranes begin to devour their salty breakfast. From a distance, the dripping bundles of cedar look like bound stalks of asparagus. The loaders are Zen masters of the joystick with finely tuned eye-hand co-ordination and an acute sense of balance, weight and distance. It takes quite the knack to keep a barge level side-to-side and fore'n'aft while lifting and dumping 25-tonne bundles of wet wood onto a slick flat deck as fast as possible for three hours at a crack.

The grapples look like they might have been painted white at some point in the distant past. Now they're the colour of coffee. Streaked with rust, pocked, peeled and decorated with thousands of battle scars, they seem to be sweating salt water. Each of the cranes can lift up to 70 tonnes at a time. But these red and yellow cedar bundles are light—only 25 tonnes apiece. Some of it's old growth that's been standing dead in the forest for years, drying out from the top down long before it was cut. One of the loaders calls it popcorn.

And guess whose job it is to feed this popcorn to the grapples? It's the multi-skilled, multi-hatted cowboy Don Rose and his hardy sidekick, Murray Haines. Yes, the tug's master and his dayshift deckhand have taken the first turn on the dozer boats—those bucking, rolling, swirling water ponies that herd the floating bundles into the waiting jaws of the *Hercules*. Thrills, spills and power tools—this job has everything a man could want.

Dozer boats are used all over the BC coast, mainly on booming grounds where logs or bundles are being made into booms. To an outsider, the dozers look more like fun than work. But the longer you watch, the more obvious it becomes that this job puts every muscle and joint through a full game workout. These stubby, barrel-chested little boats have tough iron-ribbed hulls and a wheelhouse half the size of a phone booth. They've got a great big steering wheel with a suicide knob and a skookum motor that can swing the thing around 360 degrees in its own length and go anywhere in the blink of an eye. Good dozer operators can push several floating bundles together side by side so the loader up in the crane can snatch a bigger bite with the grapple.

Forty bundles in a bag boom. Two bags down, a whole bunch more to go. By 1030 this part of the load is on deck and the dozer boats are hoisted back aboard as we cast off from the stiff-leg and head down inlet

toward Gold River. Clouds are moving in now and that little fax machine in the wheelhouse has just disgorged a storm warning for our trip home.

Out of Nesook Bay, we churn back down Tlupana Inlet and hang a left into Muchalat Inlet. At 1325, approaching Victor Island (a tiny tree-clad stub of rock in the middle of the channel with a miniature house built to look like a lighthouse), skipper Don Rose decides to step on the brakes. We have arrived at the booming ground and the town of Gold River is just around the next bend.

But how, you might ask, does one slow down or stop in the middle of a narrow inlet when there's a 5,000-ton barge barrelling down behind you at 12 knots, a great big, tailgating barge with no brakes? Don decides to "take a turn out of it." He puts the *Captain Bob's* rudder hard over and turns both tug and barge completely around in a tight circle in the centre of the channel. A 360-degree turn in a distance not much longer than the barge itself. And that does the trick. It "scrubs off some speed" and we're ready to grab the rest of our load.

At 1357 Don has again snugged up the towlines, made the barge fast to the tug's stern and laid her up alongside the stiff-leg like an NBA all-star. Murray Haines and a boom guy with "Rotten Rod" hand-scrawled in large black letters across the shoulders of his lifejacket manhandle the three mooring lines. Each line is a five-centimetre-thick braided poly rope with a wire loop at the head end.

The wire loops have a shackle on the end so the boom man can quickly attach it to the ring on the end of the boom chains embedded in the stiff-leg. Even though the fat ropes are polypropylene and don't wick up water like the old manila hawsers did, they're still wet and heavy most of the time. So this part of the job definitely qualifies as grunt work.

By 1430, Murray Haines has earned a short break and heads down for a nap before his next watch—1800 to midnight. It'll take most of five hours to load this next bag of logs. Darren Towers and Ken Roskelley will run the dozer boats on this shift.

While on the phone, Don gets a list of the next five trips for the *Captain Bob*. Five more loads from Gold River have been booked back to back. Gold River to Ladysmith, Gold River to Port Alice, Gold River to Andys Bay in Howe Sound, etc. Fifteen more days at sea. The *Captain Bob* carries 640,000 litres of fuel and can go 20 days without a refill. There's plenty of food in the reefer, so the next little while looks like non-stop work.

For three hours, Darren and Ken ride their steel broncs through a herd of cedar, cutting bundles from the pack, shoving them under the grapple. They are dodging, rolling and bucking in the foamy wash and flotsam. Three hours on a heaving dozer deck is hard on the feet, legs and lower back. Caulk boots on a rubber pad are precious little comfort. There is a tiny stool, but who's got time to sit down?

With alarming regularity wayward logs that have broken free of their asparagus bundles manage to slip out of the grapple. The dozer shoves a bundle to within easy reach of the jaws, the grapple clangs shut and the crane begins to lift. Halfway to the sky this slick cedar spear breaks free and falls butt-first into the sea. This is no job for the faint of heart. Ken rounds up two more bundles side by side and shoves them forward against the barge, where the mighty grapple snaps them up, a 50-tonne bite of wood.

Halfway through loading at Gold River, rain starts to fall. First as a light drizzle, then a steady downpour. By 2040 the light has died and they're still jiggling bundles of wood back and forth, shuffling 25 tonnes here and there trying to get the barge trim. Judging by watermarks on her hull, the *Hercules* has a 10-centimetre list to starboard.

Several bundles are shifted to the opposite side. Now they've got the same list to port. Then back to starboard again. Split the difference. Finally the *Hercules* has settled into the water under the weight of 15,000 tonnes of wet cedar. She's "up to her marks" with a deckload of logs as high as a five-storey building and it's time to go.

The fax machine beside the chart table zips out the latest updated forecast for the west coast of Vancouver Island:

GALE WARNG CONT. WINDS SE 15-25 KTS RISNG TO GALES 35 TO 45 THIS EVE. A FEW SHWRS TURNING TO RAIN THIS EVE. RAIN AND FOG TUE LOWERING VSBY TO 1 MILE AT TIMES. SEAS NEAR 1 M BLGNG TO 3 TO 4 TONIGHT. OUTLK. VEERING TO STRNG-GALE FORCE SLY.

Strong gale-force southerlies. For the northern half of the island it's even worse: winds southeast 45 to storm force. The mouth of Nootka Sound, where we're headed, is a little more than halfway up the exposed west side of Vancouver Island, so that means we're headed right into the middle of this mess.

At 2121 hours on Monday, the two train engines rumble back to life and the loaders are ferried across

OPPOSITE
The *Sandpoint Chief* is dwarfed as it moves into position alongside the *Capt. Bob*.

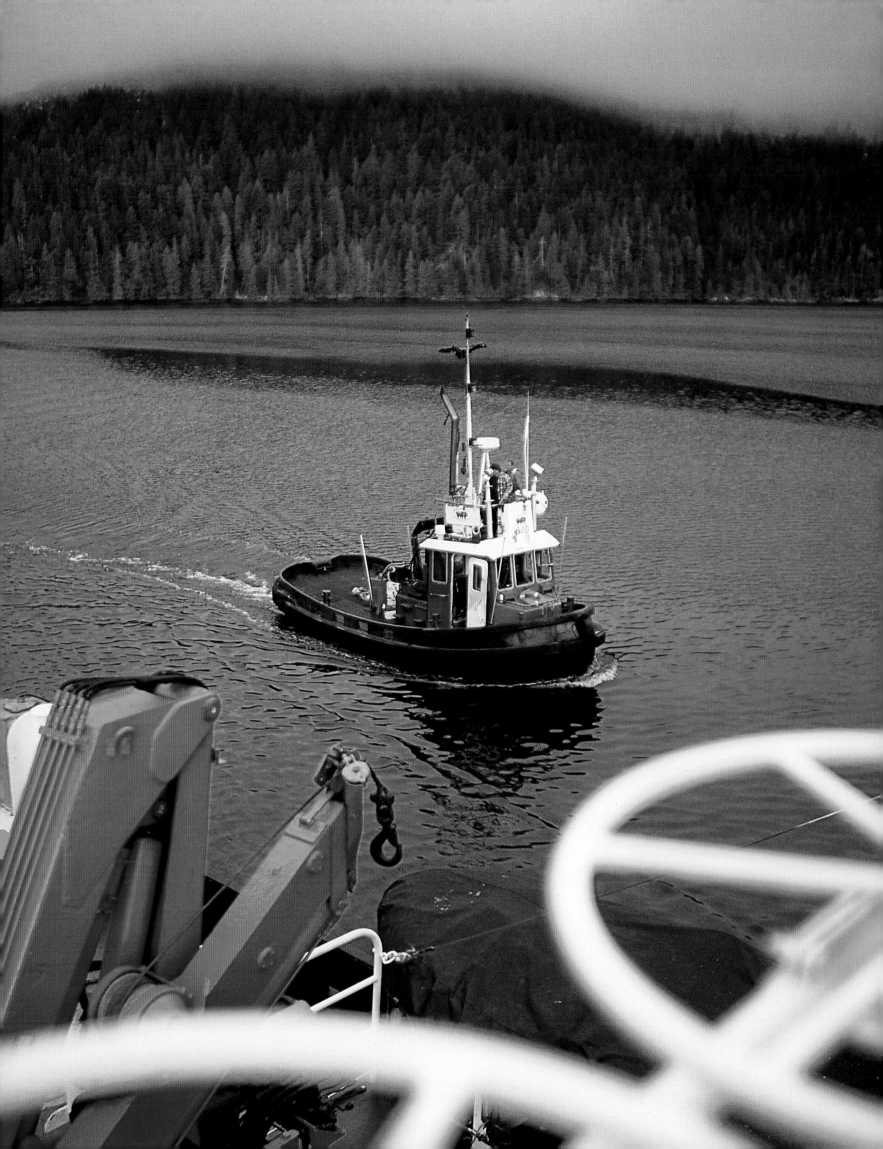

the inlet from the booming grounds to their motel rooms in Gold River. The *Captain Bob*'s mooring lines are hauled back aboard the tug and we pull away from the stiff-leg with a wide lazy U-turn into the channel. We've come and gone from this shutdown mill town without ever setting eyes on the place.

Don Rose and Murray Haines, in dripping rubber jackets, stand at the aft control station on the platform deck behind the wheelhouse. The skipper glances over his shoulder toward the bow and squints through pelting rain to see that we've reached mid-channel. Then he checks the barge to see that she's following in a straight line. Haines spins the big white horizontal wheels that release the brakes on the two towlines. Somewhere between 275 and 300 metres of cable is spooled out as the tug churns away into the long night.

With this storm it'll be a 30-hour run to Howe Sound, where we'll unload. Don cautions that the *Captain Bob* tends to roll a bit, even in a one-metre swell. It's just the shape of her hull and the fact there are no "bilge keels" for extra stability. At least we've got a lot of fuel aboard and we're hauling a fully loaded barge, which should damp out some of the ride. But now we're running headfirst into 3.5-metre seas.

The skipper tries to make a joke of it. "The good news is: she doesn't roll much more in a 50-foot sea than she does in a three-foot swell. She takes a following sea better." Comforting to know, but...

Captain Rose sends his deckhand into the black and slanted rain again to slip out a little more towline. "Three white marks, please, Murray." Each towline made of high-tensile steel is 6 centimetres thick, 915 metres long and weighs roughly 16 tonnes. Three dabs of white paint on the rusty brown wire spinning off the drum indicates roughly 550 metres of line between tug and barge. With that much towline out, Don figures there's a 30-metre catenary (sag) in the cable. A skookum enough shock absorber to make sure the lines don't go "bar tight" and snap in some midnight storm surge.

At 2315, as we approach the mouth of Nootka Sound—and the open Pacific—we start to feel her roll. And buck. And swerve. And dip. And we know this is just the beginning. The beam of the Nootka lighthouse comes bouncing and skidding across whitecaps with horizontal raindrops captured in its sweeping glare.

The wheelhouse at night on a dark black sea is eerie.

Sandpoint Chief skipper Jim Fraser steers with boot as deckhand Rob Watt keeps weather eye on the towering **Capt. Bob.**

Disorientingly dark. The first thing you're drawn to is the firelight glow of the radar, which has been switched from green to dim orange for better night vision. The engine speed indicators are bright red digits: 845 RPM on each of the two big diesels. Then you catch the green haze of salt spume from the bow illuminated by the starboard running light. Over the stern, the green and red running lights of the barge look a long way off in the distance now.

Shortly before midnight first mate Ken Roskelley comes up the companionway to relieve the watch. He's had only a few hours to nap after punching logs through the late afternoon and early evening. Now he faces six hours of dirty weather.

As the *Captain Bob* wallows through the gale, there's a booming, metallic sound like a mallet hammering on a steel drum. The salty tang of pounding surf has been sucked in through the air vents. A very pleasant effect. The rolling swing of the bunk feels almost like a hammock. It's actually not bad. It's the end of a very long day.

Tuesday morning, plowing down the outside coast of Vancouver Island, the storm is hitting us almost broadside with 1.5-metre swells. At about 1500 hours, the gale shifts around to southeasterly as we turn back down Juan de Fuca Strait. Now the sea is hitting us head-on again. The monotony of the swells continues. There is little comfort in knowing that the storm is much worse on the north end of the island. Hell, it almost always is up there. That's where they invented horizontal rain.

Tuesday at 2119, we've come around the bottom end of Vancouver Island again, past Victoria, and are heading back up Haro Strait. We're bucking a strong ebb tide as Captain Rose makes his turn into Boundary Passage. There are back eddies here that could easily grab the *Hercules* and spin it into the opposing current. Shearing from one powerful current into another running the other way—and then back again—could tip the barge and dump the logs. But not this time. We skirt the edge of the vortex with hardly a flutter.

Don Rose says predicting the behaviour and velocity of a tide rip is a refined art. "The published tide and current tables are usually considered accurate because they are the only available yardstick. But the tables only calculate the effects of the moon and the sun on the water. That much is consistent and predictable. Other less predictable things like wind, rain, river freshet, barometric pressure—all these things have a tremendous effect on the tide and current." In other words, grey hair and local knowledge win the day.

Finally, it's 0500 Wednesday and we have arrived at Andys Bay in Howe Sound with the equivalent of 70 to 80 sections of logs—roughly 3.5 million board feet of red and yellow cedar. Don glances out at the liquid sunrise and shrugs. "You can always tell when it's time to go back to work. It starts raining again."

Once again the towlines are shortened and the *Captain Bob* turns big lazy circles in the bay waiting for the assist boat to arrive. The *Rivtow Hawk* puts Ken and Murray aboard the *Hercules* to begin "pre-flooding" the portside "tipping tanks" with seawater in preparation for a "controlled dump."

The crew of the *Hawk* starts a fire pump on its bow, aims the water cannon at the *Hercules* and begins hosing the barge deck to make things nice and slick. By 0650 the tipping tanks have been flooded and the *Hercules* has heeled over on her side. Way over. Looks like she's about to capsize. A gazillion logs piled five stories high wait for the last bit of friction to wash away on a wet steel deck. One last little molecule of sand will dissolve, one final scab of bark will slip...

A heavy mechanical clank causes all eyes to turn in unison and a few of us to flinch. But it's only one of the *Hercules*'s claw-like grapples wobbling, shifting in its big metal pocket beneath the crane. "The barge is talking to herself," observes the skipper. "Sometimes those dozer boats will shift too and that'll really make you jump."

Darren Towers and Don Rose pace the platform deck behind the wheelhouse in a steady downpour. Darren takes up his position, hands poised on the two hand-brake wheels, ready to slack off the towlines in a hurry. Once the logs dump, the barge will want to dance around a bit. Actually what happens is the barge comes out from under the logs with a fast dash sideways. The towlines have to be released or it will pull the tug over. Big as the *Hercules* is, you gotta give 'er some respect and a whole lot of room.

The *Hawk*, with a line to the barge's stern, acts as an anchor to hold *Hercules* in place while the *Captain Bob* pulls slack out of the main towline. The heavy wire rope rips out of the chuck—bar tight—like a bowstring. They're holding the *Hercules* steady from both ends now. A yellow dozer boat is standing by near the shoreline, ready to corral the bundles when they come off.

Tediously, the portside tanks continue to flood. The barge has tilted so far now, the first metre or two of overhanging logs are poking into the sea like a

Captain Don Rose plots his course to the next stop. Even aboard the mighty *Capt. Bob*, Rose relies on long experience to gauge the ever-changing forces exerted on his tug and its tow. Tide tables, he notes, don't track "wind, rain, river freshet, barometric pressure—all these things have a tremendous effect on the tide and current."

thousand bladeless paddles. On the barge's bow a brown rust stain starting with the letter R in *Hercules* shows how far over she usually tips before the logs let go. Ken and Murray, aboard the barge, are waiting for their wild ride to begin. It can take an hour—sometimes two—for the tipping tanks to fill and the logs to dump.

Sometimes log barges will lose stability early and the logs are dumped with too little water in the ballast tanks. This results in a "violent" dump and is very hard on the equipment. The slower the dump (i.e. the more ballast) the less violent the motion. There are some occasions when the ballast tanks are full and the barge still won't dump. In the past some tug skippers resorted to explosives to help matters, but this tactic often resulted in damage to the barge. One answer is to right the barge again, shift some of the logs and try again. Even when the barge dumps successfully, logs are sometimes still left on the deck. If there are only a few, a small tug can pull them off one at a time, but if there are too many, the loaders will be called back to take them off with the cranes.

At 0715—with absolutely no warning—the load grumbles once and lets go. With a thundering, scraping crash, multi-millions of dollars worth of logs dive-bomb into the water. The *Hawk* drops her line. The barge lurches sideways and swings in a fast, wide arc over to starboard. Then back to port. Then to starboard again. And she shoots forward like an arrow aimed directly at the big tug's backside.

But the skipper knows it's coming and his deckhand has already slacked the towline. Throttles ahead, a jet of hot diesel exhaust, a boiling rush of white wash from those three-metre props—and we're out of there. Remarkably quick for her size, the *Captain Bob* scoots away to one side with nary a scratch, as if she does this all the time. Which, of course, she does.

What took an entire morning and half the night to load in Gold River is "control dumped" in about an hour. The bundles remain more or less intact, stacked atop one another, floating quickly across the bay toward their final roundup.

Like all barges, as soon as it has dumped, the ballast tanks begin draining, allowing the listing barge to return to an even keel. On most log barges, the ballast tank's bottom is higher than the light draft line of the barge, so that the tank drains by gravity, but on other barges the tank must be pumped dry.

As the *Rivtow Hawk* and the dozer boat begin closing up their boomstick corral, the *Captain Bob* makes its turn for the Strait of Georgia. The *Hercules* still has a significant list and it isn't until the tug is 15 to 25 kilometres into her next Gold River run that she will return to level.

NEXT PAGE Unloading: It's amazing how far the *Hercules* must list before the logs rumble into the sound. A rust mark at the 'R' in her name on the port bow reveals her usual tipping point.

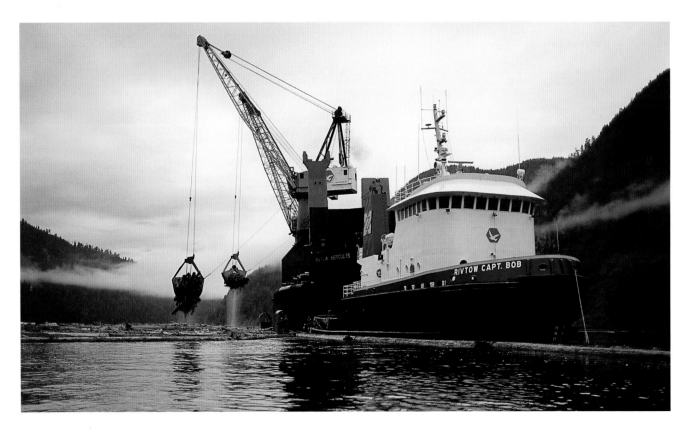

Loading: Dozer boats herd bundles into the *Rivtow Hercules* as grapples scoop up to 50 tonnes of dripping wood at a bite.

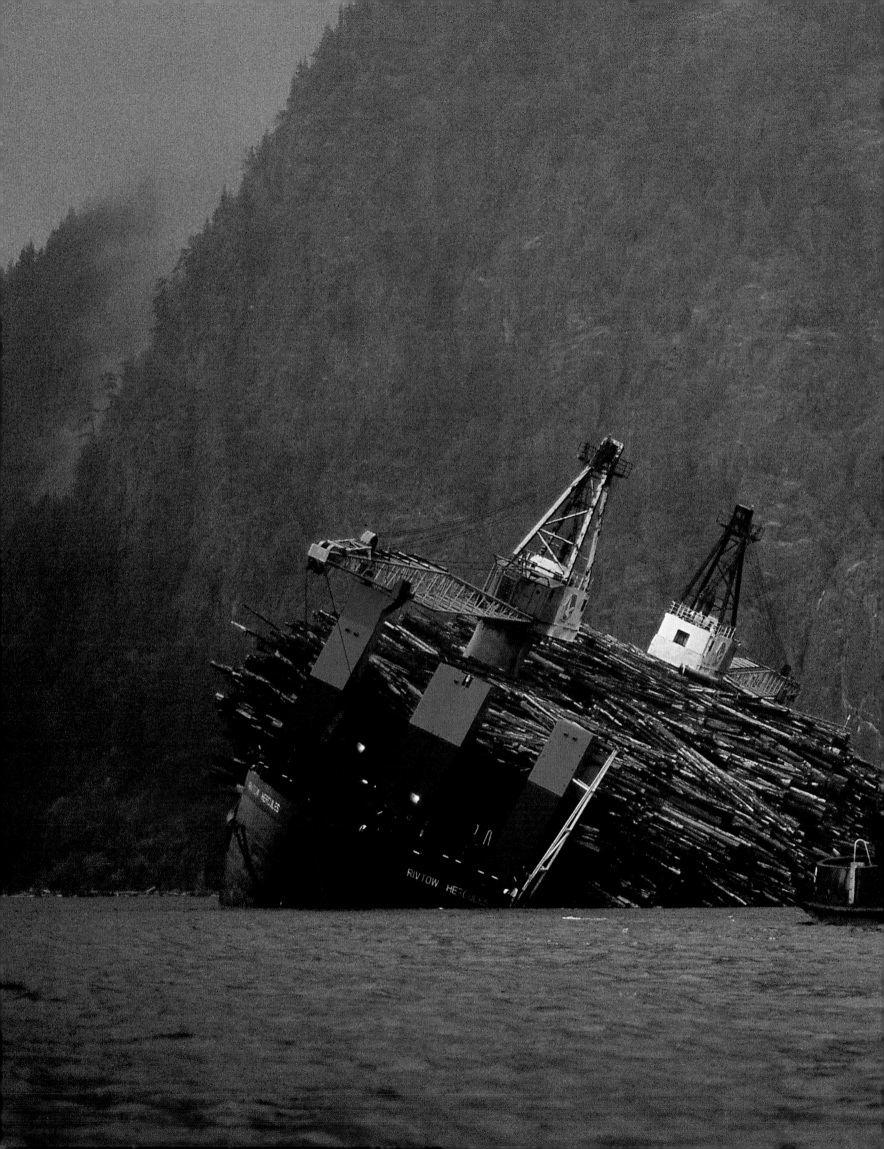

RIVTOW CAPT. BOB

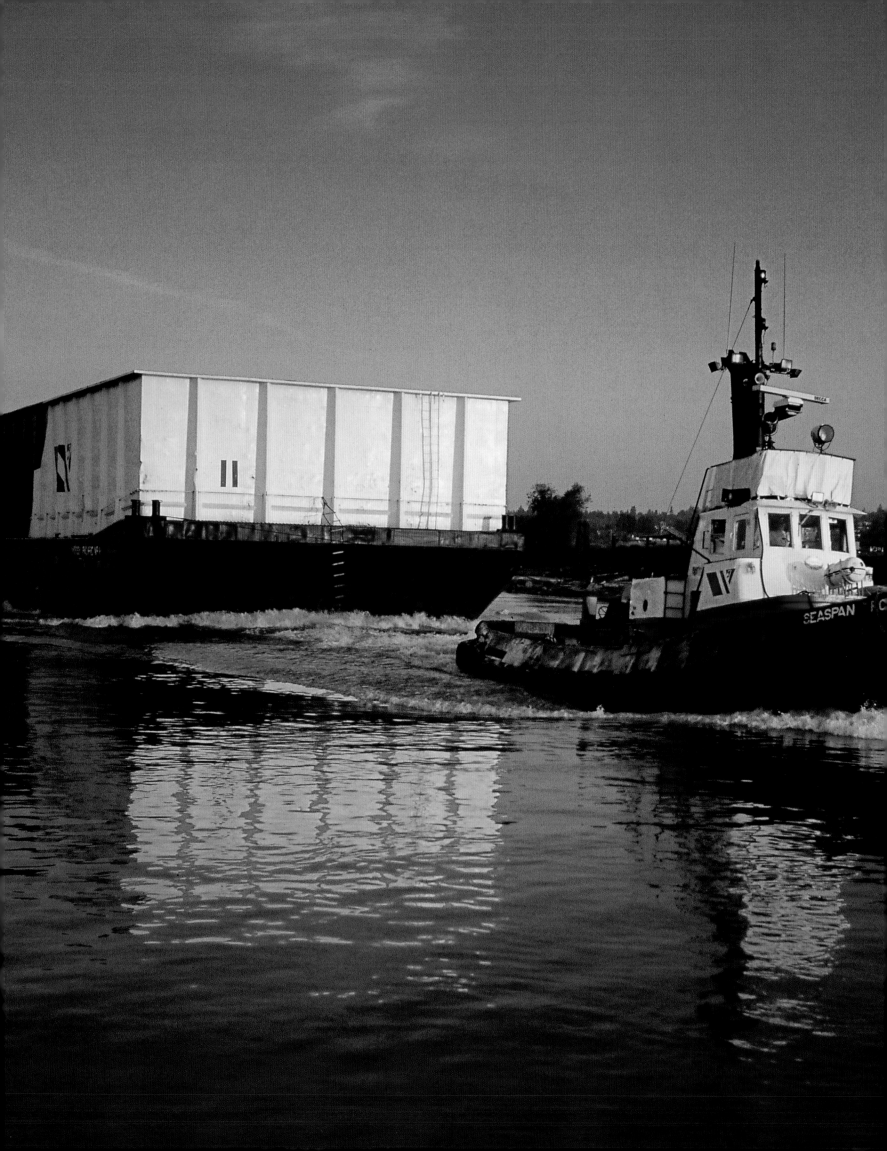

3

DAMNEDEST CARGOS IN THE DAMNEDEST PLACES

B arges are simple vessels. They are not as seaworthy as ships, but in the thousands of kilometres of protected waters along the Inside Passage, that doesn't so much matter. They are far less expensive to build and maintain than a ship, they can carry anything and they can be used in shallow waters or nosed into the beach. They are tough and can be banged around in the course of hauling rough cargos like stone, logs or bulldozers. Because they have no crews or operating overhead, they can be parked indefinitely while waiting to be loaded or unloaded. These simple advantages guaranteed the humble barge—and its accompanying tug—a critical role in the movement of cargo along the BC coast.

The 18.2-metre *Seaspan Trojan* pulls empty chip barges along the Fraser early in the morning.

OPPOSITE
Big chip barges, like big dogs, are easier to control on a short leash. Navigating the Fraser delta, a tug shortens its towline; note the towing bridle hooked to bollards on each corner of the scow.

BELOW
Day breaks dead calm at the Point Grey barge tie-up.

The first barges were simply the gutted hulls of obsolete sailing ships. They were clumsy under tow and often required a crew on board to steer them. Much heavy freight, like logging donkeys and bunkhouses, was also shifted on special "moving floats" constructed of buoyant cedar logs lashed tightly together with cable. A construction standard for the true barge gradually evolved by the early years of the twentieth century, most being built of heavy timbers and thick planks with flat sides, raked ends and sealed decks. Some had cargo boxes built on top. Others had skegs installed at the stern to improve tracking—the ability of a barge to hold a straight course at the end of a towboat's towline.

Durable as they were, these doughty old wooden barges posed maintenance problems as they aged. With steady damage from the heavy cargos they carried and from collisions with beaches, docks and tugs, it was difficult to keep the topsides tight, and in heavy seas they took on water. If not pumped in time, they might sink or list until they dumped their loads. High-volume barge pumps became fixtures in the barge towman's arsenal and rigging up the pumps was a regular ritual to go through before daring to leave the tie-up. Nowadays most of the barges you see bucking along the BC coast are made of steel, which is proof against most of these perils and lends itself better to the huge dimensions now in demand.

Listing the uses barges have been put to over the years would fill a book much thicker than this one. One of the early applications was for transporting coal from mines on Vancouver Island to the urban centres of Vancouver and Victoria. When stone was an important building material, rock barges working out of quarries up Howe Sound and on Haddington, Nelson, Hardy and Texada islands represented one of the more common tows. Barges saw much early use in the fishing industry for hauling mobile fish camps and support gear, as well as for packing fish. Many processing plants and net lofts were perched upon their own permanent barges.

In the forest industry, barges came into early use for moving camps and equipment from one roadless, dockless bay to the next. When the first pulp mills started up around the time of World War I, they became the biggest single user of barges, hauling in chlorine, caustic soda, hogfuel and chips and hauling out baled pulp and giant rolls of paper in special covered barges that never seemed to miss a trip no matter what the weather. In the last 30 years, coastal

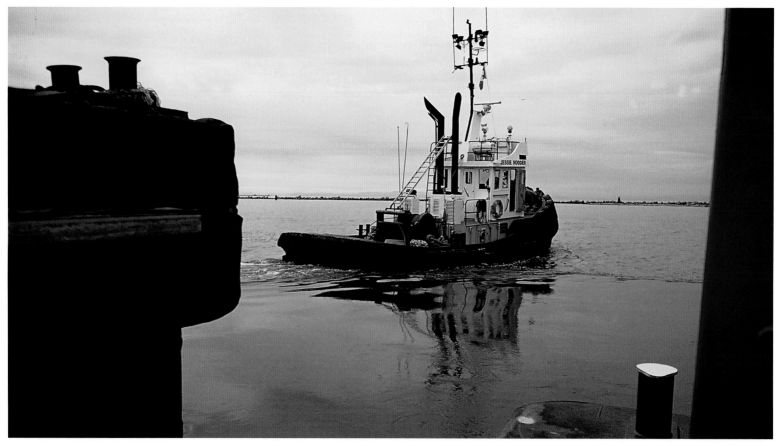

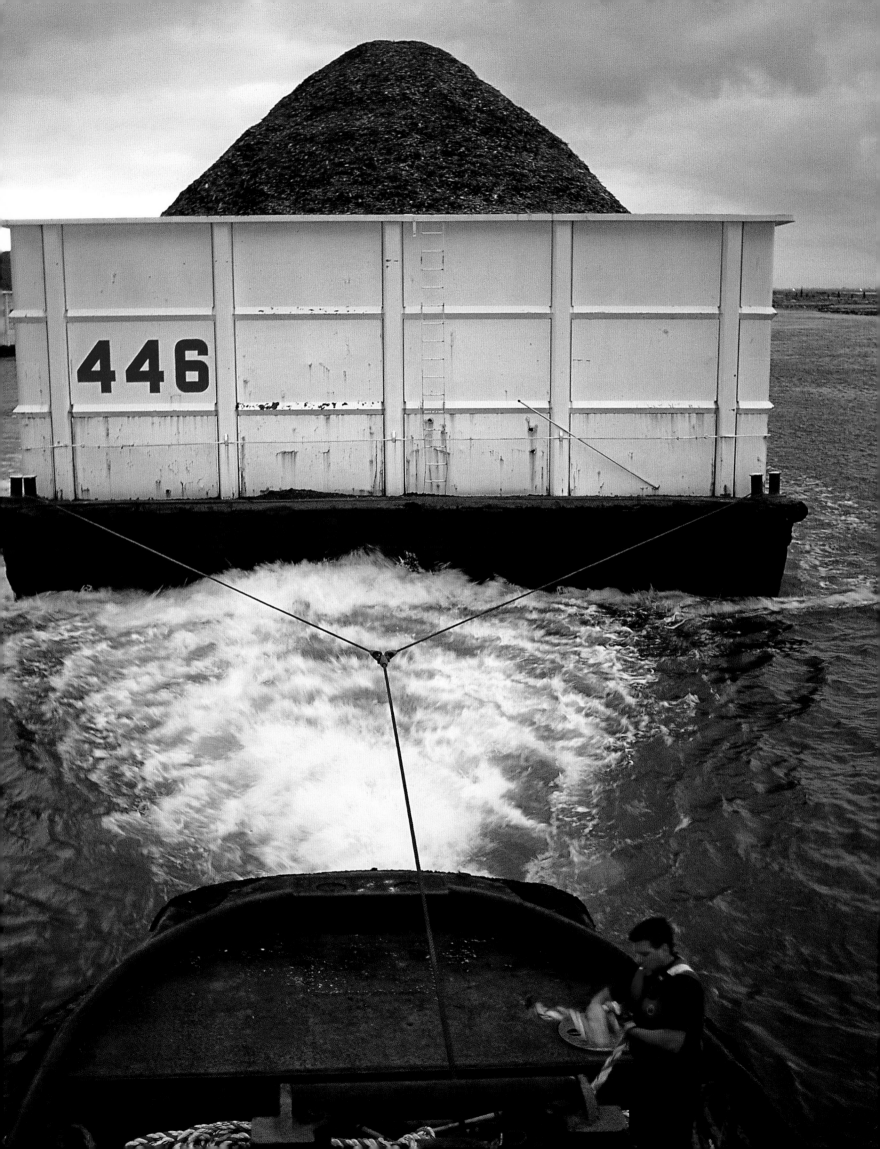

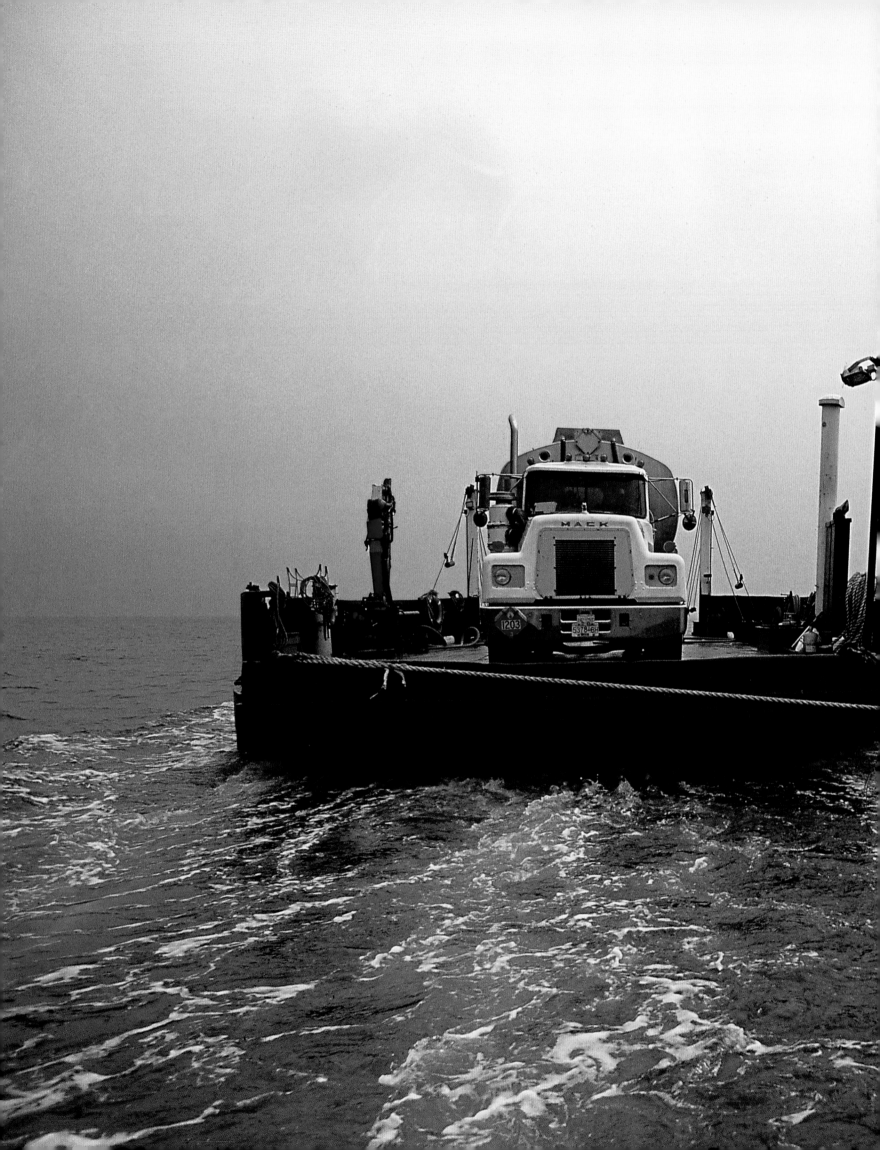

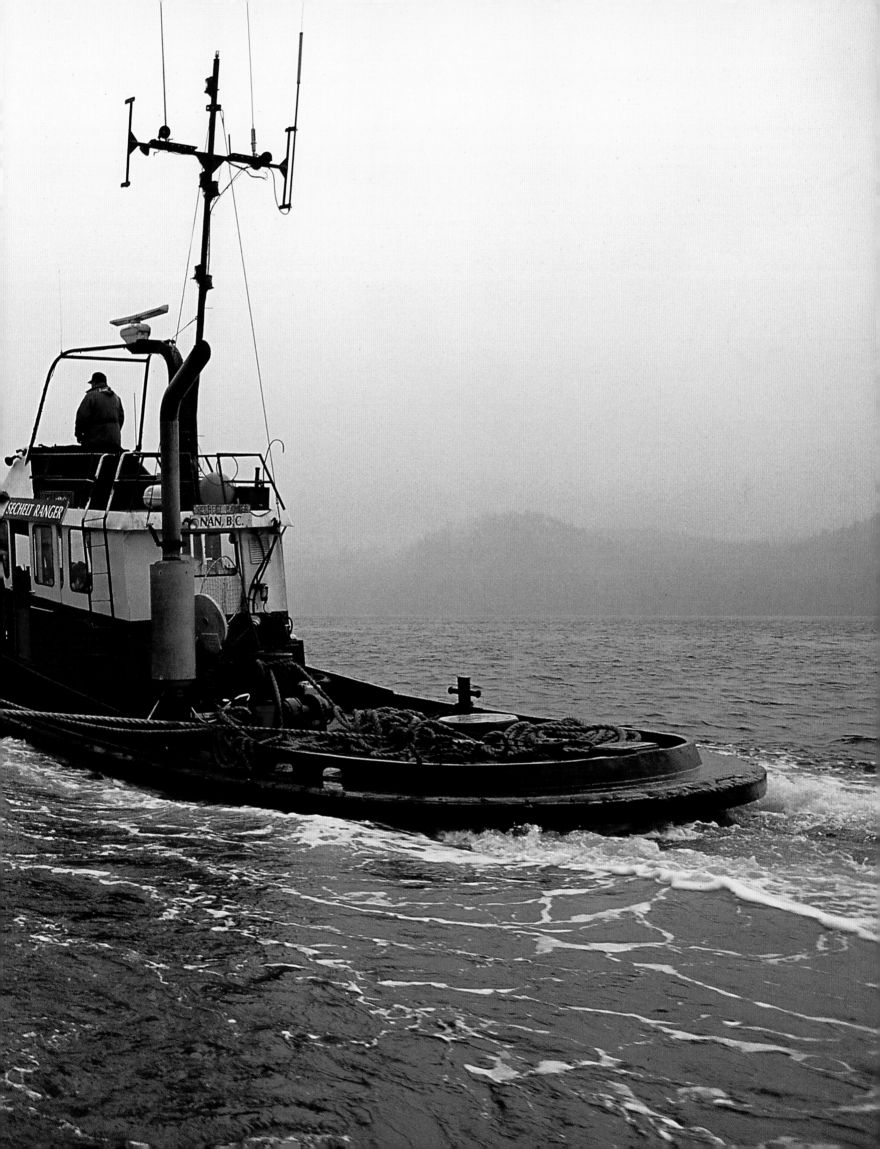

PREVIOUS PAGE The *Sechelt Ranger*, based in Tofino, barges a fuel truck to serve fish farms on the west coast of Vancouver Island.

mills have become more dependent on chips shipped in from sawmills in the Lower Mainland and the BC Interior, and this created a huge demand for chip barges—jumbo steel hulls with wooden walls about 3.5 metres high around the edges to contain the loose piles of flaked wood. The latest "chippers" are 65 metres long, 16 metres wide, and can carry 3,000 tonnes of chips. A tug of reasonable size can tow three chippers at a time.

Modern cities are built largely of gravel and powdered limestone, and barges have long been the transporter of choice for moving gravel and limerock from pits up the coast down to the populated centres. Specialized 120-metre barges with heavily reinforced steel decks and low cargo boxes carry limestone from the great quarries on Texada Island to cement plants on the Columbia River.

When railroads first started arriving in Burrard Inlet, they found they could extend their services to many rail-less communities around the coast with the help of special roll-on, roll-off barges fitted with tracking laid into the deck. Modern rail barges run up to 120 metres long and have up to five lines of track on deck with a capacity for more than 30 freight cars. When they became established, trucking companies followed the

Pacific Cachlot's 10-metre *Shaymar* hurries to assist a log tow.

example of the railroads, and now regularly scheduled truck and trailer barges operate out of Vancouver to Vancouver Island, the Sunshine Coast and points north.

And of course, anywhere there is anything else going on, fuel is getting used, so there is a steady traffic of fuel barges in and out of every coastal community, whether a city or an isolated settlement. These barges can be highly customized, with separate tanks for the different products, pump-out systems, and double bottoms in case of accidental rupture. Many fuel barges have a notch in their sterns into which the tugs fit their reinforced, fendered bows, pushing rather than pulling. Regulations require that tugs handling the fuel barges have twin power for added safety.

Apart from the more common freights, barges have been put to 1,001 improvised uses as varied as coastal life. They've moved garbage, water, dynamite, oysters, herring, dredges, pile drivers, heliports, shake bolts, salal leaves, bridge spans, concentrated ore, whole live-stock herds, fish-farm pellets, the drill rig used in the unsuccessful attempt to blast away infamous Ripple Rock, and every sort of building from the warm-up shack used by log-birlers at Expo 86 to the Cracroft Hotel to Premier Bill Vander Zalm's ersatz seventeenth-century castle.

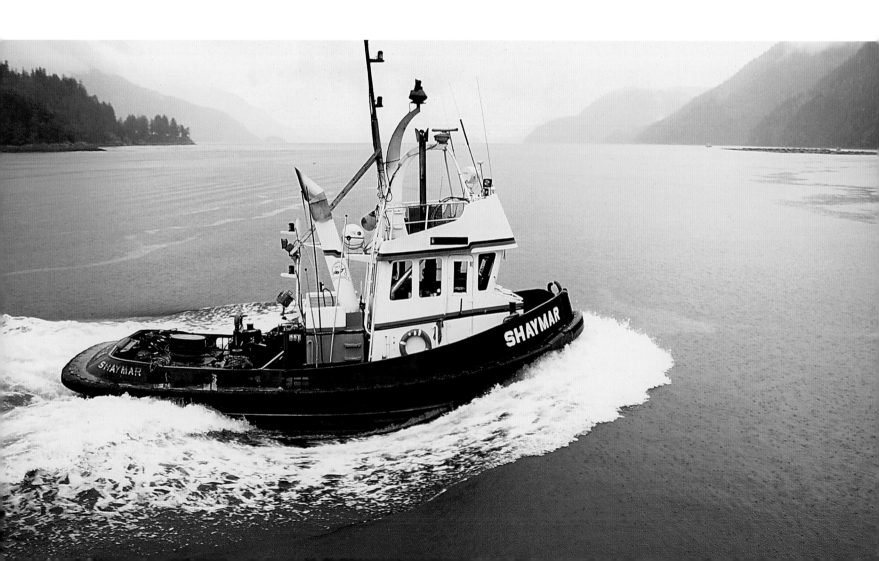

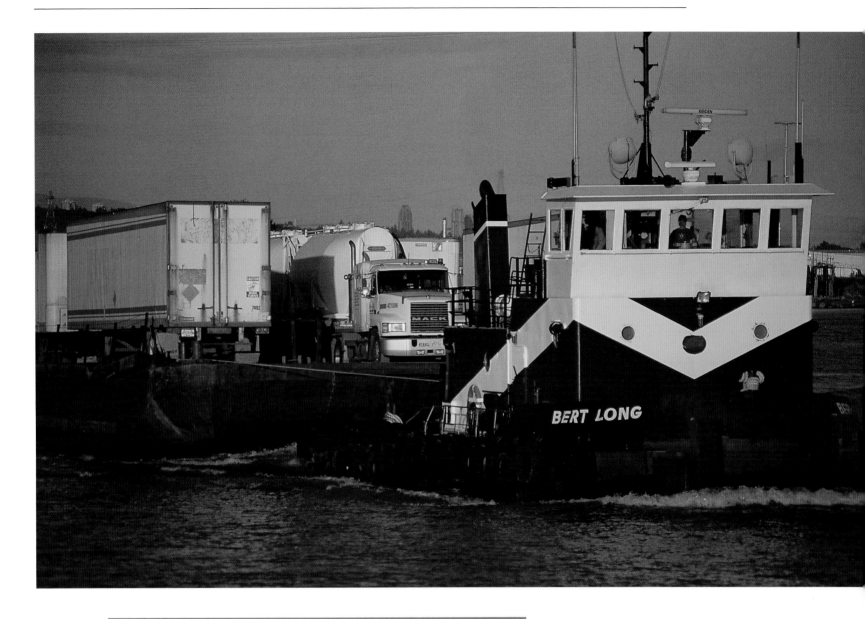

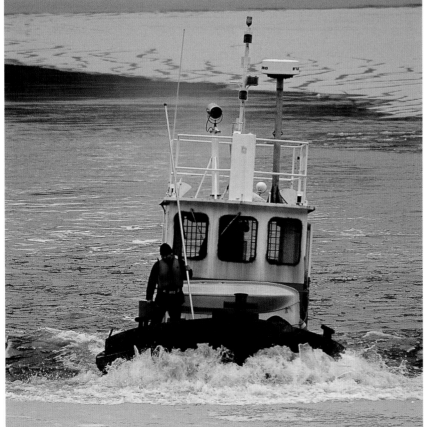

ABOVE
Mercury Launch & Tug's 20-metre *Bert Long* shifts barge-loads of trucks and trailers between Vancouver and the Sunshine Coast.

LEFT
On a bitter morning the *Castle Lake* crunches through ice at Kitimat.

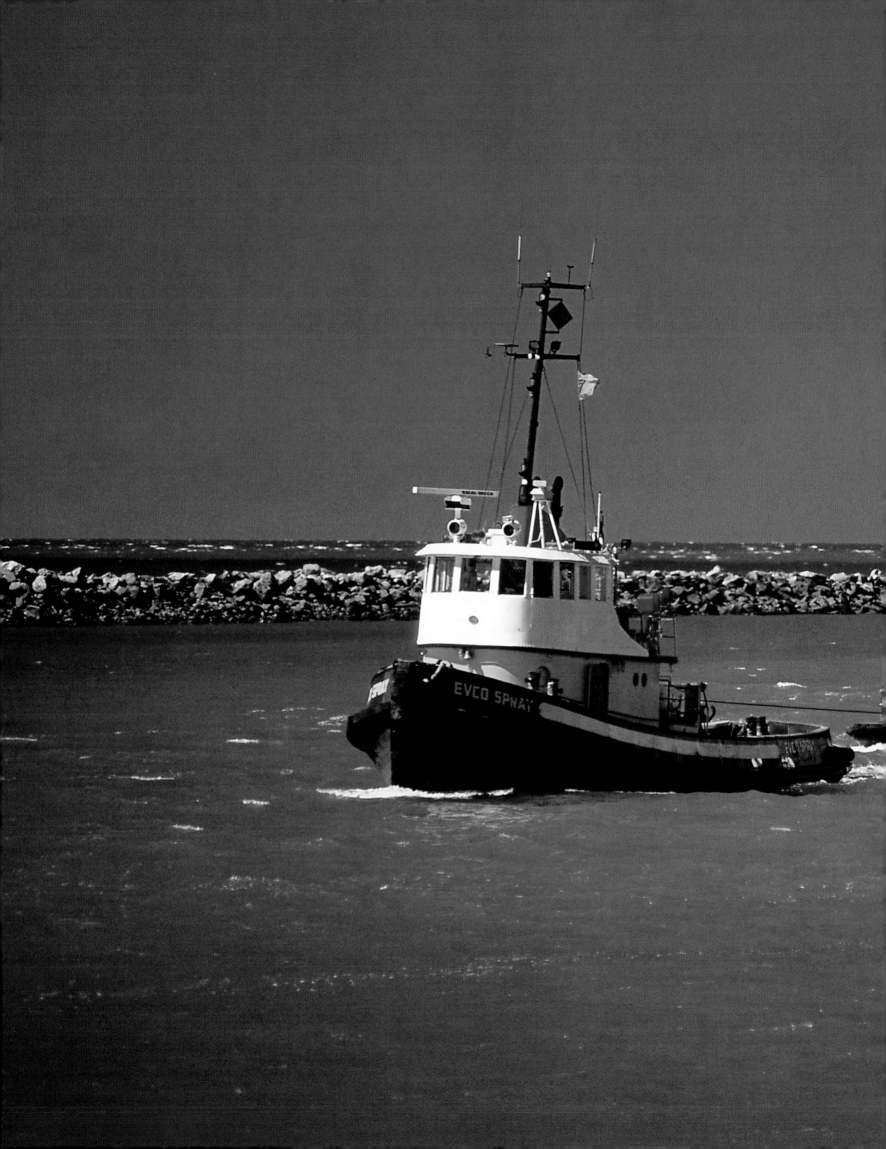

PREVIOUS PAGE
The 20-metre *Evco Spray* heads past the Fraser jetty with a gravel barge.

RIGHT
Deckhand Norm Finley looks to the dock as the *Jessie Hodder* prepares to cast off from the Hodder docks in Richmond.

BELOW
Mercury Launch & Tug's 12-metre *F.W. Wright* muscles a broad barge laden with general cargo.

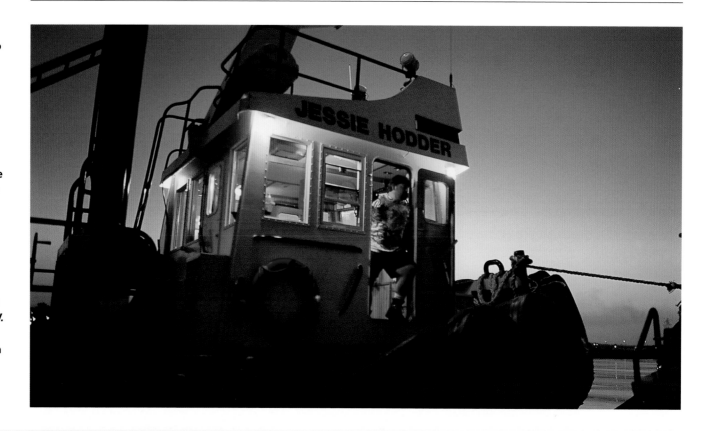

LEFT
With the *Jessie Hodder* under way, Norm Finley looks back at the tow.

BELOW
A night-shift deckhand stands lookout as a coal ship docks at Roberts Bank.

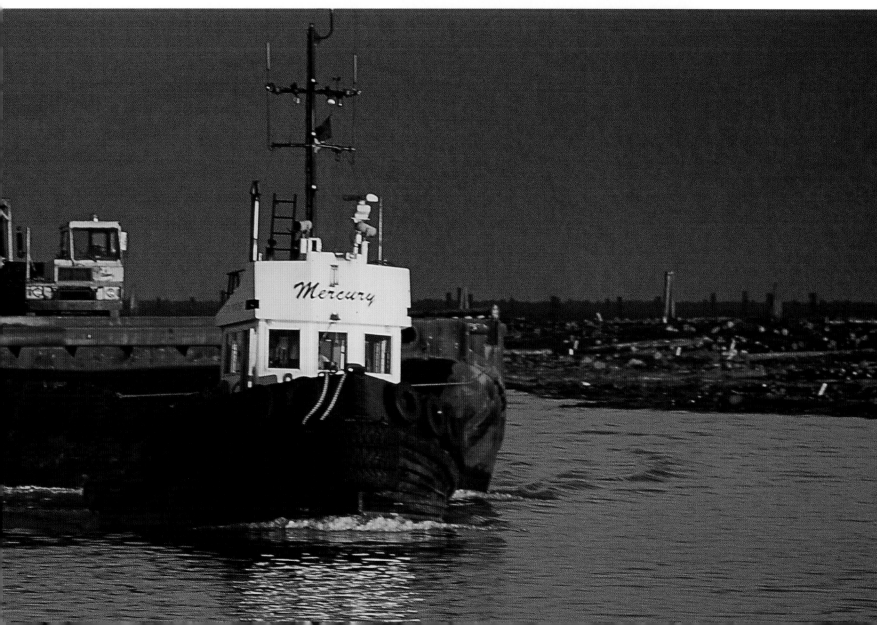

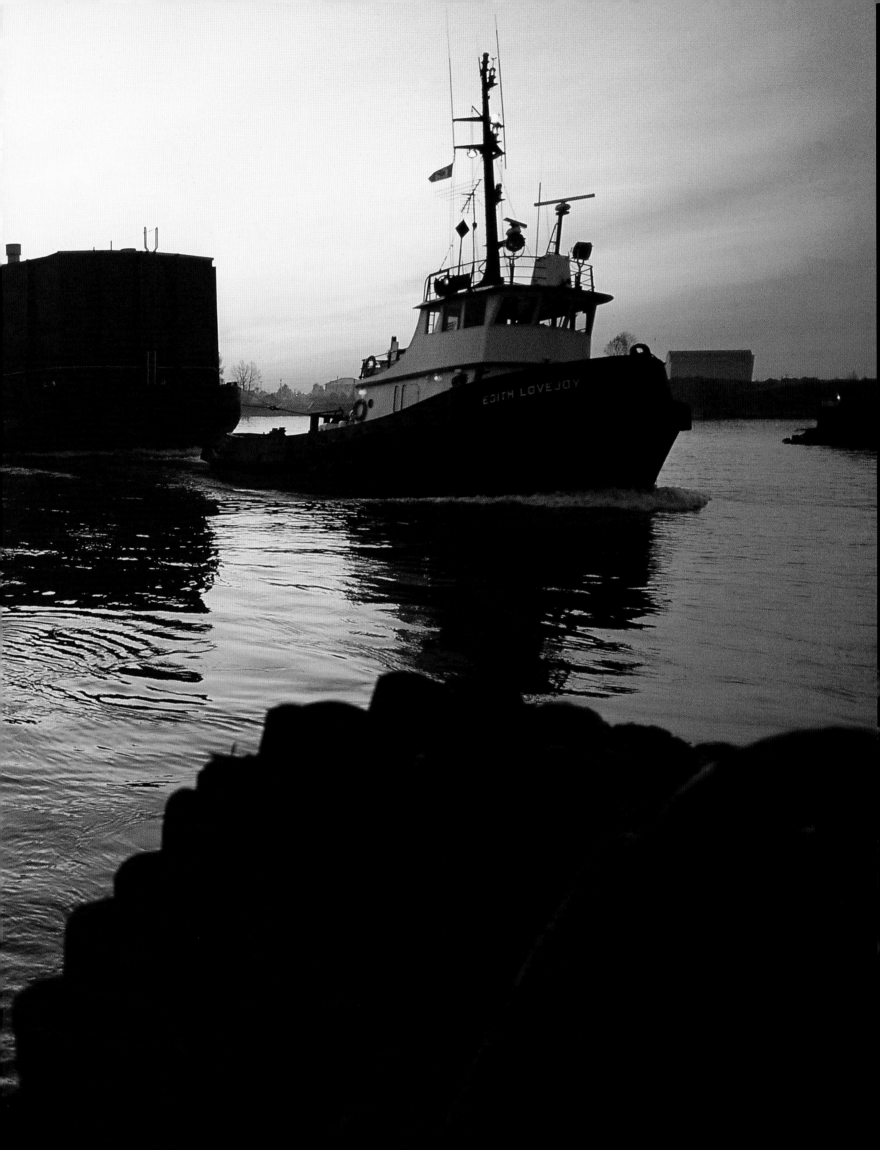

But this is a book about tugs, and the point is that for every one of these multifarious roles played by barges, there had to be a tug involved and there had to be a tug crew planning the moves, checking the tides, figuring how to unload the damnedest cargos in the damnedest places, and desperately trying to get home alive. Barges drag tugs into some of the most varied and interesting work, but also some of the most dangerous.

Coming away from the dock near the south foot of Hudson Street in Vancouver at 0530, it is hard to see much of anything. Darkness on the North Arm of the Fraser River hides all but the obvious. In the compact wheelhouse aboard the *Seaspan Trojan* only one thing stands out—a small black plaque glued conspicuously to the window jamb just below the tide chart: "A collision at sea can ruin your entire day." A friendly reminder for skipper Brent Gilker and deckhand Shawn Kelly that hauling big steel barges up and down the river or out in the Strait of Georgia is a potential "contact sport" with a dangerous downside.

A voice on the radio crackles through the wheelhouse. After a cheery good morning, the Seaspan dispatcher rattles off the first order of business, "I want you to run light to Point Grey for a picture. Look for *446*. You'll be meeting the *Texada Crown* coming out of the harbour with two for Mellon."

Translation: the skipper's marching orders are to head downstream "running light" (with nothing under tow) and to draw a verbal "picture" for the dispatcher, who is sitting in a building on the north shore of Vancouver Harbour where he can't possibly see the river himself. The picture will be an updated listing of all the barges tied up by the overnight crews in the moorage spaces just inside the rock jetty at Point Grey, at the mouth of the North Arm.

After that, Brent and Shawn's next job will be to drag the 2,000-ton barge *Seaspan 446*, full of wood chips, from its wedge-tight parking spot at Point Grey. They will tow it across the morning chop on English Bay toward Point Atkinson and hand it off to an outbound tug already pulling two other barges. There, the trick is to juggle the three huge hulks into a single, straight-line tow—all without interrupting the tow in progress from Vancouver Harbour to the pulp mill at Port Mellon in Howe Sound.

Deckhand Chris Hodder gets ready to jump from tug to barge.

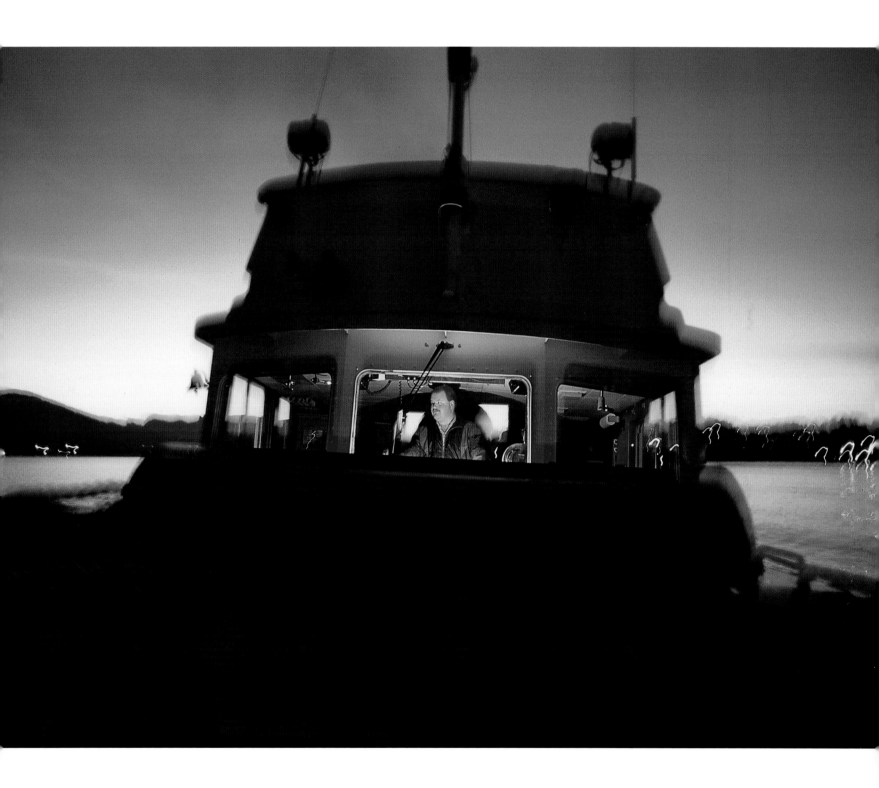

**Cates skipper Walter Moffat takes the night
shift in Vancouver Harbour.**

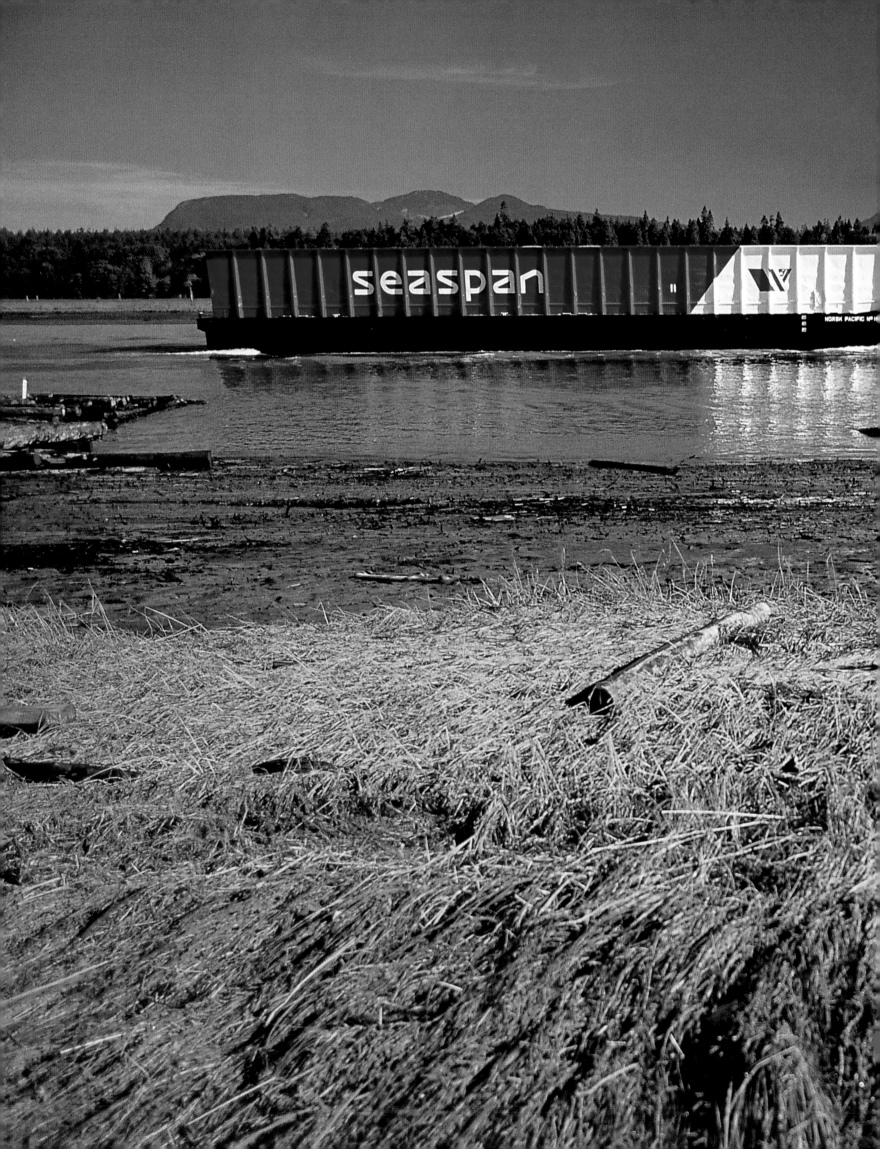

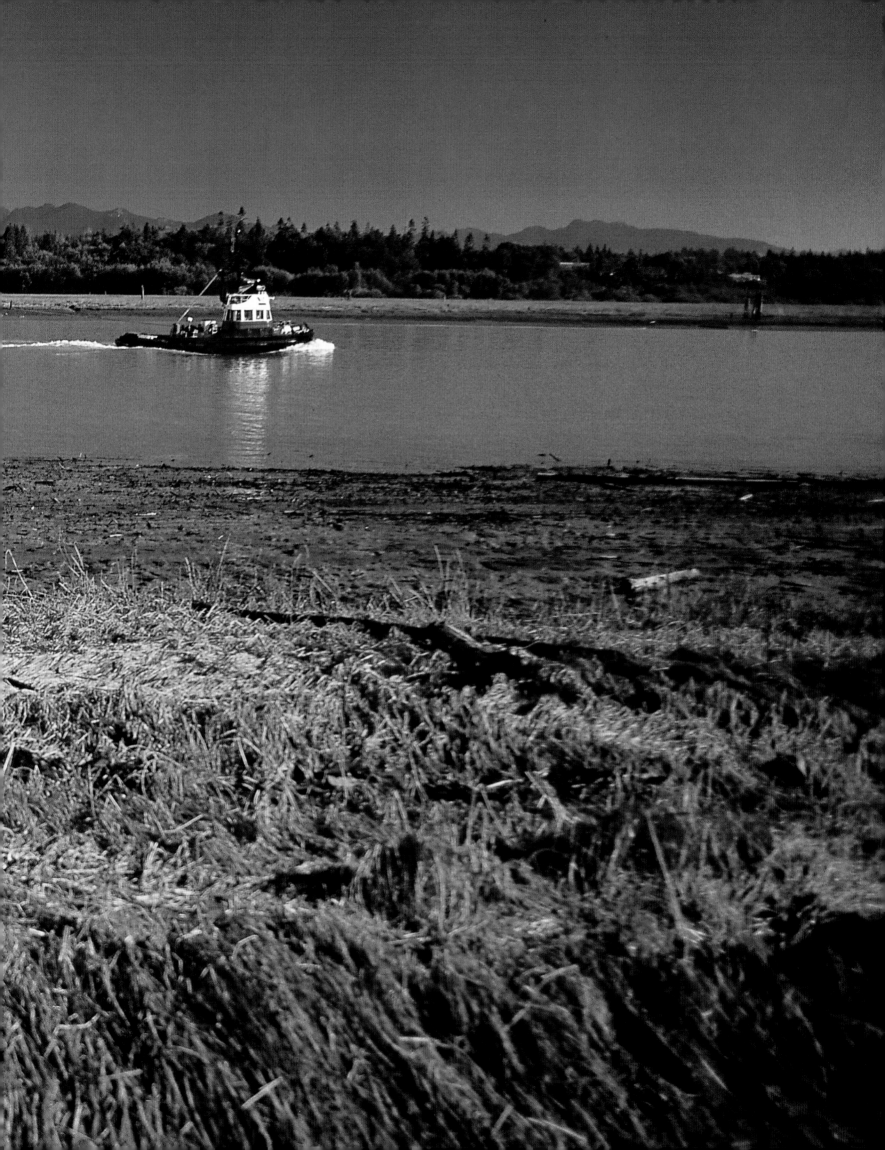

**PREVIOUS PAGE
A Seaspan tug
and barge ride
high past mud
and eelgrass
along the Fraser.**

The 20-metre, 1,100-horsepower *Seaspan Trojan* was originally built as a pilot boat back east. She was converted to tug duty in later life. Her wheelhouse is a tad wide for working in close to barges, she's not as manoeuvrable as modern tugs, and visibility out of the back of her wheelhouse is limited. This makes operating the *Trojan* a bit of a challenge, but the Seaspan crews have adapted to its little quirks.

Running light down the North Arm, Brent and Shawn coffee up and get ready for the job. Past the airport on the left, past a row of expensive riverside homes, past the golf courses, the dense black forest of the Musqueam Indian Band lands, beneath the tall woods of the University Endowment Lands, along the tide flats they go. Past hectares of bundled log booms tied to pylons in the mud along the rock jetty, then across the river channel to the big barge parking lot just east of Wreck Beach at Point Grey. It's like an aquatic parkade, with red, white and black Seaspan chip scows tied side by side in a double row for almost a kilometre along the riverbank.

**The day's work
done, a
Wainwright
Marine tug
heads home to
Prince Rupert.**

After a quick tally, Brent grabs the mike to call his dispatcher. "Seaspan, the *Trojan*. I'll go right up the sticks. The whole place is packed. No spaces..." He calls out the hull numbers of the 14 barges, a pair of them tied to

each piling or "stick," with no empty slots available at the moment. The dispatcher now has his picture.

Brent then slides the *Trojan* alongside *Seaspan 446*. Shawn steps across the gap from the stern of the tug to the port side of the barge. First he unwinds the figure-eights of thick poly rope that tie the *446* to the other barge—which is tied to the piling. With the *446* floating free, Shawn uses his pike pole to reach back across to the tug's stern, where he snags the first half of the towing bridle.

He drops the loop of wire rope across the bollard on the port bow. Then Brent eases the *446* out of her berth at a 45-degree angle. As soon as the *446* is out in the open, Brent veers back to starboard—across the front of the barge—so that Shawn can snag the other half of the towing bridle. He slips that loop over the bollard on the starboard bow—and they are ready to go.

Shawn leaps back across the gap and the *Trojan* pulls away, while another tug with another Seaspan scow waits patiently for the empty parking spot. The sun climbs through fir and cedar crowns on the cliff above Wreck Beach as the 100-ton *Trojan* surges against more than 2,000 tonnes of steel barge and wood chips.

"There's a kind of freedom on the river," Brent says, sipping the cold remains of his coffee. "I like the solitude,

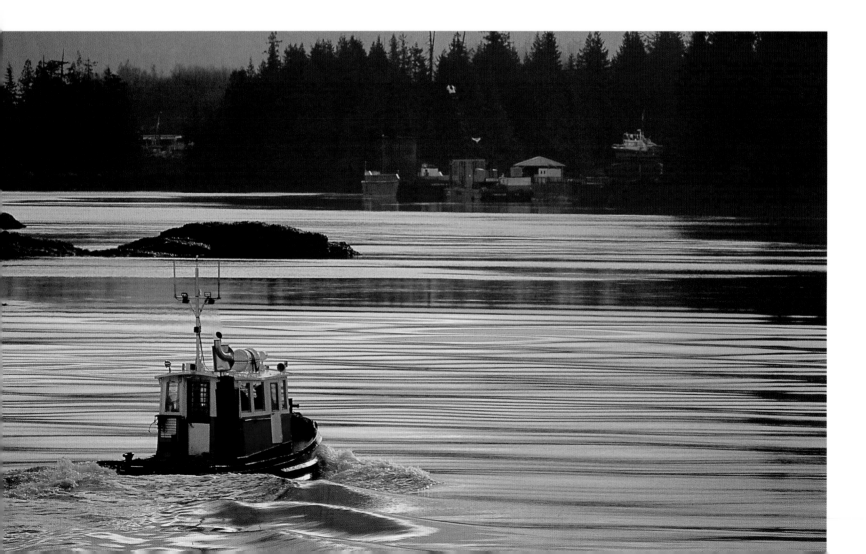

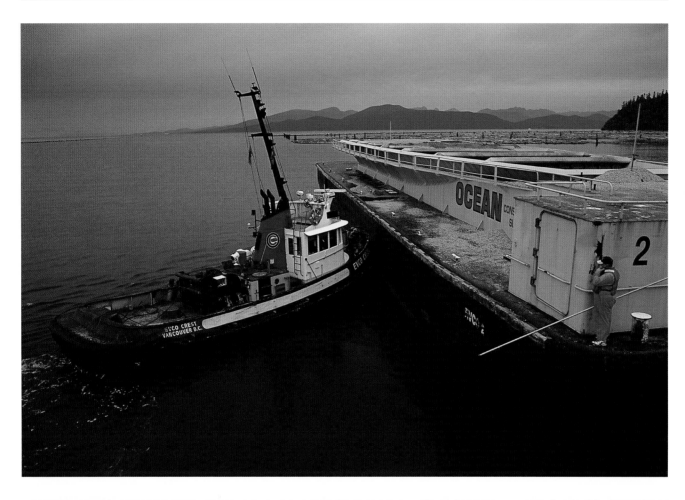

LEFT
15-metre *Evco Crest* noses into an Ocean Cement barge near the Fraser jetty.

BELOW
Seaspan tug yards a couple of battered old chip barges. There's a chance part of a cargo like this made its way into the book you're reading right now.

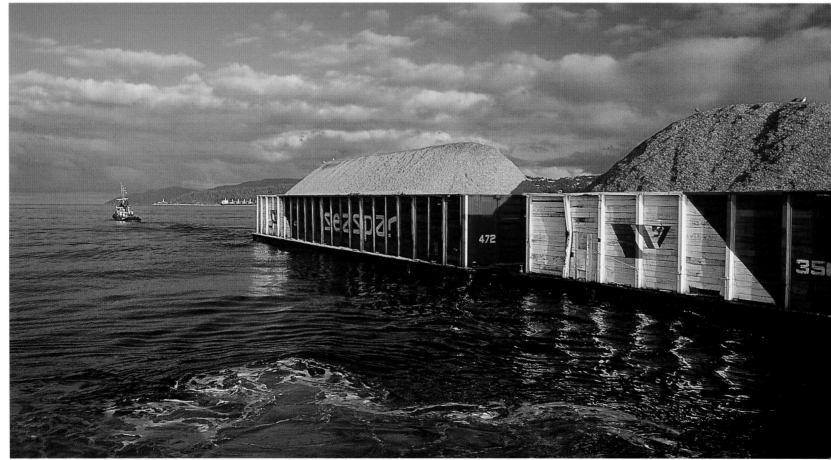

Aboard their Sabre Marine tug, Perry Boyle and his son Mark get a lot of double takes.

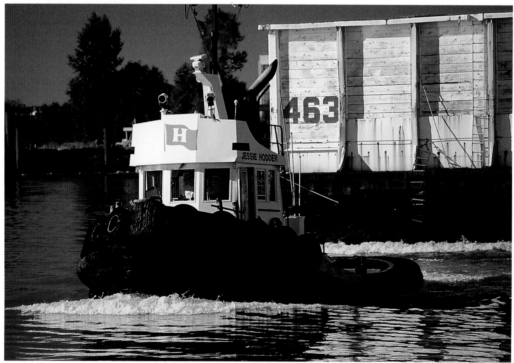

ABOVE
The *Jessie Hodder* pulls a light load.

RIGHT
The *Jessie Hodder* joins a chip-barge parade.

working in a natural setting. I enjoy the feeling of self-sufficiency and independence." He smiles at the luxury of being left alone to do his own work and solve his own problems.

The *Trojan*, with the *Seaspan 446* not far behind, angles past the end of the rock jetty and across English Bay toward Point Atkinson. A stiff westerly breeze pushes a washboard of greenish breakers across sandbars at the mouth of the river. That's when it becomes obvious that getting rid of excess coffee can be a bit of a gamble on a bucking tug. "Takin' a spray" over the side requires one hand on the lifeline, extreme dexterity with the other—and careful timing. Lumpy water can take slack out of the towline when a guy least expects it. And then there's always that gust of wind you don't see coming...

For Brent Gilker, being skipper of a tug is a line of work that he just sort of "evolved into." When he graduated from high school in 1965, he worked on the W.A.C. Bennett Dam construction project. "One of the first jobs I had... you're crawling underneath steel rebar

to clean up the rocks so that the cement would adhere... I was a sandblaster on that same job project, blasting the surface of cement once again so the next cement would stick to it, you know. With no protection but a dust mask and a hood."

In 1975 he was working as a boom man at the Canadian White Pine sawmill on the North Arm of the Fraser. After learning to operate a dozer boat, he started watching the river tugs and liked what he saw. Especially the work schedule and the amount of time off that towboat crews could earn.

Each of the three big maritime union contracts has a slightly different formula for calculating the value of overtime at sea, but basically most of it is converted to time off instead of cash. Over the course of a calendar year, a 37.5-hour work week translates into roughly 123 workdays. The workdays are longish—usually at least 12 hours on the water—but the rest is time off. And to Brent, from his job down on the booms feeding logs into the mill, those tugs looked like nothing more than overgrown sidewinders. So he said to himself "Hey, I can do that."

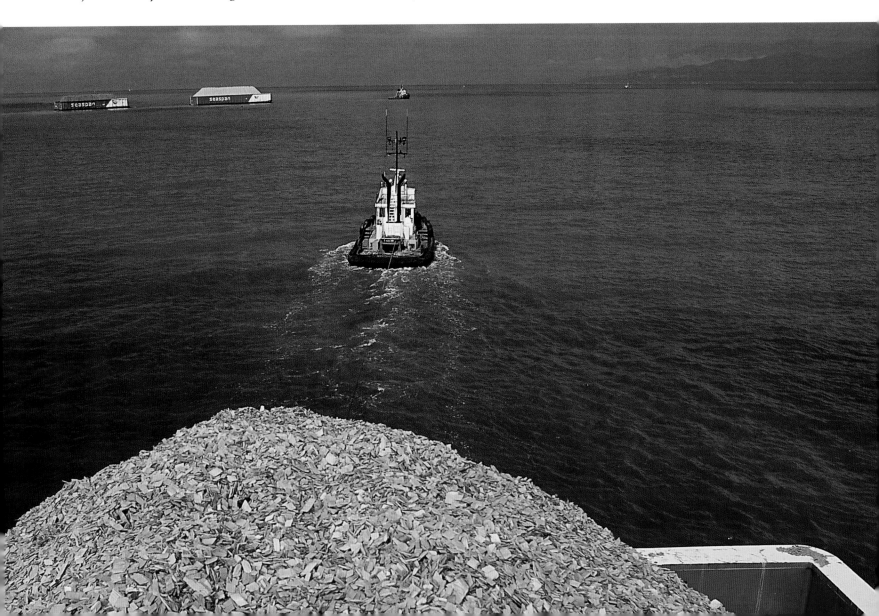

He "decked" at Seaspan for a dozen years, then went to the Pacific Maritime Training Institute in North Vancouver for a 10-month course to get his watchkeeping mate's papers. Because two-man tugs on the river don't have any mate's positions (most sail with just a skipper and a deckhand) Brent logged two more years of sea time before taking and passing the exam for "command endorsement." Then he waited another year for the posting that finally put him in the driver's seat as skipper of the *Seaspan Trojan*.

On a morning like this Brent Gilker couldn't name another job he'd rather be doing. The 20-metre tug bucks its way across the bay as he searches the horizon for a silhouette in the brilliant yellow glare of sunrise now topping the First Narrows. The *Texada Crown* is out there somewhere, plain as day on radar. But even with good binoculars, squinting as hard as he dares at the diamond flash of bouncing light, Brent still cannot spot the outbound tug—until she is well past the Lions Gate and side-lit against the North Shore mountains. The two boats are no more than a mile apart by the time they find each other just east of the Point Atkinson Light.

The *Texada Crown* comes almost to a stop as she pays out her towline. She creeps ahead slowly, letting her

two barges drop back and opening a space at the head of the line for the *446* and her heaping mound of chips. The bridles for each of the barges are connected to her towline, which passes under the leading barge.

Brent hauls the *446* in close behind *The Trojan* to give him more control for the coming hand-off. Shawn grabs his pike pole and steps into space—leaping the churning white and green gap from tug to barge.

Coming up close behind the *Texada Crown*, Brent jogs the *Trojan* slightly to starboard, as if he's going to cut across between the other tug and its two barges, jogging just long enough to slide the barge toward the open slot behind the *Crown*.

On the barge, Shawn, ready to pounce, stabs his pike pole towards the stern of the *Texada Crown*, snatches its towing bridles, and connects them to the *Seaspan 446*, at the same time releasing the bridle of his own tug. The *Crown* will now ease out the towline and the three barges will be in line. With the hand-off complete, Shawn steps around to the barge's portside railing and waits for Brent to loop around and pick him up again. At that point the two tugs go their separate ways. The *Texada Crown* has her three barges in a straight-line tow for Port Mellon and the *Trojan* is thumping back across English Bay to pick up her next assignment.

Down in the cluttered galley Shawn rustles up

The *Seaspan Trojan* "hands off" a chip barge to another tug already under way with its own tow.

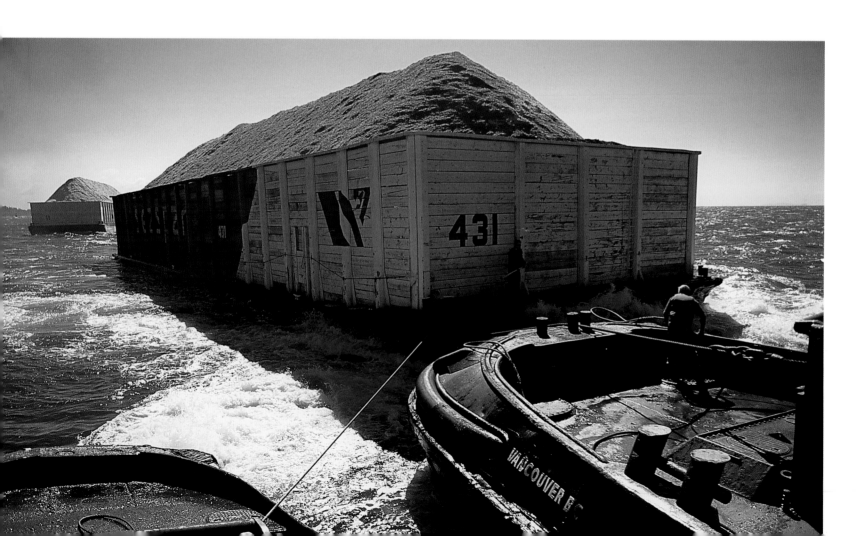

ABOVE
Norm Finley stands on a barge, pike pole at the ready, as the *Jessie Hodder* pulls away from dolphins on the Fraser.

LEFT
A deckhand catches his breath on the afterdeck following a hard workout on the tow.

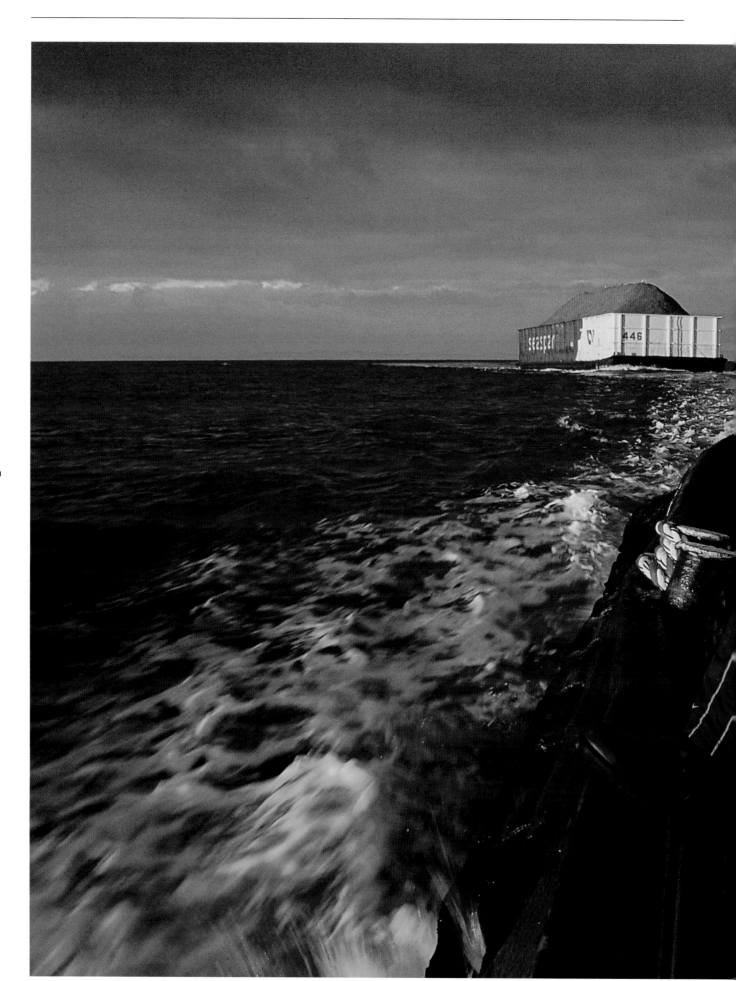

Shawn Kelly
keeps an eye on
the tow as the
Seaspan Trojan
prepares to
hand off to the
Texada Crown.

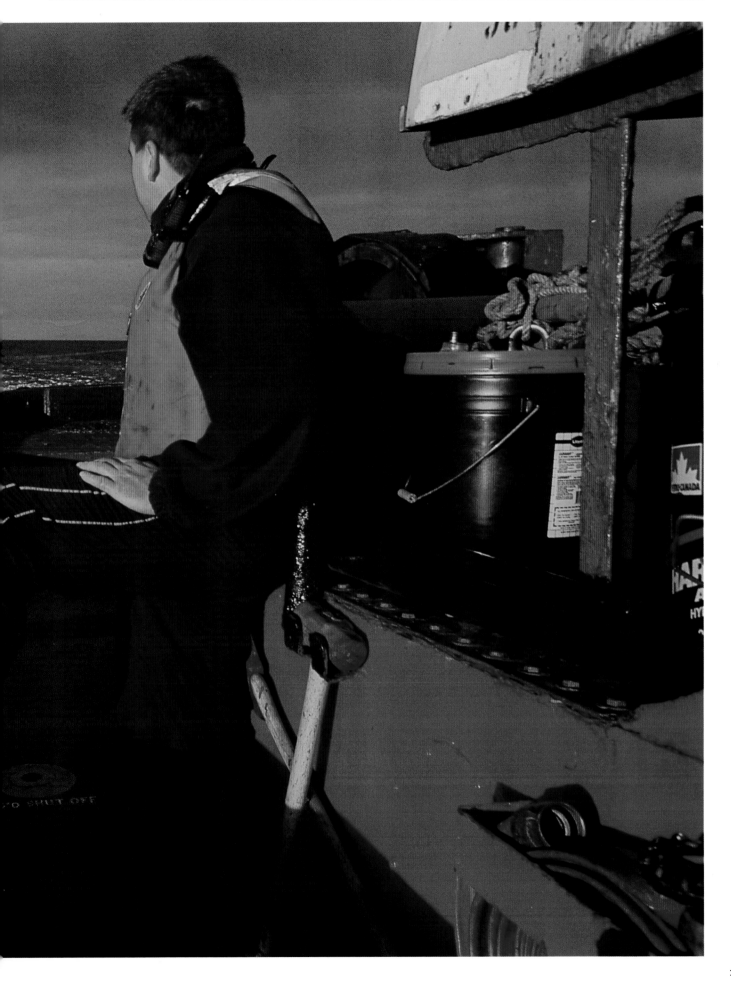

ABOVE
Gripping the lifeline with one hand and pike pole with the other, deckhand Mike Vandenborn makes his way
along the narrow ledge around a chip barge. If you fall overboard, it is a long way back up.

PREVIOUS PAGE
Chips out, gravel in. The 21-metre LaFarge tug *Captain Cook* enters the Fraser with a load of gravel, passing a
Seaspan tow of chips. Both barges are on shortened towlines for better control in the congested North Arm.

another pot of coffee as a flamboyant American judge flaps her arms and berates some poor schmuck on a fuzzy daytime TV screen. Shawn climbs to the wheelhouse with a cup for Brent, then climbs back down to make himself a baloney sandwich.

Shawn used to deckhand on "outside" boats—tugs that work the upper coast, but he didn't like being gone for weeks at a time and pulling those long six-hour watches, staring at the horizon mile after sleepy mile. Boring, really, really boring. Bring plenty of reading material or movies. Worse, on outside tugs, a deckhand is expected to cook. "I can do steak or chicken okay, but these guys want muffins and cakes and stuff like that. And it's hard to work in the galley when you're out there rollin' around, eh?" On river boats like the *Trojan*, a deckhand doesn't usually have to attempt anything more ambitious than the odd jug of java. "At least on the river there's lots of yarding. Keeps you busy." Having recently split up with his wife, and with a daughter to raise on his own now, he's grateful to be able to tie up and get home at roughly the same time almost every night.

Glancing out the galley porthole as Brent turns the *Trojan* back upriver to grab another barge, Shawn chuckles. "Hope it don't slow down too much, or he'll make me paint."

The next job is another moving target delivery just outside the rock jetty. The *Trojan* hands off the *431* to the *Seaspan Navigator*. Same routine as before, only this time the water is a bit rougher. Blue sky and whitecaps all the way to Vancouver Island.

Shawn grabs his gloves and lifejacket and heads back out on deck. Always the lifejacket. Always one hand on the lifeline strung around the outer edge of the barge.

Nearly all these steel-hulled barges were built the same way: big box on a sprawling flat deck. The box walls are made of weather-beaten, chewed-up and frequently splintered six-by-ten timbers in a crib five metres high that is usually overflowing with wood chips or hog fuel. Outside the box walls there's a narrow ledge with nothing more than a wire lifeline between you and the deep blue. Walking that ledge is the only way a deckhand can get around the barge from port to starboard or bow to stern. An extra thrill comes when the ledge is ankle deep in spilled woodchips.

With sawdust swirling in his eyes, Shawn snags the *Navigator*'s towing bridle and drops wire loops over the cleats on the *Seaspan 431*. Then he jumps back across the churning void to the *Trojan* as the dispatcher calls out their next job: meeting the *Seaspan Valiant* coming across the strait with two empties. Take them upriver... But moments later the mission is scrubbed as Brent and Shawn discover a "bird's nest" in the *Trojan*'s towline. A faulty control valve caused the winch drum to keep turning as they were travelling and now it's just a big ball of steel spaghetti.

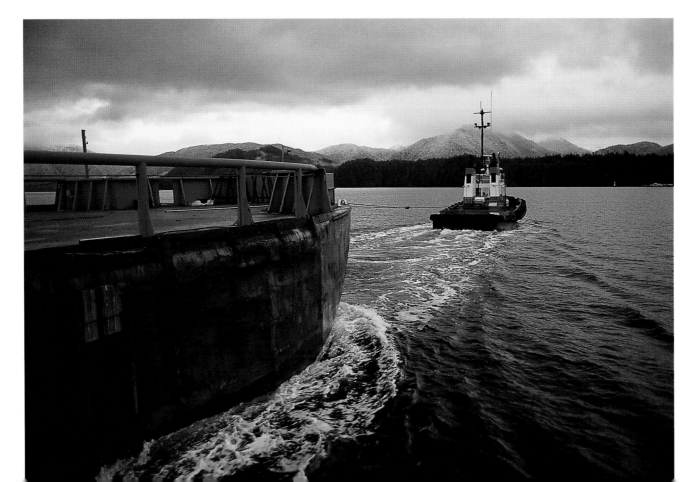

Under a lowering Rupert sky, the *Rivtow Star* hustles home with an empty barge.

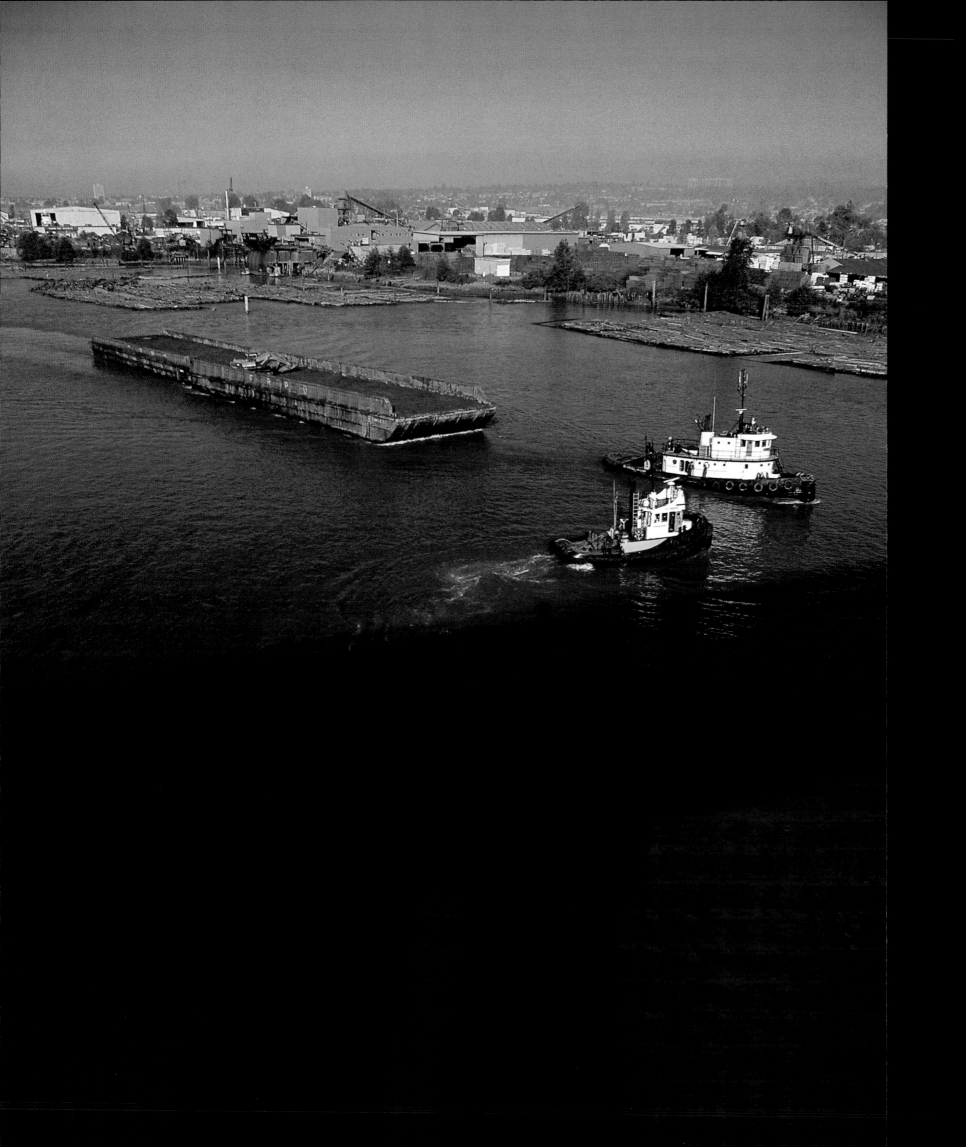

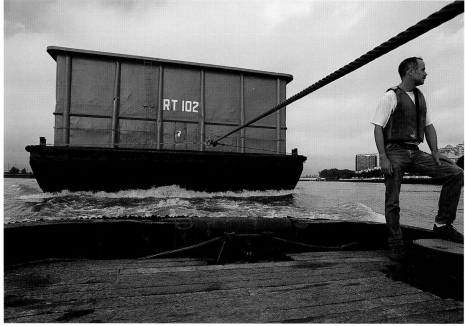

OPPOSITE
Empty barges head into the shadow of the Knight Street Bridge across the Fraser between Vancouver and Richmond as waiting assist boat manoeuvres to lend a hand.

ABOVE
The *Rivtow J.R.W.* pulls yet another chip barge down the Fraser.

LEFT
Mike Vandenborn enjoys a quiet moment on the afterdeck as the towline draws taut behind him.

PREVIOUS PAGE
A Seaspan tug heads into a fog bank with a string of barges. This weather calls for a close eye on the radar and an ear to the radio.

Dispatch reassigns the *Valiant* job to somebody else while Brent backs the *Trojan* into the lee of one of the barges at the Point Grey tie-up. Shawn climbs up on the winch with a fire axe and a sledgehammer, but the heavy cable won't budge. They put a line to the barge and try going ahead on the boat, but no dice. The loops are clamped together like hell's own teeth. Meanwhile the crew of the *Jessie Hodder* has been watching from the far side of the river where they are putting together a log boom, and they scoot across to see if they can help. They shackle a hook to the end of their towline, put it through one of the loops, and try breaking it free with their powerful deck winch. The loop moves but doesn't come free. They try another loop. Same thing. Then another. For half an hour nothing much happens, but gradually, very gradually, the tangle starts to loosen up. Finally something pops, and the tangled line shoots clear with a series of loud snaps and bangs. Amazingly, there is no damage to the line and it winds back on the drum smooth as silk thread. The crew of the *Jessie Hodder* shove off with quiet thanks from Brent and Shawn. They work for a rival outfit but that's the way it is on the river.

It is late afternoon, last gig of the day. The *Trojan* steps outside the jetty into all that lumpy water again to fetch two empties—*Seaspan 464* and *414*—for delivery up the North Arm. Back they motor past the mud flats where half a dozen smaller tugs, including the *Jessie Hodder*, are muscling bundle booms apart, separating, sorting and shuffling logs into storage spots along the river. Past the flat booms that will be towed upstream to one of the mills. Round the bend past the golf course, past the rusting Celtic Shipyard, past those ritzy houses again, underneath soaring bridge decks choked with car traffic, past three kids playing at water's edge. Brent gives them a friendly toot on the whistle.

The river is clearly a different place. A special, secret little world known only to those who work and live down here at water's edge. The real world is up there on the decks of the Arthur Laing and the Oak Street spans. Surging, seething rush hour gridlock. All those Dash-8s and 737s and fat, thundering A-320s, little pinpricks of landing lights stacked for 30 kilometres up the valley, swooping low overhead every minute or two, screaming down on the new airport runway hidden behind a wall

A tug, a barge, a light chop in the Strait of Georgia—emblems of the BC coast so familiar we sometimes forget they are there.

of tangled brush lining the river. The real world indeed.

The tug is pulling upriver against the current. The two empties are snugged together with six-metre poly couplers. Now, for the day's final challenge, this whole outfit—the tug and both barges together—has to be turned completely around and parked on the opposite side of the river between the end of a log boom and another double row of barges. With a gushing river curling past. And plenty of other boat traffic in the channel.

According to Brent, "parking empties" is probably the most dicey job on the river. A big empty barge, riding high out of the water, catches wind like a sail and can easily overtake a tug. The *Trojan* has plenty of scars to prove it.

How does one cope with a windblown empty? "You make it up as you go," laughs Brent, glancing over his shoulder at his two frisky charges. "All towboating is looking for an exit when things go wrong. Gotta have a Plan B. Never go to Plan A without a Plan B."

Even with the empties hauled tight against the stern Brent knows it will take the whole of the channel to pull a U-turn. Fortunately, the only traffic in sight is a tug and two fishboats, who will know enough to keep out of the way. Brent wheels hard a-port. The *Trojan* and her two high-riding empties swing broadside to the stream, blocking the river from one side to the other. Just before the current can grab hold, Brent gooses the trusty old diesel and the two empties fall into line alongside the parking spot. A nudge here, a nudge there, some splashing of lines, one last death-defying leap, and the two barges are snugged down for the night.

Brent and Shawn amble downstream to the Ocean Cement dock and a few minutes later the *Trojan* is tied up where they'd picked her up at 0530. Brent climbs down into the engine room to put the big Cat diesel to bed. He checks fuel, oil and transmission fluid levels while Shawn hoses the day's accumulation of salt spray from the upper works. He stows the deck gear, collects the sack of garbage from the galley, and double-checks the tie-up lines. Brent makes his closing entry in the *Trojan*'s log. Another 12-hour shift on the river. A few kinks and bumps, but when you're dealing with wind and tide and leaky valves, this is as close to perfect as it gets.

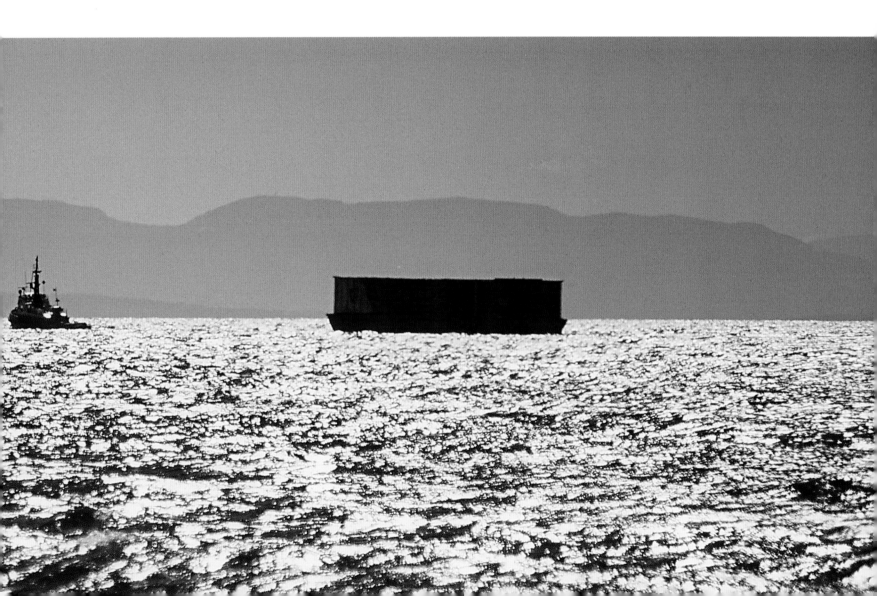

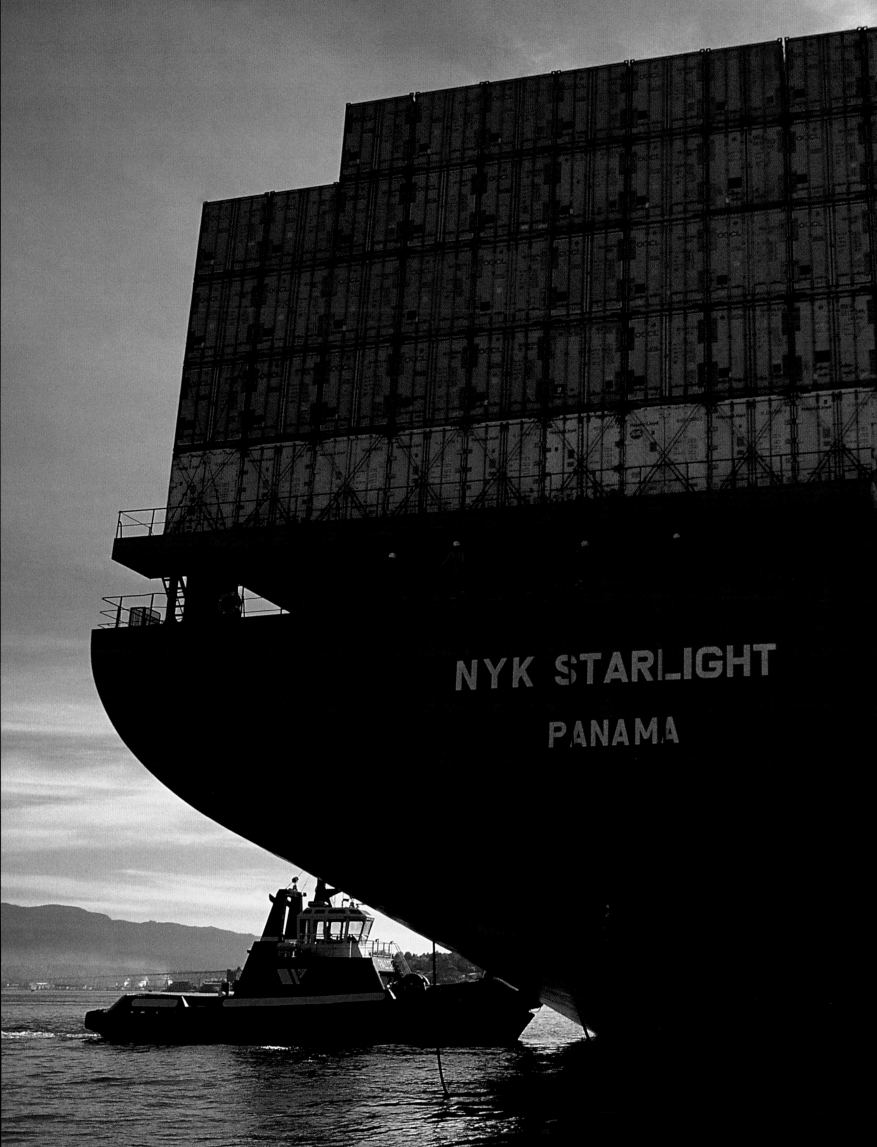

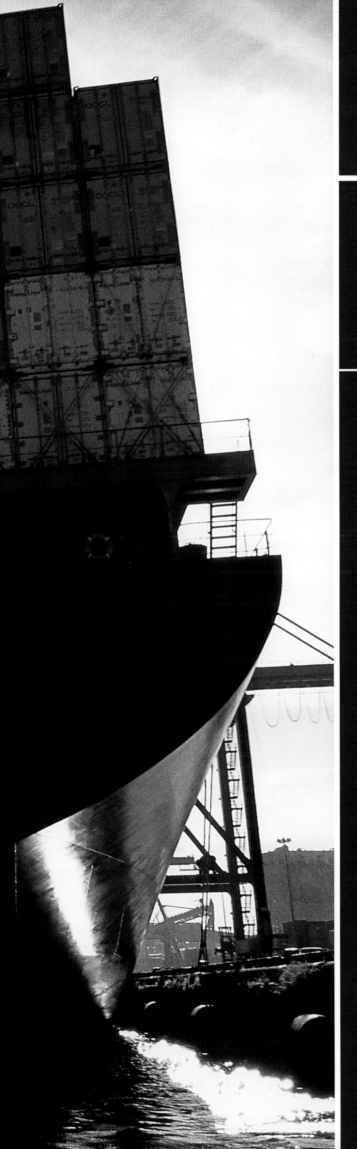

4

SHIP WRANGLING

Demand for ship-berthing tugs has soared in the last 30 years as new deep-sea ship terminals were developed at Prince Rupert (to export grain and coal) and at Roberts Bank (to export coal and handle containers). Meanwhile, existing bulk loading and container facilities in the Fraser River and in Vancouver Harbour have been steadily expanded, and Vancouver has become a leading cruise ship port, hosting 300 sailings per year at its Canada Place terminal. At the same time oil tankers, container ships, coal, grain and dry-bulk carriers and cruise ships have been growing steadily larger. As ships increased in size, more towing power was required to dock them.

The 3,100-horsepower *Seaspan Falcon*, one of the first of a generation of new-look tractor tugs, lays into a container ship in Vancouver.

At the beginning of the twentieth century, the job of berthing ships fell to single-screw steam-powered wooden tugs. The main design feature was that the housework was placed well back on the hull where it was out of the way of the ship's side, and they all had big bow fenders to facilitate pushing. The pioneer firm C.H. Cates and Sons used a small fleet of these mighty-mites to dominate Vancouver shiphandling for a century. Over the years they developed a shallower, wider hull that could turn without tipping, and they adopted a rounder bow that would hang onto the ship's side better, but the basic design of the berthing tug remained outwardly the same. This changed in the 1980s with the arrival of the Z-drive or tractor tug, a innovation pioneered in Vancouver that revolutionized harbour tug design worldwide.

The great limitation of the conventional tug, with its fixed propeller-and-rudder propulsion system, is that it is unidirectional. It can turn and go in reverse, but only with some awkwardness and much-reduced power. For working at full power it is pretty much a straight-ahead

In a wheelhouse with no wheel, the skipper uses twin joysticks to make his state-of-the-art Z-drive tug dance around a docking freighter.

proposition, and in close quarters around ship and dock where manoeuvrability is everything, this is a decided liability. The tractor tug, on the other hand, is multi-directional. It can go backwards with as much power and almost as fast as it can go ahead. It can truly spin on a dime. What makes this possible is its azimuthing propulsion unit or Z-drive, which frees the propeller from its traditional rigid mounting so it can aim in different directions like an outboard motor. But even better than most outboards, the Z-drive uses a system of gears to "azimuth," or turn in a complete circle, delivering full thrust to any point of the compass at the touch of a finger. Z-drives had been around since the 1960s but it took a few years for tugboat designers to absorb the implications of the new system and develop an almond-shaped hull that is just as happy surging backward as it is charging forward, and can even make a fair stab at ploughing sideways.

For experienced crews who learned their seamanship on conventional tugs, these new boats take some getting used to. The traditional spoked wheel has been

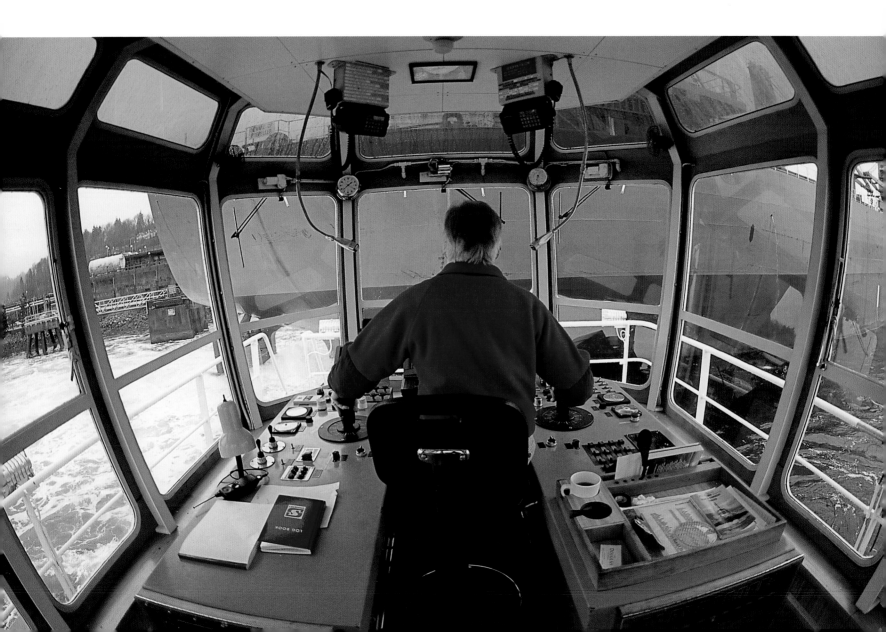

replaced by futuristic joystick-type controls or levers, but once the hand-eye coordination comes together, good skippers can make a hulking tractor tug dance like a dozer boat.

A typical modern Z-drive tug is around 24 metres long by 14.5 metres wide. It weighs about 150 tons and is powered by two 1,500-horsepower diesel engines. Top speed is about 11 knots and almost that going backwards. It's able to go from full ahead to full stop and turn 180 degrees in about a boat length. In appearance, it's hard to tell the back from the front. The pilothouse has glass on all sides like an airport control tower and is set amidships. The traditional heavy fendering of the harbour tug is now continued right around the boat, since it can push from any point. The price tag: about $3 to $5 million.

These specialized ship-berthing tugs can be seen handling ships not only in Vancouver Harbour but at the Deltaport container terminal at Roberts Bank and the adjacent Westshore coal terminal (both of which are designed to accommodate the world's largest container and bulk ships). They're also on the job on the Fraser River at the South Surrey container and automobile facility in New Westminster and at the grain and coal terminal at Ridley Island in Prince Rupert.

Most, however, work out of Vancouver. The Port of Vancouver handles more cargo than any other port in Canada or on the west coast of North America. Tugs handle more than 2,800 cargo vessels per year. Those ships bring in some five million tons of various goods (including over a million containers) and export some 64 million tons. Over 80 percent of exports are bulk cargos such as grain, coal, sulphur, potash, logs, sand, gravel, wood pulp, oil and food products. Cruise ships pump through a million passengers.

Regardless of the cargo or the port, the job of the tugboat is the same: to get ships safely into and away from their berths and out to where they can manoeuvre safely under their own power.

A typical cargo ship starts its voyage from China or Japan and crosses the Pacific at 12 to 16 knots (container ships are much faster). By the time it enters

A deckhand's view of the *Seaspan Falcon* running light.

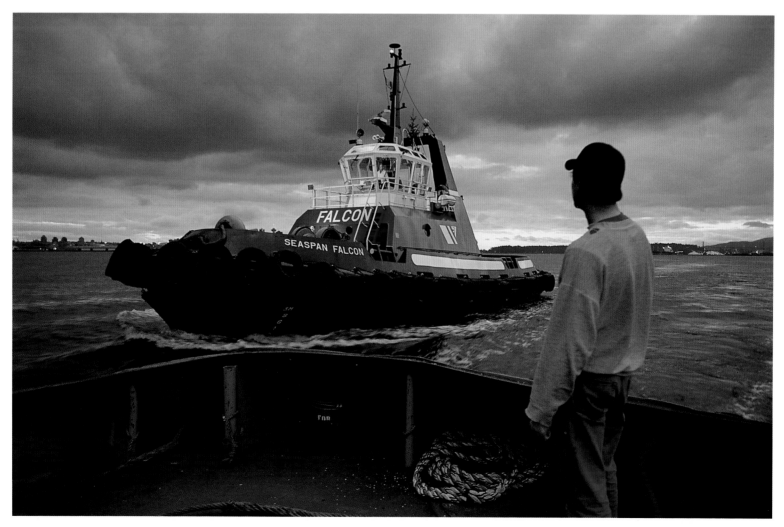

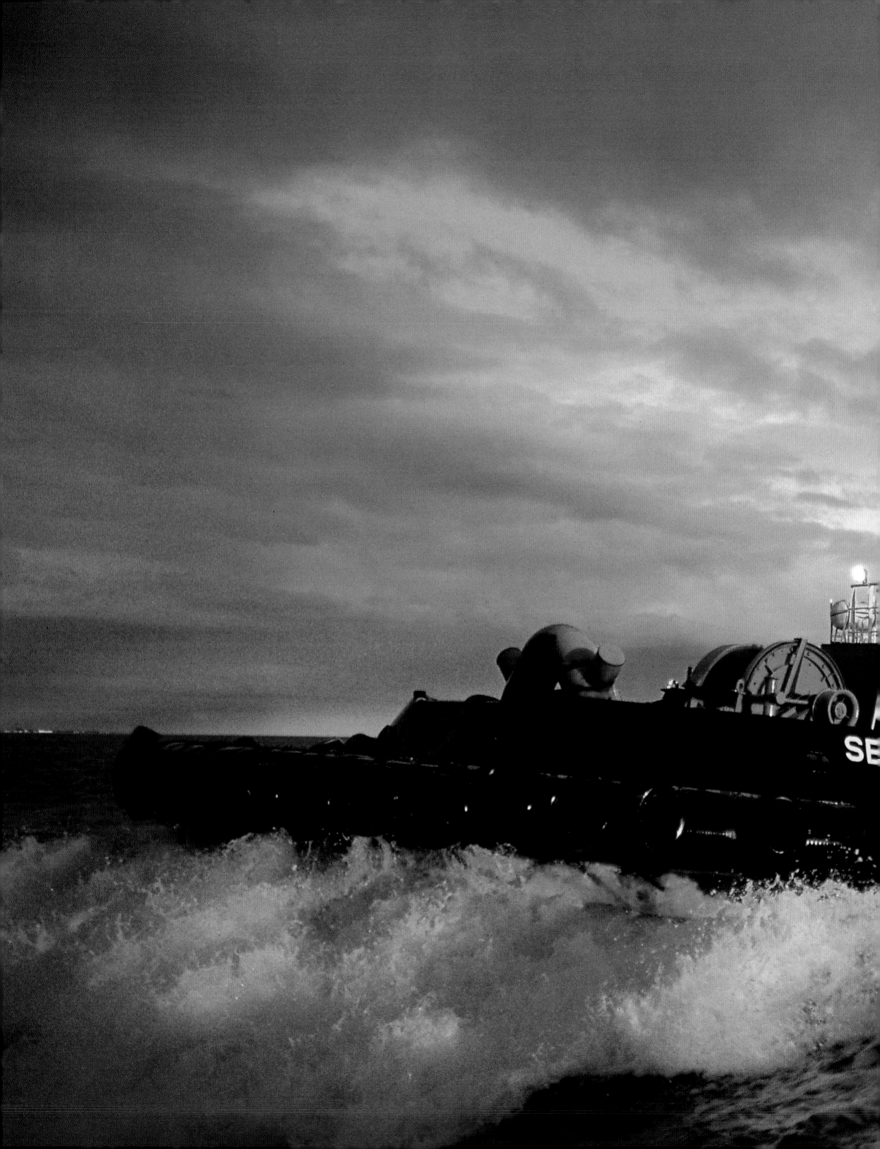

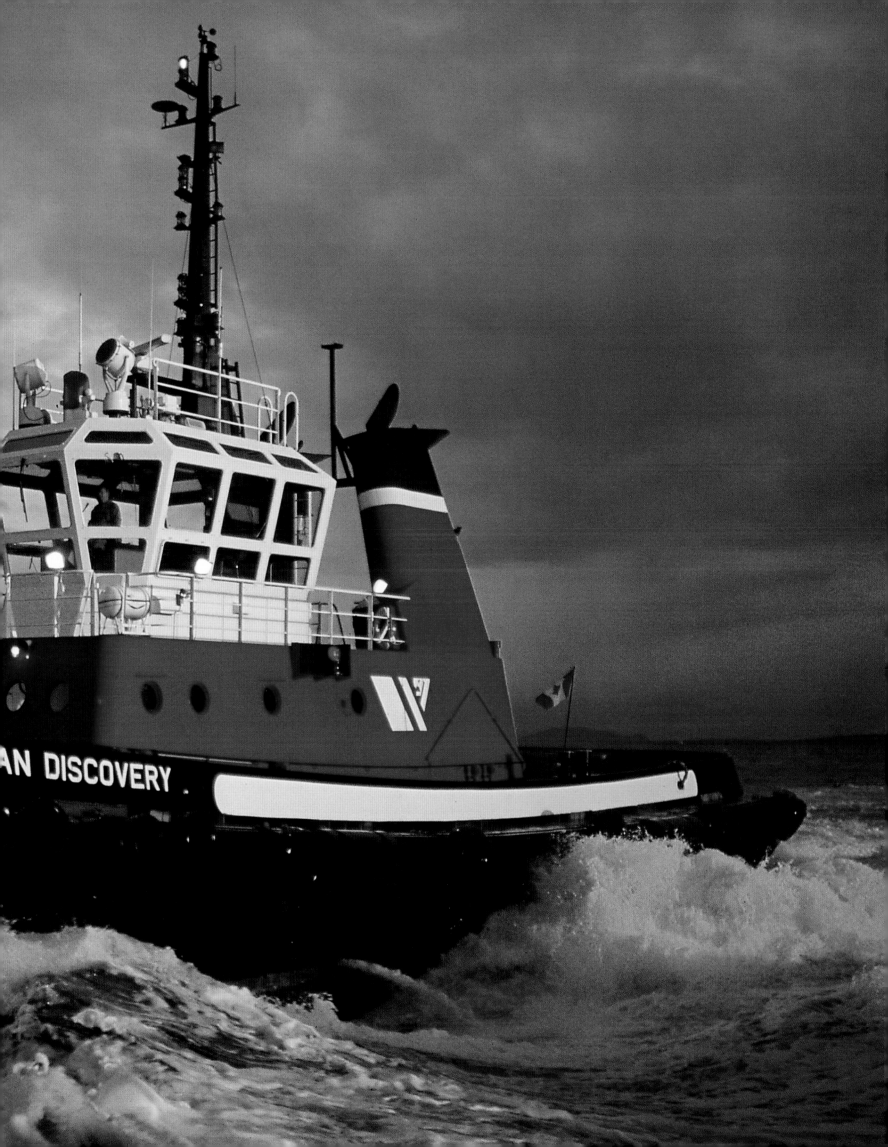

PREVIOUS PAGE
The 33-metre, 435-ton *Seaspan Discovery*, pride of Seaspan's harbour fleet, churns across the strait to meet a freighter.

OPPOSITE
Berthing tugs escort a freighter out of the harbour. Most large freighters require the aid of two tugs to manoeuvre in restricted waters.

BELOW
Tugs from Seaspan and Cates—both part of the Washington Marine Group—berth a cargo ship.

BC waters, its agents have arranged for its berth and for tugs with the appropriate horsepower to dock the ship. Two tugs are generally required.

The tugs belong to one of three companies. Most of Vancouver's fleet of 12 ship-berthing tugs is owned by Seaspan International and C.H. Cates, both of which are owned by the US-based Washington Marine Group. These tugs have "Seaspan" or "Cates" as part of their names. The other main ship-berthing company, Tiger Tugz, a subsidiary of Rivtow Marine, is owned by Smit International of Rotterdam and its vessel names are prefixed with the word "Tiger."

As the ship passes Victoria, a BC Coast Pilot boards the ship and is responsible for seeing it safely along the coast and into its berth. During the berthing operation, he is in constant contact with the berthing tugs.

The inbound cargo ship begins to slow many miles outside the harbour and travels at a reduced speed when it passes under the Lions Gate (First Narrows) Bridge.

Under the guidance of the ship's pilot, the two tugs manoeuvre alongside the ship in order to attach towlines. Generally, one tug will be assigned the forward (bow) position and one will be assigned the aft (stern) position.

Once alongside, deckhands on the ship's bow and stern each toss a lightweight heaving line down to the deckhand on the tug below. The deckhand then ties the heaving line to the tug's towline, which is pulled up to the ship and made fast. Towlines used for ship docking—still the essential tool of the tugboat—are now woven from extremely strong, synthetic fibres. This makes them lightweight and buoyant and easily handled by the tug's one deckhand at deck level. These lines are worth up to $45,000 each and have superb breaking strength, allowing a tug to pull at full power without fear.

Unlike conventional tugboats that have their winches on the aft deck and run their towlines over the stern, many Z-drive tugs have a shiphandling winch on their foredeck. The line runs from the winch, through a fairlead near the bow known as a "staple" (an oversized inverted "U" made of tubular steel) and up to the ship. Once the line is secured, the tug can pull the ship in any direction—and hold its position in relation to the ship by moving forward, backwards or sideways.

With the tug's lines connected, the ship continues to slow. As it does so its speed through the water isn't enough for its rudder to be effective, and it loses its ability to steer. The tugs must now do the steering.

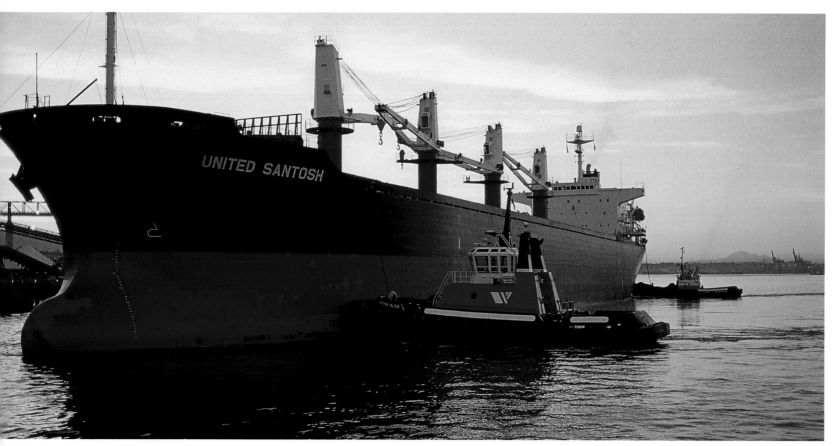

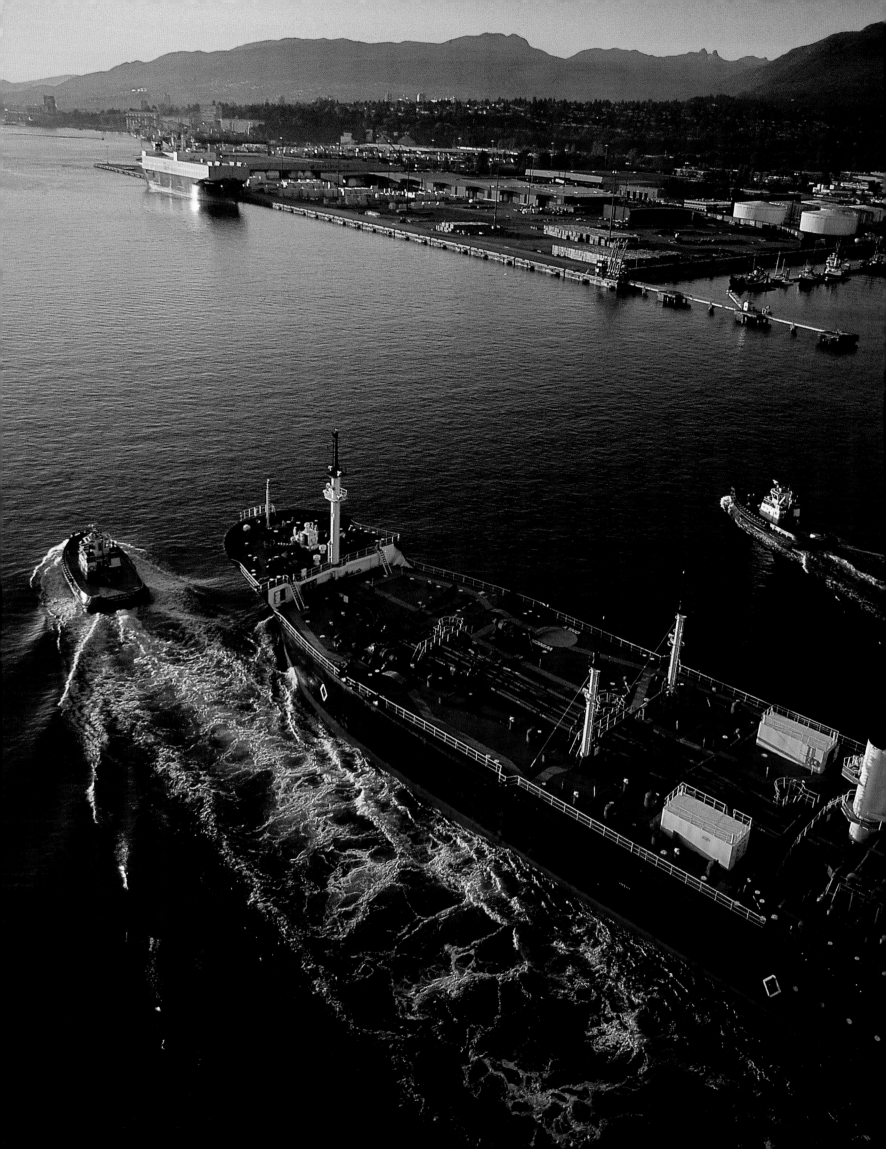

Once the ship is parallel to the dock and pointed in the right direction, the tugs push until it's close enough for mooring lines to be passed down from the ship to the longshoremen waiting on the dock. Sometimes a smaller "line tug" is used to ferry the heavy mooring lines ashore. The tugs hold the ship in position against the dock until all the mooring lines are hooked over the bollards and winched tight.

If you consider that a cargo ship can weigh more than a thousand times as much as a tugboat, and that tidal currents can swing a ship out of control in minutes, it's easy to see why a successful ship berthing requires a great deal of coordination between the pilot and tug masters. Many ships are designed to be loaded and unloaded from only one side. If this is the case, the tugs may swing the vessel 180 degrees just before berthing to get the working side of the ship against the dock. Sometimes a ship is swung around so it is pointing the right way to leave the harbour. Turning ships in the Fraser River when the spring freshet is running at its peak is particularly challenging.

Two of those tugs that work Vancouver Harbour are the *Tiger Sun* and the *Tiger Shaman*.

We're scooting across the harbour on a water tractor

with orders to intercept the *Chaun He*. She's come all the way from China with 5,250 steel boxes of cargo stacked deep in her belly and six-high on her main weather decks. Stacked so high they look as if they'd tip over and spill into the sea in a heavy blow. Makes you wonder why they don't. Or how often they do. These steel boxes are packed with everything from bicycles, TV sets and mandarin oranges to clothing and who knows what else. The actual cargo manifest is, of course, confidential according to the broker.

She's a 66,000-ton container ship owned by COSCO—the China Overseas Shipping Company—on her regular liner run (like a scheduled airline or freight train service) from Shekou to Hong Kong to Yokohama to Long Beach and Seattle in a grand circuit she makes every 35 days. Vancouver is her final stop on this side of the Pacific.

She's 280 metres from stem to stern, 40 metres across her beam and she needs water at least 14 metres deep to keep her afloat. The *Chaun He* entered Canadian territory five hours ago just off Victoria where she picked up a BC Coast Pilot to jog through the Gulf Islands, around the sandy mouth of the Fraser, across the busy traffic lanes of English Bay and into Burrard Inlet. As soon as she transits the Lions Gate

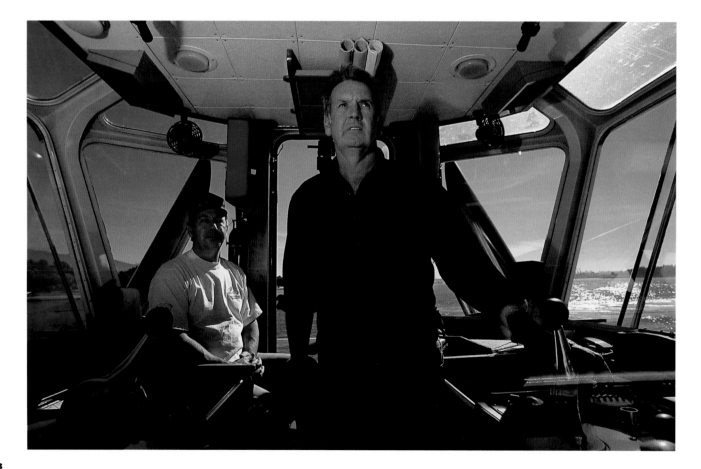

Hugh Wallace, known by some as the Wayne Gretzky of ship-berthing skippers, and deckhand Barrie Berrington.

Bridge, we'll be "picking up the tow," which basically means we'll snag her on the run.

To maintain steerage through the eddies that swirl beneath the Lions Gate, the pilot has her moving along at nine knots, a fairly brisk pace for a vessel this big in tight quarters. Modern cargo ships are designed to cross long distances with heavy loads in as little time as possible. With her engines cranked up to full speed ahead, the *Chaun He* bores across the Pacific fully laden at a respectable 24.5 knots, or 45.4 kilometres an hour, which may not sound like much until you get up really close and have a look at 66,000 tons cutting a salty swath like a runaway iceberg.

The sheer bulk and ponderous weight of a ship like this creates an awesome amount of kinetic energy. Even at lower speeds large ships would do a vast amount of damage if they hit something. When it comes to tight turns and precise manoeuvres in the confined spaces of an inner harbour with congested docks, strong winds and surging tides to fight, they're not at all graceful. In fact, they're downright awkward and potentially dangerous, which is why they need tugs to help them park.

Waiting to lasso this treasure chest of Asian cargo are two professional ship wranglers, skipper Earl Matheson

and deckhand Dwayne Slade of Tiger Tugz Ltd., saddled up and ready to ride in a flaming yellow and red $5-million state-of-the-art Z-drive tug called the *Tiger Sun*.

According to Earl and Dwayne, the *Tiger Sun*, clean as a whistle and bright as a new penny, is "the most powerful tug for its size in the world." She's 24 metres long, "rubber to rubber," and 14.5 metres wide, with a draft of 4.5 metres. Just imagine the *Sun*'s 149 tons going up against the *Chaun He*'s 66,000 tons and you can understand the need for power.

The *Tiger Sun*'s top speed going forward is 13 knots; she can go almost that fast (11.5 knots) backwards. She can even go 9 knots sideways! She's beamy enough that the tug remains stable even during the most extreme turns. "This is the primo one," brags Earl shamelessly as he demonstrates the *Sun*'s athletic prowess.

She's plowing along full speed ahead—and then stops—in her own length. She turns completely around—in her own length—and goes the other way. With his hands on two smoothly curved black joysticks, Earl's now cutting doughnuts—spinning this 24-metre tug—in tight circles of briny foam.

While the *Tiger Sun* waits at Brockton Point for the *Chaun He* to clear the bridge, we watch the *Mercer*

Berthing tugs, like the *Westminster Chinook*, are so powerful they can punch a dent into the ship's side, so many ships have "TUG" markings to indicate reinforced pushing points.

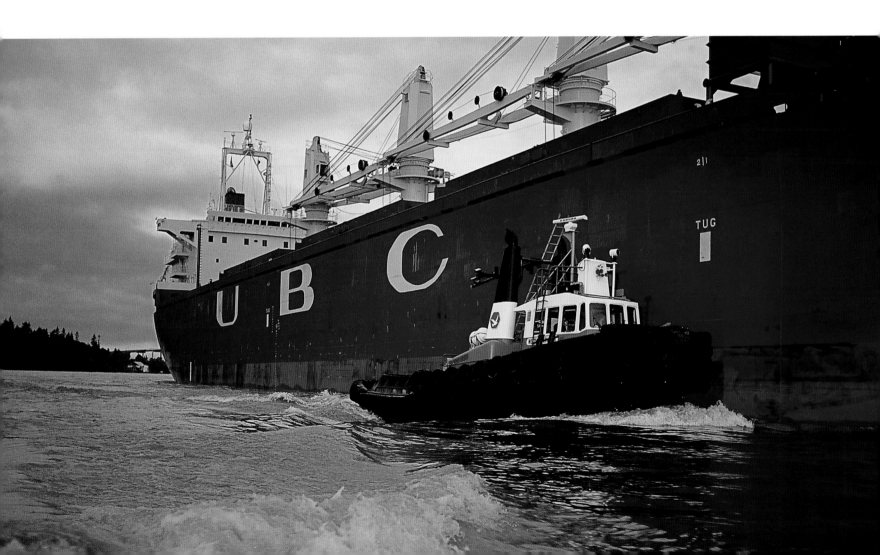

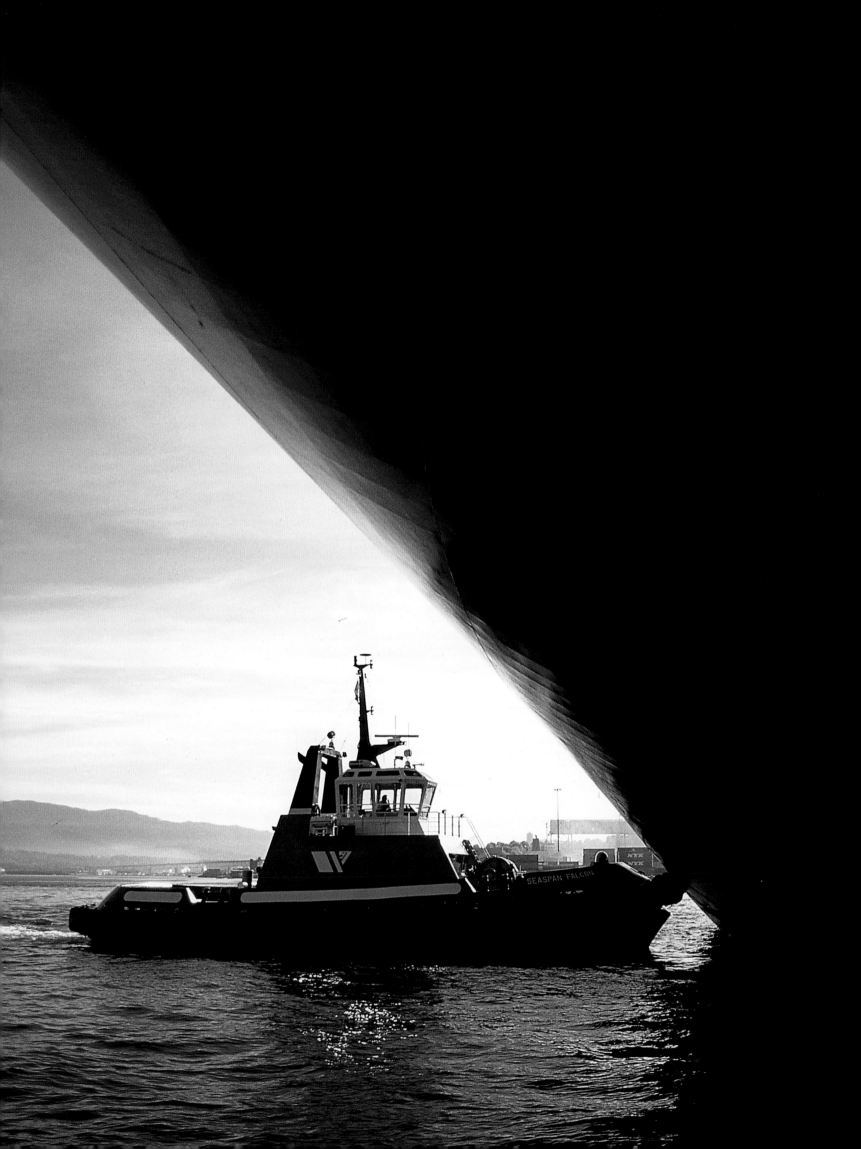

Straits plowing outbound with "the metal kettle" in tow, a chemical barge whose real name is the *Metlakatla*, full of caustic soda destined for a pulp mill in Prince Rupert. Almost anything you can think of moves by tug and barge along this far-flung coast.

Earl and Dwayne spot their Chinese freighter coming around the point. The pilot, fearing that the outgoing tug and barge could cause problems, comes on the radio and asks them to zoom out to meet the *Chaun He* and "stand by in case that barge [the *Metlakatla*] shears my way."

Earl and Dwayne grin and jump into action. They launch the *Sun* into the outbound traffic channel well ahead of the metal kettle and race to meet the incoming freighter. Once they're alongside, Earl whips his two joysticks around, pulls a quick U-turn, and magically we are now running parallel to the *Chaun He*. As we angle closer, a massive wall of steel looms over the tug, blotting out the afternoon sun.

Dwayne pulls on a pair of white cotton work gloves and walks out on deck to lower the *Sun*'s mast. It's hinged to swing down out of the way when the tug has to work close underneath the flared bow of a big ship. And this is most definitely a big ship. Especially when

you're looking up at it from this angle. From the waterline the ship's hull swells upward and out over our heads. We have disappeared underneath the vast steel sky that is the *Chaun He*. Even with the mast down, there's no more than a metre of clearance between the tug and the overhanging freighter.

In making our approach, we hit the *Chaun He*'s bow wave, which first tries to push us away and then—as we cross through it—tries to slam us against the ship's hull. But the *Tiger Sun*'s skipper knows this is coming and has those Z-drives at the ready. With a flex of the joysticks, 5,400 horses of diesel muscle jump into action and stop our sideways slip. We pass through the vortex with nary a bump and are now in position snugged up against her port bow, ready to escort the ship to her berth at the Vanterm container dock.

No need for a towline to be passed across just yet. We're simply running along in lockstep, our bow parallel to hers. As we angle to the right from mid-harbour toward the container dock, the pilot calls Earl on the radio and asks him to shift around to the starboard bow. This puts us between the *Chaun He* and the dock so that if the ship's own engine and bow thruster aren't powerful or responsive enough to break her speed as

OPPOSITE
The *Seaspan Falcon* almost disappears under the overhang of the freighter it is berthing. Tug's superstructure is angled inboard so it doesn't foul on ship.

The *Westminster Chinook* runs alongside a bulk carrier in the Fraser.

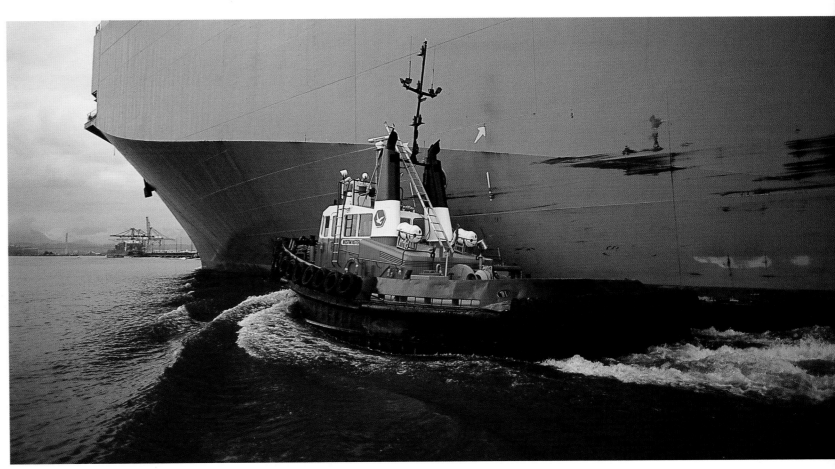

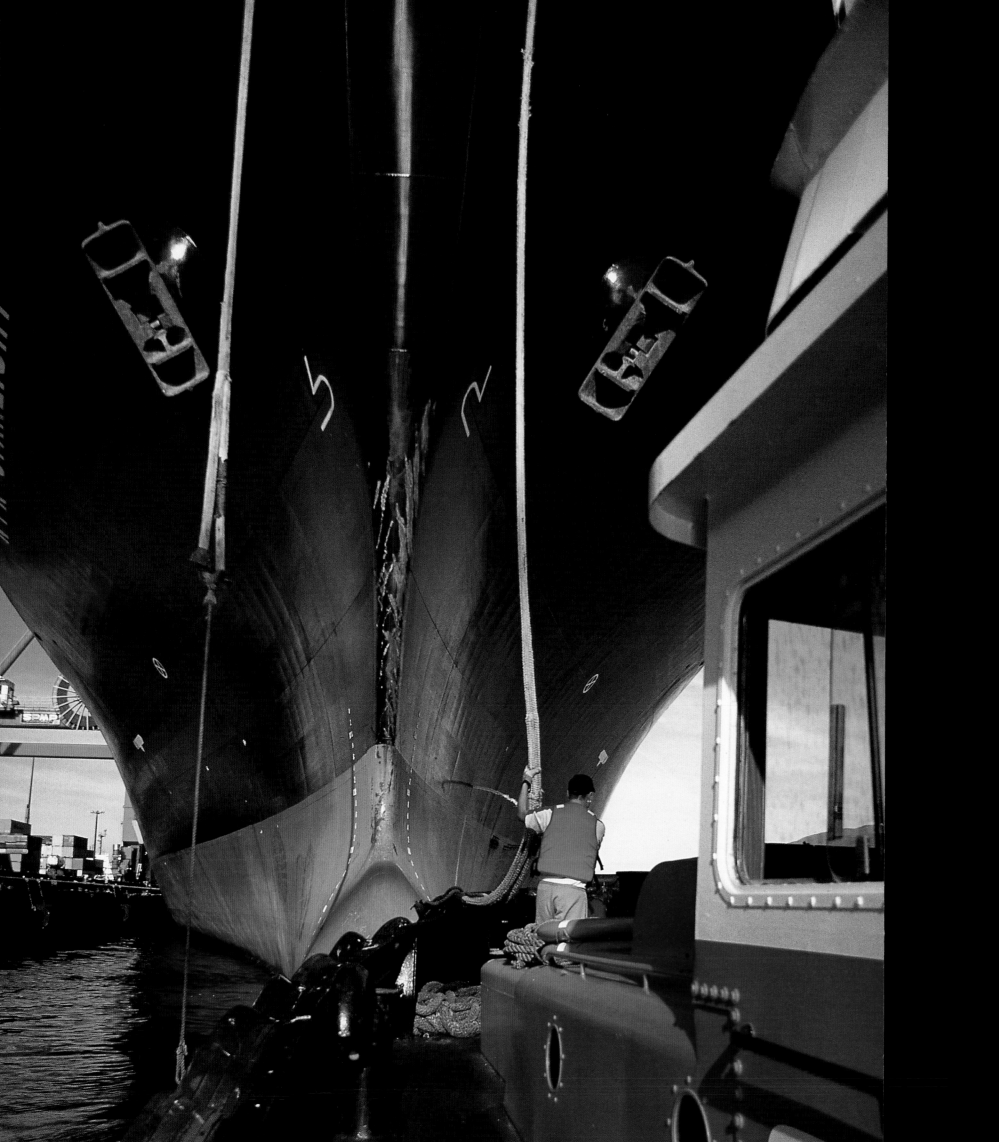

she makes the approach, the beefy *Tiger Sun* will be there filling the breach with enough heft to stop her smashing into the pier.

In a swirl of white water, Earl peels off to the left, boots it around behind the ship and comes up the opposite side. Once we're running parallel to the starboard bow, Earl rotates the tug 90 degrees to port, puts our bow against the side of the ship with a wet rubber kiss and then crabs along sideways, maintaining this position as we slide closer to the dock. A second, smaller tug, the *Tiger Shaman*, pulls alongside to assist.

The pilot asks the *Shaman* to nip around to the port bow and have a look to see if the ship's 3,000-horsepower bow thruster is churning any foam. The pilot has his doubts because the last time the *Chaun He* was here the thruster cranked away at maybe half power. The *Shaman* confirms a small wake, so it does appear to be working, but the pilot asks the skipper to stand by on the port bow just in case. With the freighter all but stopped now, parallel to the container dock, the pilot orders the *Sun* to move around to the port quarter and prepare for the final docking manoeuvre—two tugs shoving sideways toward the dock.

A fat black cartoon-like arrow points down the ship's hull to a point where the *Sun* should push. Knowing the power of modern tugs, naval architects have built steel reinforcement into the hull plating at strategic spots with big arrows to make it obvious in any language. If a tractor pushed too hard against an unreinforced hull section, it would leave a deep nose print—a nasty, expensive dent that somebody would have to pay for. Most old salts will tell you it's damned easy to do a million dollars damage with a tug.

How hard the tugs push depends on how skilfully the harbour pilot has positioned the ship against the dock. If the freighter is exactly parallel, as the *Chaun He* is now, then quite a lot of power must be applied in the sideways shove because a wall of water between the ship and the dock must be squeezed out of the way. It's like forcing water through a narrow pipe—there's a fair bit of resistance. The steel slab wall of the freighter's hull is like a bulldozer blade shoving that wall of saltchuck against the pier until it squirts away on either end.

Back on the port quarter, Dwayne ducks his head as a monkey fist drops down from the *Chaun He*'s deck crew. He checks to make sure it's only a tight ball of laced rope (three interwoven strands of heavy cord) and not a lead weight wrapped in a string sock. The

OPPOSITE
A freighter drops its mooring lines to the bow of a line tug in Vancouver Harbour.

Now how does that granny knot go again? Deckhands have to use all their strength to manhandle freighters' heavy mooring lines.

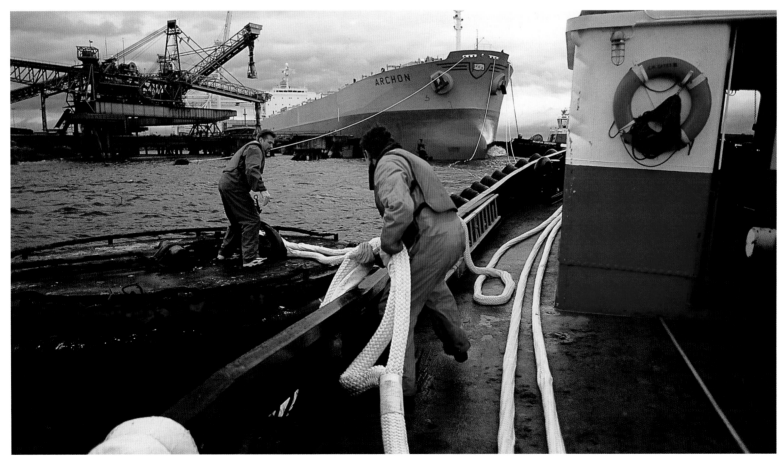

extra heft makes it easier to throw but lethal to the receiving deckhand. If it is a hunk of heavy metal, Dwayne usually slips out his knife, cuts the dangerous clunker loose and tosses it into the chuck. Today, we're okay; it's a standard monkey fist. He feeds the tug's towline up to the ship's crew and in minutes we are winched hard against the freighter's hull. We can push or pull, whatever the job requires.

Over the radio comes the pilot's voice. "*Shaman*, give us a push on the port bow."

A voice from the *Shaman* responds immediately. "*Shaman* full away on the port bow."

"*Sun*, how hard are you pushing?"

"Pushing easy."

"*Sun*, push half." Pushing half means ramping the engine up from a thousand to 1,500 rpm. Any more than 1,500 and the *Sun* is pushing full. With her skookum power plant, the *Sun* seldom gets to use full power.

"*Sun*, down easy."

"*Sun* pushing easy."

"*Shaman*, push full."

"*Shaman* pushing full."

"*Sun*, push full." Oh boy, here we go. A roiling plume of diesel-blue and white water boils up from the *Sun*.

"Pushing full." We're muscling that wall of water out of the way.

"Four bollards to the wall."

"*Shaman*, stop."

"*Shaman* stopped." The smaller tug ferries the head mooring lines across to the dock where the longshore-men are waiting.

"*Sun*, push easy."

"*Sun* easy."

"*Sun*, stop." And that's it. The *Chaun He* is tight against the dock, all lines are over and made fast. Mission accomplished.

The *Cates No. 2* races through Vancouver's Second Narrows astern of team-mate *Seaspan Falcon*.

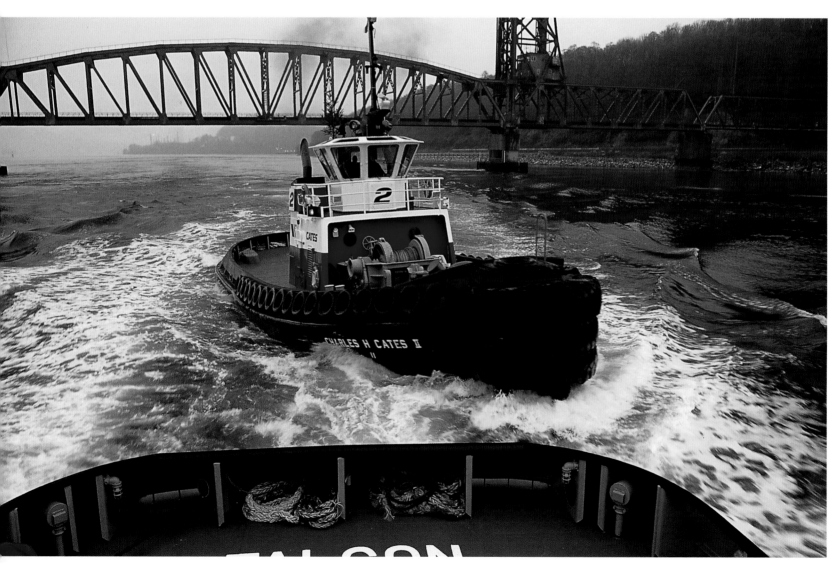

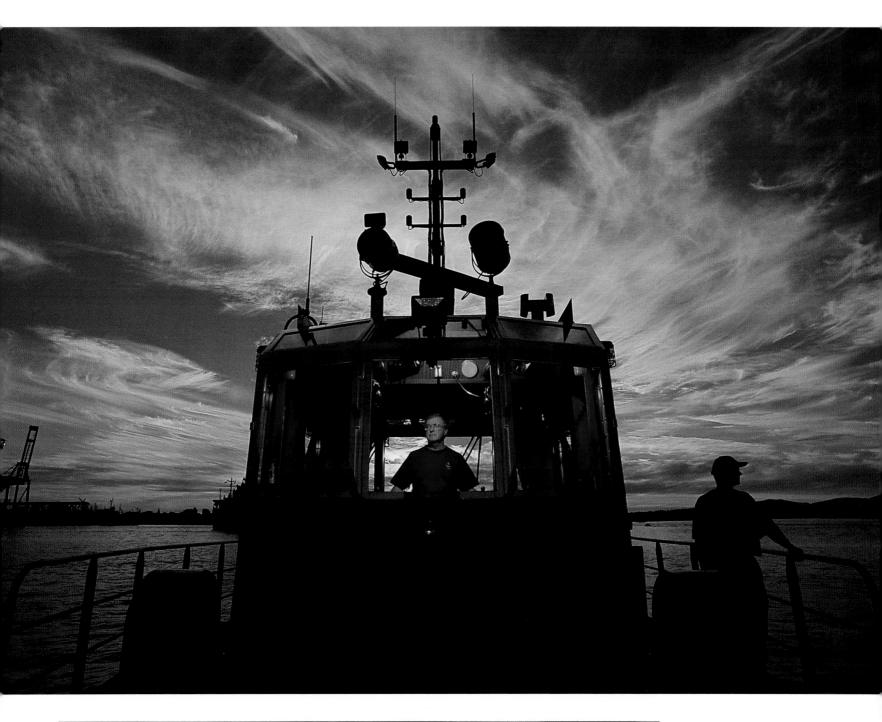

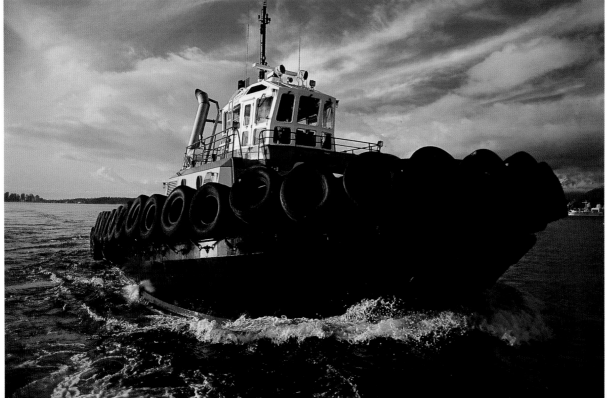

ABOVE
Another ship berthed,
Captain Bill Carey
returns the *Tiger Spirit*
to dock.

LEFT
The 21-metre, 5,400-
horsepower *Tiger Sun*
is reputedly the most
powerful ship-berthing
tug of its size
anywhere.

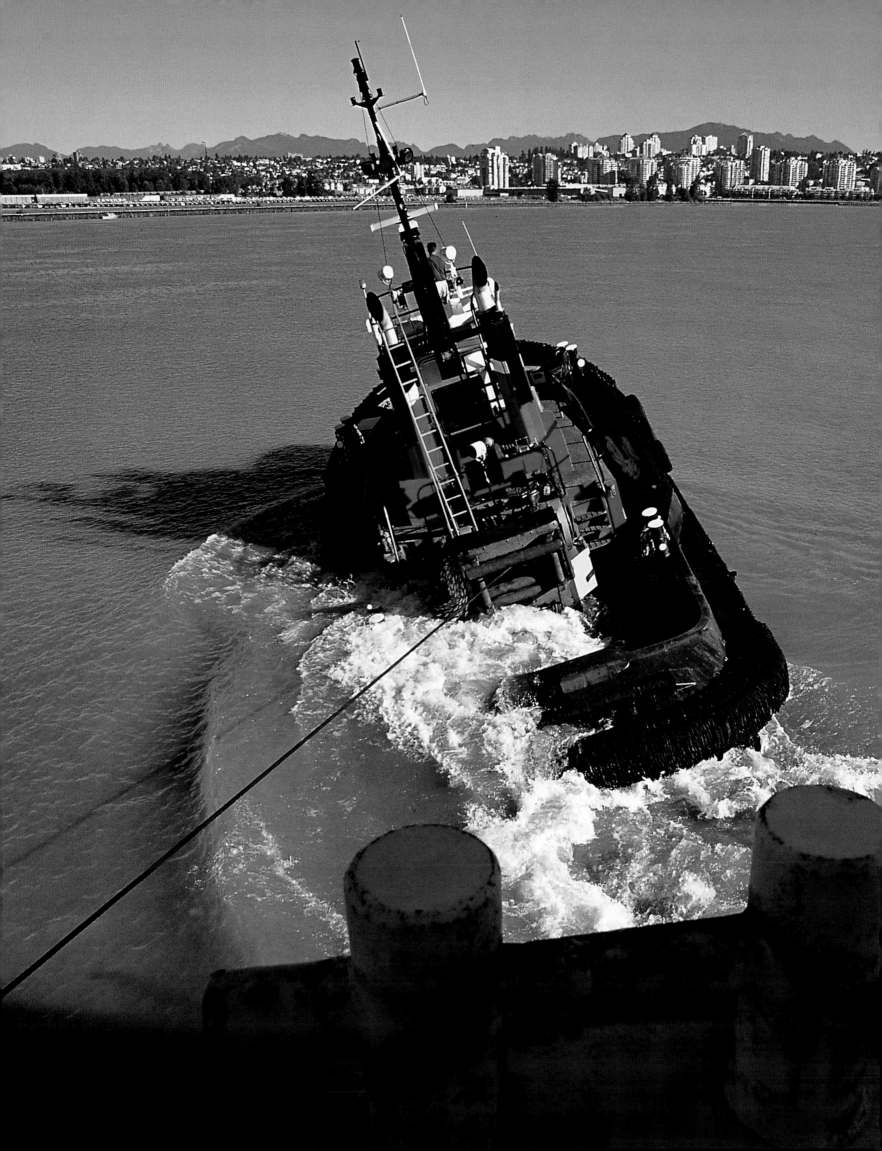

5

BOREDOM AND TERROR

Pat McBride was bringing a rail barge out of the Burlington Northern docks in Vancouver Harbour one evening in 1988. As skipper, Pat was working from the topside control station above the wheelhouse with the barge snugged up against his stern. His deckhand Roy was aboard the barge. Pat was on his way down to the winch to run out some towline, when he stopped momentarily, leaned into the wheelhouse and switched radio frequencies to be on the same channel as the tug that would assist him later in the tow. What he didn't notice was the tide rip—and what it was doing to the barge.

Danger is never far away pulling a close-hauled barge. Here, a tug buries its afterdeck straining to make a turn under power.

The outgoing tide was running west, parallel to the shoreline. Running north, the straining tug had ploughed through the rip, no problem. But as soon as the current hit the barge, it shoved the entire thing sideways. That swung the tug around to the right like a toy on a string. The tug ended up sideways against the bow of the oncoming barge. Seen from above, the tug would have looked like a tiny blade being folded into a very big jackknife.

"I just stepped into the door of the wheelhouse— and that's when I felt the boat take the lurch. I looked back and tried to get to the winch. But I knew right away—my sailor bones told me—this is big trouble."

Clinging to the outside of the wheelhouse door, Pat saw that the tug had now folded right in against the oncoming barge.

"I could feel the bow of the barge resting on my shoulder."

He scrunched down and made himself as tiny as he could to keep from being crushed as the barge kept coming, grinding metal on metal, until the tug rolled over and began to sink.

"I actually walked along the side of the housework as the tug was rolling over," said Pat. "I stepped out onto the hull of the tug and dove into the water as she went down."

From there the story takes on an oddly dreamlike quality.

"I hit the water and it was an instant sensation of relief. And then I realized it was really dark. Like I've never been anywhere this dark."

Pat groped with his hands until he felt cold metal. "And that's when I realized I was underneath the barge. And I could hear—the engine on the tug was still running—and I could hear the tug underneath me. Behind me. Bumping on the hull of the barge."

Pat started swimming. "I had no idea whether I was swimming the width or swimming the length. So I just

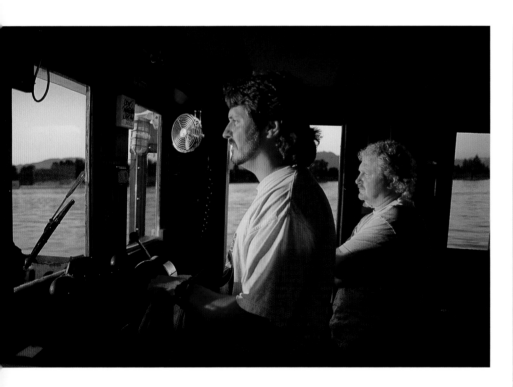

ABOVE
Towing is well described by the phrase, "hours and hours of boredom interrupted by moments of sheer terror."

RIGHT
A Wainwright Marine tug rolls up a big bow-wave running against the current at Prince Rupert.

started breaststroking. Luckily I was swimming the width. And I popped up about fifteen feet off the barge." With his head back above water, Pat looked around at the harbour lights and began to feel a weird kind of serenity. He said to himself, "What a beautiful night this is."

Eventually, Pat was rescued and pulled aboard the assist tug. Through the haze of his hypothermia he barely made out his buddies cracking feeble jokes to cheer him up.

"Robbie White, one of the crew on the assist tug—I'll never forget it to this day—Robbie says, 'Well, I don't know what the problem is. After all, shit floats.'"

After watching it all pass before his eyes again, Pat quietly adds, "Now, that's the closest I came to dying."

But he didn't quit. Only a few days later he was back on the job. "You realize something like that is a very uncommon occurrence. Thank God. And you just carry on. You get back in the saddle and carry on."

Did he ever think about finding a safer line of work? Not really. "Still enjoy the job, yeah. Ran the boat again after that, and it was fine. But yeah, scary moment. We do say on the tugs that it's hours and hours of boredom interrupted by moments of sheer terror."

So what is it that attracts people to the towboating life and keeps them at it despite all the boredom and terror? According to Pat McBride, the positives far outweigh the negatives.

"When you been up and down the coast for a few years, you've seen a lotta things people would pay good money to see," says Pat. "The whales at Robson Bight, spectacular sunsets, fire water glowing under the boat at night, the wave tips all lit up. It's a different kind of job. You go out and play around in Mother Nature. You work long hours. And the camaraderie—the team thing—I really enjoy that. I like the people I work with."

"Old guys'll say the industry's really changed. 'Sure

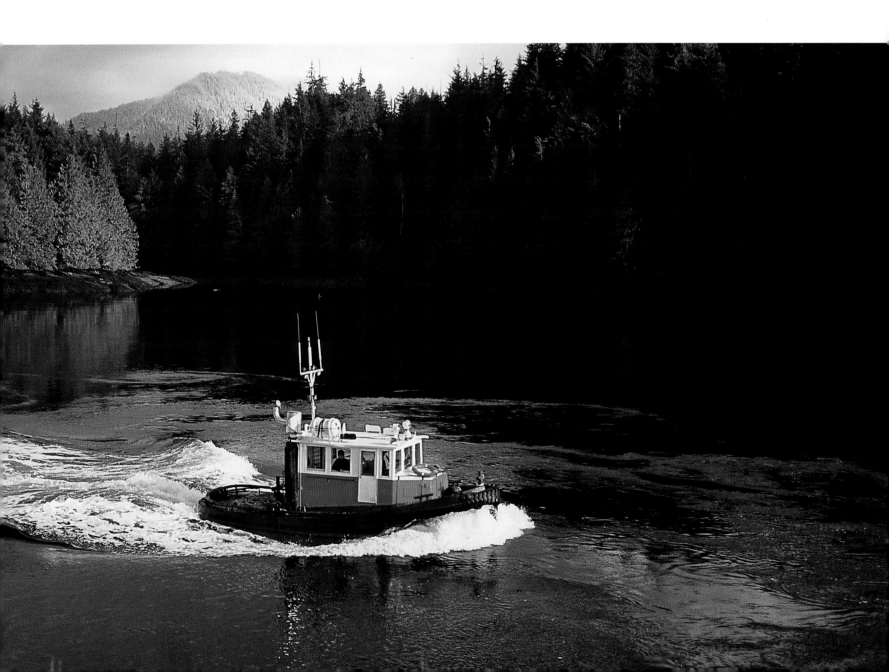

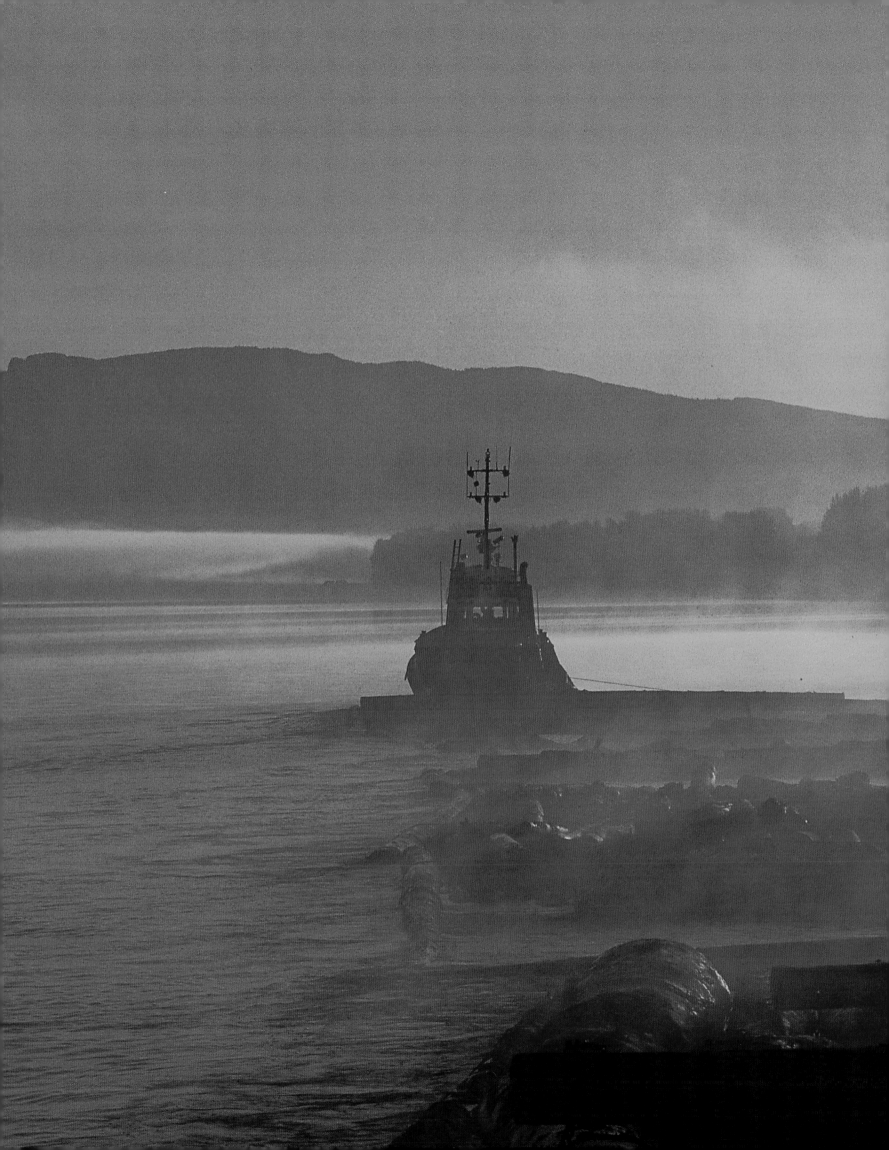

am glad I'm gettin' out.' But young guys say it's great. We got better equipment. Better boats." And before too long, Pat figures there'll be plenty of opportunities for the young guys. Lots and lots of boomer generation guys will be retiring soon.

Pat's son, Shawn, agrees that there is a future in the industry and he wants to be part of it.

"My ultimate ambition would be to run a boat someday," says Shawn. But before that day comes he wants to learn a lot more from the old salts. "I don't want to run a boat—and I don't even wanna be a mate—until I'm very comfortable with myself out there, unless I know that I know that job. As skipper, you're responsible for everyone else. I want to be able to answer every question that someone has. I want to be able to remember all the points I've gone by and every bay that I've been into. For now though, I just try and pick up on the really important things."

Wayne Whyte worked tugs, including the *Sudbury II*,

for much of his life, making skipper at the age of 29. He eventually became a BC Coast Pilot, guiding foreign ships along the coast, and retired in 2002. One of his sons now works as a skipper, getting his first command at the same tender age his father did. Wayne says, "Sure, the industry has changed, but there is an aura about tugboating. It was an awesome life. There were certainly lots of lonely nights and tough weather, but you got a real sense of accomplishment from the work."

Pat McBride agrees. "There's a lotta things computers can't do. And running a tug is one of them. Despite all the new technology for satellite navigation and whatnot, when the wind comes up and the sea is rough, it still comes down to human hands, experience and local knowledge. You go down and do your job and nobody bothers you. The office can send out all the damn memos they want. But eventually we gotta leave the dock and do our work."

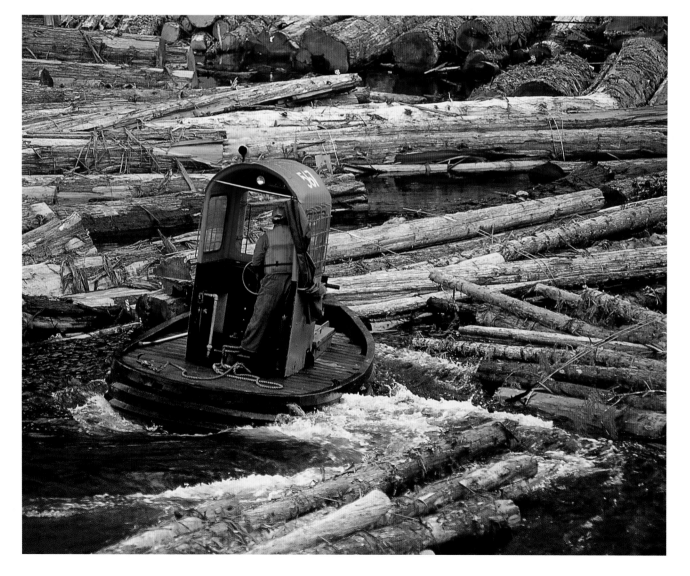

For Tyler and Kate.
My two greatest teachers.
ROBB DOUGLAS

The most challenging part of photographing tugboats for this book was making the shots look different. Fortunately I had a helicopter to hang out of and log booms to run up and down, thanks to the enthusiasm and generosity of many people. I would like to thank the following individuals for their part in this book. If I have overlooked anyone it is entirely due to the poor memory of the photographer.

Special thanks to Jerry Thompson for collecting stories on the water. Capt. Tim Mackenzie from Harken Towing and Capt. Doug Towill and Kelly Francis from the Washington Marine Group gave me the access I needed to shoot the initial images. Capt. Don Rose donated a great deal of time and expertise, as did Capt. Bill Carey, Capt. Ken Schmidt, Capt. Brent Gilker and Gerry Dyson. Kerry Moir from Riverside Towing never turned down a request and supplied me with tugs as photo boats. Don Sharpe from Jarl Towing and Art Beaulieu from Pacific Cachalot put me up in their tugs for several days while I documented the life of a towboater on the Yucultas Rapids run. Perry Boyle from Sabre Marine intro-duced me to the towboating community in Prince Rupert and provided the best clam chowder I have ever tasted. Len Robson guided us in his boat for the *Rivtow Capt. Bob* log-dumping shot. Sandy Gibb from Fleetwood Forest Products provided me with his helicopter and pilot, Walter Squires, who did some superb flying while I shot tugs from the air. Danny Sewell from Sewell's Marina donated the use of his rental boats for the Howe Sound photos. Henriette Oskam took time on her day off to let me shoot her portrait. Glen "Bronco" Cathcart donated his time and expert eye to edit the original images down to 300. George Laszuk got up at first light to take my portrait. In 1975 Ross "Hutch" Hutchinson faithfully drove me to photography school whenever I was suffer-ing the effects of the night before. And finally, my wife Linda encouraged me to follow my dream, especially during times of uncertainty. — Robb Douglas

The editors thank Alan Bone, Shane Hall, S.C. Heal, Ray Lee, Don MacKenzie, Royal Maynard, Rob Morris, Mel Scott, and Wayne Whyte for technical assistance and expertise.

Text copyright © 2002 Peter Robson and Betty Keller
Photographs copyright © 2002 Robb Douglas
Second printing 2006

Published by
HARBOUR PUBLISHING CO. LTD.
P.O. Box 219
Madeira Park, BC Canada
V0N 2H0
www.harbourpublishing.com

Page design and composition by Roger Handling
Cover design by Martin Nichols

Printed in China

Harbour Publishing acknowledges the financial support of the Government of Canada through the Book Publishing Industry Development Program (BPIDP) and the Canada Council for the Arts, and the Province of British Columbia through the British Columbia Arts Council, for its publishing activities.

THE CANADA COUNCIL FOR THE ARTS SINCE 1957 | LE CONSEIL DES ARTS DU CANADA DEPUIS 1957

BRITISH COLUMBIA ARTS COUNCIL
Supported by the Province of British Columbia

National Library of Canada Cataloguing in Publication Data

Douglas, Robb, 1950-
 Skookum tugs

 ISBN 10: 1-55017-275-1 ISBN 13: 978-1-55017-275-1

 1. Tugboats--British Columbia--Pictorial works. I. Robson, Peter A. (Peter Andrew), 1956- II. Keller, Betty. III. Title.
VM464.D68 2002 387.2'32'097110222 C2002-910760-1

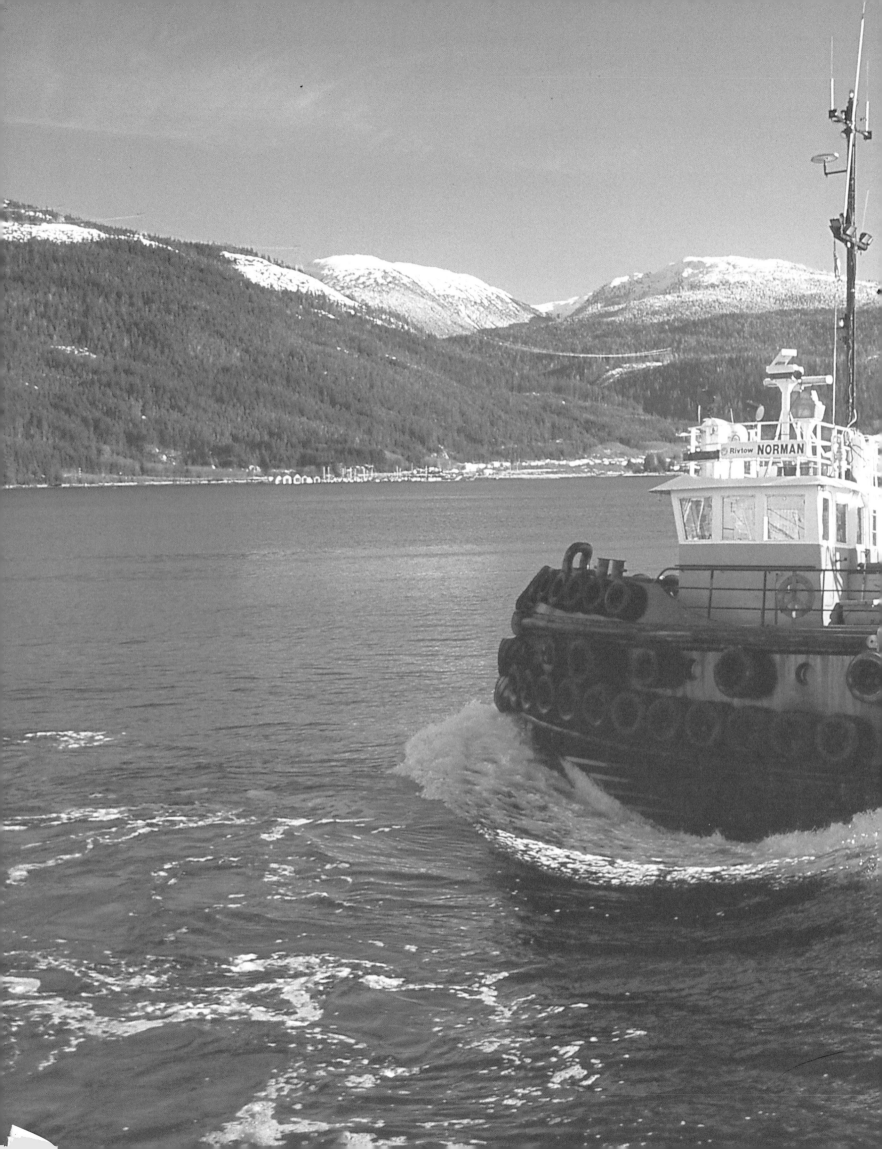